Books are to be returned on or before
the last date below.

D1581858

058218

THE HENLEY COLLEGE LIBRARY

THE HENLEY COLLEGE LIBRARY

50 JEWISH ARTISTS
YOU SHOULD KNOW

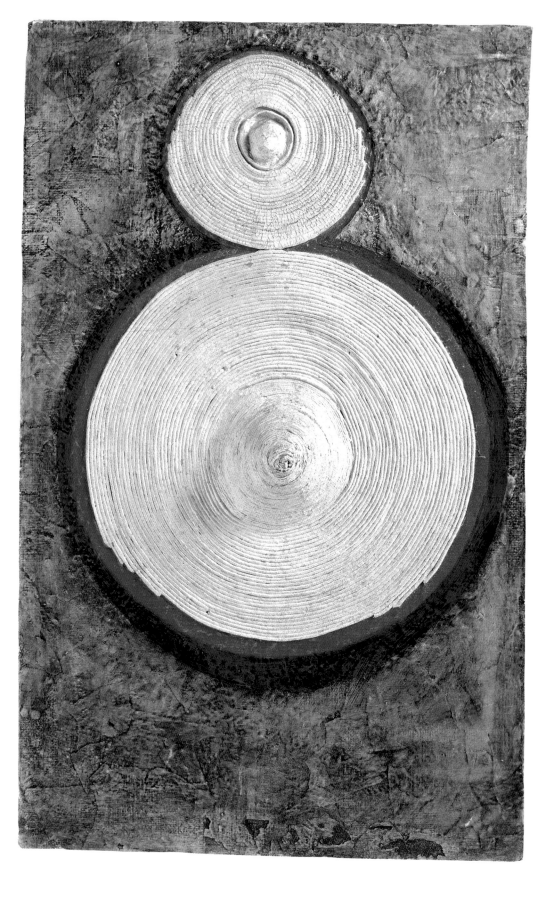

50 JEWISH ARTISTS
YOU SHOULD KNOW

Edward van Voolen

Prestel

Munich · London · New York

Front cover from top to bottom:
Marc Chagall, *Expulsion from Paradise* (detail), 1961, oil on canvas, 190.5 x 283.5 cm, Musée National Marc Chagall, Nice, see p. 57
Man Ray, *Noire et Blanche* (detail), 1926, see p. 67
Lee Krasner, *Composition* (detail), 1949, oil on canvas, 96.5 x 71.1 cm, Philadelphia Museum of Art, Philadelphia, see p. 96
Amedeo Modigliani, *Reclining Nude from the Back* (detail), 1917, oil on canvas, 64.5 x 99.5 cm, The Barnes Foundation, Merion, Pennsylvania

Frontispiece: Eva Hesse, *Ringaround Rosie*, 1965. Varnish, graphite, ink, enamel, cloth-covered wire, papier-caché, unknown modeling compound, Masonite, wood, 67.5 x 42.5 x 11.4 cm, Museum of Modern Art, New York, fractional and promised gift of Kathy and Richard S. Fuld, Jr., 2005

Pages 10–11: Sigalit Landau, *Melon Meal on Salt Funnel*, 2007. View of the exhibition *The Dining Hall*, KW Institute for Contemporary Art, Berlin

© Prestel Verlag, Munich · London · New York, 2011
© for the works reproduced is held by the artists, their heirs or assigns, with the exception of: Jankel Adler, Marc Chagall, Jim Dine, Ilya Kabakov, Anish Kapoor, Sol LeWitt, El Lissitzky, Louise Nevelson, Barnett Newman, Felix Nussbaum, Larry Rivers, Arnold Schoenberg, Richard Serra, Ben Shahn, Chaim Soutine, Nancy Spero, Ossip Zadkine with VG Bild-Kunst, Bonn 2011; Lee Krasner with Pollock-Krasner Foundation / VG Bild-Kunst, Bonn 2011; Man Ray with Man Ray Trust, Paris / VG Bild-Kunst, Bonn 2011; Mark Rothko with Kate Rothko-Prizel & Christopher Rothko / VG Bild-Kunst, Bonn 2011; Grisha Bruskin with © Grisha Bruskin, courtesy Marlborough Gallery, New York; Otto Freundlich with © Jewish Museum, Berlin; R. B. Kitaj with © The Estate of R. B. Kitaj, courtesy Marlborough Gallery, New York; Jacques Lipchitz with © The Estate of Jacques Lipchitz, courtesy Marlborough Gallery, New York; Eva Hesse with © The Estate of Eva Hesse. Courtesy Hauser & Wirth; Morris Louis with ©1951 Morris Louis; Reuven Rubin with © Courtesy The Rubin Museum, Tel Aviv; Charlotte Salomon with © Charlotte Salomon Stiftung.

Prestel Verlag, Munich
A member of Verlagsgruppe
Random House GmbH
Prestel Verlag
Neumarkter Strasse 28
81673 Munich
Tel. +49 (0)89 4136-0
Fax +49 (0)89 4136-2335

www.prestel.de

Prestel Publishing Ltd.
4 Bloomsbury Place
London WC1A 2QA
Tel. +44 (0)20 7323-5004
Fax +44 (0)20 7636-8004

Prestel Publishing
900 Broadway, Suite 603
New York, NY 10003
Tel. +1 (212) 995-2720
Fax +1 (212) 995-2733

www.prestel.com

The Library of Congress Number: 2011935622
British Library Cataloguing-in-Publication Data: a catalogue record for this book is available from the British Library; Deutsche Nationalbibliothek holds a record of this publication in the Deutsche Nationalbibliografie; detailed bibliographical data can be found under: http://dnb.d-nb.de

Prestel books are available worldwide. Please contact your nearest bookseller or one of the above addresses for information concerning your local distributor.

Project management by Claudia Stäuble, Franziska Stegmann
Copyedited by Jonathan Fox, Barcelona
Production by Astrid Wedemeyer
Cover and design by LIQUID, Agentur für Gestaltung, Augsburg
Layout by zwischenschritt, Rainald Schwarz, Munich
Origination by ReproLine Mediateam
Printed and bound by Druckerei Uhl GmbH & Co. KG, Radolfzell

Verlagsgruppe Random House FSC®-DEU-0100
The FSC®-certified paper *Hello Fat Matt* produced by mill Condat has been supplied by Deutsche Papier.

Printed in Germany

ISBN 978-3-7913-4573-4

FSC
www.fsc.org
MIX
Paper from
responsible sources
FSC® C004229

CONTENTS

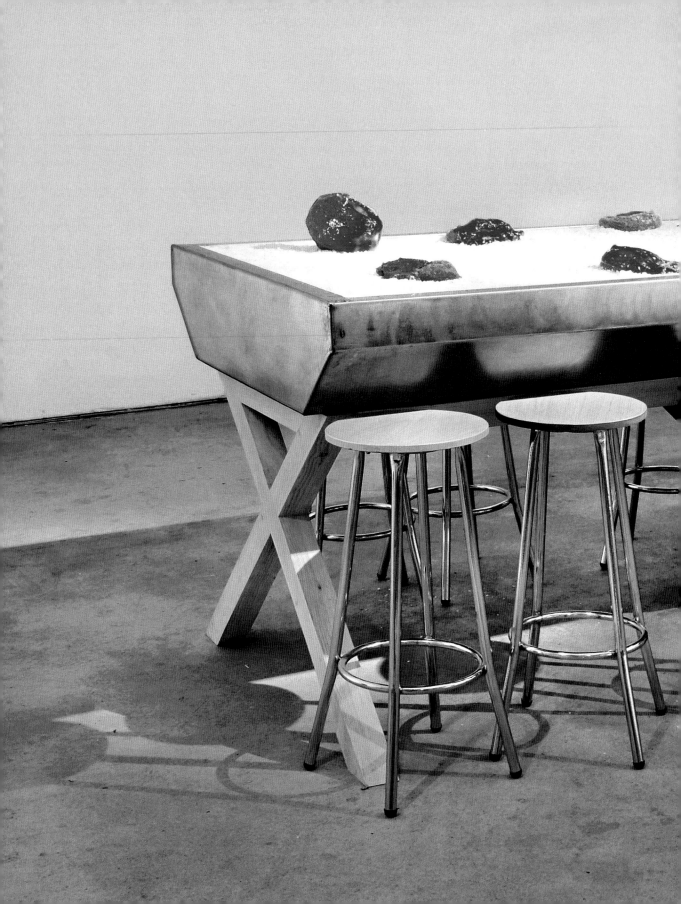

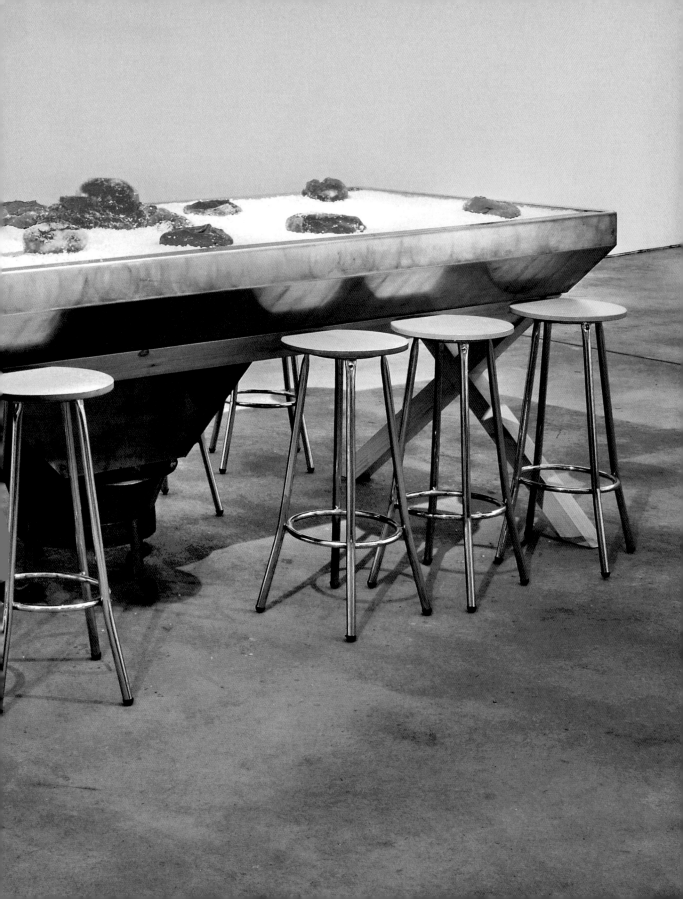

JEWISH ART AND JUDAISM

This book shows what Judaism has meant and still means to fifty individual Jewish artists during the last two centuries. Each of them gives his or her own expression and definition of Judaism, in much the same way that two thousand years ago a Jewish scholar in first-century Roman Palestine had. One day rabbi Hillel was asked, "Tell me the essence of Judaism while you are standing on one foot." He answered, "What is hateful to you, do not do to your fellow human being." And continued, "That is the essence. All the rest is commentary. Go and learn."

What is Judaism?

When talking about Jewish art, the first question is obvious: What is Judaism? Judaism is the religion and culture of a people known as Jews, Hebrews, or Israelites. Hebrews refers to the biblical ancestors Abraham, Isaac, and Jacob, patriarchs who lived some thirty-three centuries ago and wandered from Mesopotamia (present-day Iraq) to Canaan, where Isaac and Jacob were born. After Jacob wrestled with an angel and prevailed, he was called Israel ("he wrestled with God"), and his twelve descendants, the children of Israel or Israelites. The tribe Judah gave its name to the southern kingdom with Jerusalem as its capital, and later, in the Greco-Roman period, to the province Judea. The word "Jew" is derived from the Judeans, inhabitants of the kingdom Judah, their descendants and all those who joined them in the course of time. That is why Judaism is not a race: physically, Jews do not differ much from the people in whose midst they live—you will find white and black, blond and dark-haired Jews.

In 586 BCE, the southern kingdom also fell: Nebuchadnezzar destroyed Jerusalem and its Temple and deported part of the Jewish people into the Babylonian exile. But his empire in turn fell to the Persians, whose king Cyrus allowed the Judeans to return home in 533 and rebuild the Temple. Some however decided to remain behind: the dispersion of Jews—the Diaspora—from then on became a fact of Jewish life.

Even today, after the foundation of the State of Israel in 1948, the majority of Jews still lives in the Diaspora. Actually, most of Jewish history has taken place in exile. Exile is as much an essential experience of the Jewish people as (the memory of) the land of Israel. Currently Jews are spread over the whole world: about fifteen million in total, of whom almost six million in the United States of America, and over five million in Israel, approximately 500,000 in France, 375,000 in Canada, 300,000 in the United Kingdom, 280,000 in Russia, 185,000 in Argentina, 120,000 in Germany, and 100,000 each in Australia, Brazil, and the Ukraine; in other countries their numbers are smaller.

Hebrew, the language of the Bible, is over three thousand years old. It is an alphabetic script with twenty-two consonants. Each consonant has a numerical value, and since the early middle ages vowels have been added. The discovery of the Dead Sea scrolls in Qumran, in 1947, testifies to the development of biblical Hebrew as a spoken language up to the revolt against the Romans in 66–70 CE. At least until that time Hebrew was spoken and written; later it served as the second language for religious and literary use next to the vernacular or Jewish languages such as Yiddish (medieval German, with Hebrew words) and Ladino ("Jewish Spanish"), both written in Hebrew characters. When Jews in the late nineteenth century emigrated to Palestine, Hebrew was revived as a spoken language for what would become in 1948 the State of Israel.

So, what is Judaism? It refers to anything Jews have ever created and done over the past thirty-three centuries in any number of places. So, clearly no single Judaism ever existed, but many different ones: the Judaism of the patriarchs differed from that of Moses, and later the prophets. Biblical Judaism differs from that of the Pharisees, the sects of Qumran, and the early Christians. Medieval rabbinic Judaism was divided on many practical and philosophical issues, and modernity created a plethora of movements in Judaism—religious, political, and cultural. Many Judaisms existed and still exist next to each other, and often against each other.

And who is a Jew? Officially, everybody is considered a Jew who has a Jewish mother, but also everybody who upheld Jewish values and accepted its challenges; and indeed, from biblical times until today proselytes joined born Jews and were integrated into the Jewish people. Examples include the wife of Moses, and Ruth, the ancestor of King David. But who determines who is a Jew? The rabbis, but here the problem starts once again—the rules and regulations of Jewish law are interpreted in a wide variety of ways by Orthodox, Reform, and Conservative religious authorities. A secular admission to Judaism does not exist.

Finally: What keeps all these different Jews together? Jewish identity was—and partially still is—based on a common memory of the past, a shared sacred language, a joined cycle of festivals and life-cycle celebrations, a similar communal structure, and a shared vision of a future of justice and peace for all humanity. Jewish identity is shaped in the home, where children are taught the basics of Hebrew and Jewish tradition, and in the synagogue.

What is Jewish Art?

At first glance, Jewish art seems to be in conflict with the second of the ten commandments in the Bible, which states, "You shall not make for yourself a sculptured image, or any likeness of what is in the heavens above, or the earth below, or in the waters under the earth" (Exodus 20:4, Deuteronomy 5:8). Literally interpreted, the verse prohibits the possibility of visual arts amongst Jews and seems to

reflect a Jewish aversion towards images. However, an absolute prohibition against the making of images only concerns the adoration of idols, as it says in the verse immediately following, "You shall not bow down to them or serve them" (Exodus 20:4). But there is no prohibition against making objects in the context of the sacred service. Thus, shortly after the laws were given, Moses was commanded to construct a Tabernacle. Since Moses could not read the blueprints, the execution of cherubs, winged animals on top of the Ark of the Covenant, and the seven-branched Menorah, a candelabrum in the form of a tree, was left to Bezalel (his name means "in the shadow of God"). This first Jewish artist is described as a man endowed with special skills and qualities. The Tabernacle and its implements are thus the first examples of Jewish art and architecture within the parameters of the second commandment—not in the service of idolatry (as is the Golden Calf built in the shadow of Mount Sinai), but the abstract God of Judaism.

A few centuries later, King Solomon invited Hiram, a foreign artist from Tyre, to create all the metalwork for his Temple in Jerusalem, including a giant bronze laver (a basin supported by twelve oxen). In this first permanent sanctuary for Jewish worship were to be found such naturalistic forms as lions, flowers, pomegranates, trees, and cherubs (I Kings 7:1–51). In Solomon's own royal palace there was an ivory throne overlaid with fine gold, two lions standing beside the arms, and twelve lions standing on the six steps, six at each side (I Kings 10:18–20).

The battle against idolatrous practices pervades the Bible, and lasted until the Hellenistic period; the Maccabees revolted successfully against the placing of Greek gods in the Temple in the second century BCE, giving rise to the festival of Hanukkah. After this event, the fear of idolatry gradually diminished and gave over to a more tolerant interpretation of the second commandment. In the first post-Christian centuries, several stories in rabbinic literature (Mishnah and Talmud) relate that the religious authorities permitted works of art, even in the synagogue. Their testimonies coincide with the wall paintings in the synagogue of Dura Europos (third century CE) and mosaics in Israeli synagogues. Medieval rabbis were more concerned with the question of whether the faithful would be distracted by images than by concern for a literal interpretation of the second commandment. Opposition to art on religious grounds coincides with iconoclasm (in Christian Byzantium, Protestant regions, or sometimes in Islamic-ruled countries), and with Jewish pietists in twelfth- and thirteenth-century Germany. Yet, figurative art did not disappear. On the contrary, most communities and rabbis supported the idea that ceremonies should be performed in a beautiful synagogue with attractive objects (hiddur mitzvah, based on Exodus 15:2). Some of these were executed by Jews, most by non-Jews for their

Jewish clients. But however highly the "People of the Book" regard books—and above all their traveling sanctuary, the holy Torah (the five first books of the Hebrew Bible)—there are few material traces left. Manuscripts as well as sacred objects were looted and burned, and synagogues destroyed during persecutions and expulsions in the Middle Ages. Few survived.

Jews decorate their sanctuaries, embellish their ceremonial objects, and illustrate their sacred texts, all with the intent to glorify their abstract God, who is never depicted. The Bible forbids idolatry, but not the making of images, as long as they are within the context of the official religion. The image of Judaism, Jewish art, is as multifaceted and diverse as Jewish life.

Jewish Art in Modernity

Prior to the nineteenth century, Jews enjoyed autonomy in their communities: they could live, to a large extent, according to their own laws and regulations. Christian society, and to a lesser degree Islam as well, imposed restrictions on Jews, limiting them professionally and sometimes forcing them into separate areas. Yet Jews never lived completely separate from society at large—even while in the ghetto there was exchange with the outside.

The Enlightenment was the harbinger of modernity and resulted in an emancipation movement that gradually accorded Jews equal civil rights, first in the United States (1776), then in France (1789), the Netherlands (1796), and in the course of the nineteenth and early twentieth centuries all European states. Jews were no longer a semi-autonomous, separate "nation within a nation," but individual adherents of the Jewish religion, which became a matter of personal choice. In the footsteps of Baruch Spinoza (1632–1677), the German philosopher Moses Mendelssohn (1729–1786) argued that religious authorities had no right to coerce, religion being a private, personal matter. With real political power limited to biblical times and to the pre-modern, semi-autonomous Jewish minority in Europe, Jews would now be loyal to the state. Yet, equality before the civil law did not guarantee equal opportunity in society, as Jews were quick to discover. Particularly in Europe, the emancipation of the Jewish minority turned out to be a slow process, during which the Jews tried to integrate into society at large—sometimes successfully, but often stumbling over Christian religious or modern racial prejudices.

The Jewish people have been deeply involved in the arts from Biblical times on, whether as commissioners or creators. After discriminatory measures—such as the exclusion from guilds—were lifted, Jews were permitted for the first time to express themselves in the arts unencumbered by official restrictions. The wish to be accepted went hand in hand with the search for identity. In the nineteenth century, as a result of their emancipation, Jewish artists could

successfully contribute to the fine arts for the first time, whether openly exhibiting their Judaism to the outside world or indirectly alluding to their background. Examples are Max Liebermann, Maurycy Gottlieb, Jozef Israëls, and Arnold Schoenberg. Inspired by the search for national roots then popular in many European nations, artists like Issachar Ryback, El Lissitzky, and Marc Chagall explored the trails of their past material culture and contributed to a modern renaissance of Jewish art in the early 1900s. The same current had given rise to the search for an Israeli art once the first pioneers had settled there, as we see in the work of Reuven Rubin. Others, in the early twentieth century, became innovators of the arts in general, with Judaism playing only a marginal role in their work. Examples include Camille Pissarro, Man Ray, and Chaim Soutine. Despite the prejudice which hounded Jewish artists—namely that Jews were by nature or "race" more inclined to the word than to the image—the spirit of optimism prevailed—in Europe, in Israel, and increasingly in the United States, where twentieth-century Jewish artists thrived. The battle for equal rights proved difficult: in Germany it took three generations before Jews received citizenship in 1871, which only lasted until its revocation in 1935; in France, the anti-Semitic campaign against Captain Alfred Dreyfus led to a political crisis and raised doubts about the sincerity of the French towards their Jews. In Russia, anti-Semitism seemed endemic; pogroms between 1881 and 1914 resulted in a massive exodus of Jews form the tsarist empire, with some two million Russian Jews immigrating to the United States, amongst them artists like Ben Shahn, Barnett Newman, Mark Rothko, and Louise Nevelson. The center of gravity had now moved definitively to the Anglo-Saxon world.

A large exodus took place under the threat of Nazism in the 1930s, when 280,000 German Jews (of a total of 500,000) managed to escape: almost half to the United States, and about 55,000 to British Palestine. The Jewish artistic response to the Nazi rise to power came quickly—artists and writers expressed their fears of expulsion and humiliation, and their premonition of the horrors to come, as we can see in the works of artists like Jankel Adler, Jacques Lipchitz, Charlotte Salomon, or Felix Nussbaum. The Holocaust claimed six million victims amongst European Jews. Most affected numerically were Jews in Poland (2,900,000 victims, 88 percent of the total Jewish population), the former Soviet Union (1,000,000, 33 percent), Romania (420,000), the former Czechoslovakia (300,000), Hungary (200,000), and the Baltic republics (220,000, 90 percent); followed by Germany (200,000), France (130,000), and the Netherlands (107,000, 80 percent).

Contemporary Art

After the systematic mass murder of six million European Jews, the philosopher Theodor Adorno thought it would be forever impossible to create poetry—and by extension, art—after Auschwitz. Yet, the Holocaust has become a major theme for modern Jewish artists. It has inspired them—in Europe, where the atrocities occurred, but also in Israel and the United States, where most Jews currently reside. The modern Jewish experience is shaped by the memory of the Holocaust and the creation of the State of Israel in 1948, a refuge for the survivors, for Jews migrating from Arabic counties in the sixties and seventies, and Jews from the former Soviet Union and its successor countries in the last decades of the twentieth century. The Holocaust and the creation of the State of Israel are the two most influential events in the twentieth century—the former dealing with collective death, the latter with the rebirth of an ancient nation.

After 1945, American Jewish artists Ben Shahn, Lee Krasner, Louise Nevelson, and Morris Louis were the first to reevaluate their assimilation into mainstream culture by responding to the atrocities and to the nascent Jewish state. Israeli artists like Mordecai Ardon, primarily occupied with shaping a national identity, integrated the Holocaust into the visual arts, while Moshe Gershuni and Menashe Kadishman reflect upon the wars that plague the country and absorb the effects of a swelling Palestinian nationalism. The postwar generation, whether in Europe, Israel, or the United States, is shaped by the memories of survivors, and attempts to come to grips with the greatest trauma in Jewish history since the destruction of the Second Temple. Richard Serra and Jonathan Borofsky are good examples.

There is as little a Jewish artistic style as there is a Christian, Muslim, American, German, or Israeli style. Jewish artists play an integral part in all of the disparate artistic movements of modern pluralistic society. While some are inspired by traces of a now-lost world, others are attracted by the revival of Jewish mysticism. Amidst the resurging nationalism and fundamentalism of our times, the universalistic, prophetic dream of peace and justice remains—for artists as well (Nancy Spero, William Kentridge)—enduringly vibrant.

Edward van Voolen

Literature

Amishai-Maisels, Ziva, *Depiction and Interpretation: The Influence of the Holocaust on the Visual Arts*. Oxford and New York, 1993.

Apter-Gabriel, Ruth, ed., *Tradition and Revolution: The Jewish Renaissance in Russian Avant-Garde Art, 1912–1928*. Exh. cat. The Israel Museum. Jerusalem, 1987.

Baigell, Matthew, and Milly Heyd, eds., *Complex Identities: Jewish Consciousness and Modern Art*. New Brunswick and London, 2001.

Bilski, Emily, ed., *Berlin Metropolis: Jews and the New Culture, 1890–1918*. Exh. cat. The Jewish Museum. New York and Berkeley, 1999.

Bland, Kalman P., *The Artless Jew: Medieval and Modern Affirmations and Denials of the Visual*. Princeton, 2000.

Cohen, Richard I., *Jewish Icons: Art and Society in Modern Europe*. Berkeley, 1998.

Cohen Grossman, Grace, *Jewish Art*. Southport, 1995.

Godfrey, Mark, *Abstraction and the Holocaust*. New Haven and London, 2007.

Kampf, A., *Jewish Experience in Twentieth-Century Art*. Exh. cat. Barbican Art Gallery. London, 1990.

Kleeblatt, Norman L., ed., *Too Jewish? Challenging Traditional Identities*. Exh. cat. The Jewish Museum. New York, 1996.

Kleeblatt, Norman L., ed., *Pollock, De Kooning, and American Art, 1940–1976*. Exh. cat. The Jewish Museum. New York, 2008

Malinowski, Jeerzy, et al., eds., *Jewish Artists and Central-Eastern Europe*. Warsaw, 2010.

Mann, Vivian B., *Jewish Texts on the Visual Arts*. Cambridge, Mass., 2000.

Mendelsohn, Ezra, ed., *Art and its Uses: The Visual Image and Modern Jewish Society*. Studies in Contemporary Jewry 6. New York, 1990.

Olin, Margaret, *The Nation without Art: Examining Modern Discourses on Jewish Art*. Lincoln and London, 2001.

Sed-Rajna, Gabrielle, ed., *Jewish Art*. New York, 1997.

Shatskikh, Aleksandra, *Vitebsk: The Life of Art*. New Haven, 2007.

Soussloff, Catherine M., *Jewish Identity in Modern Art History*. Berkeley, 1999.

Tumarkin Goodman, Susan, ed., *Chagall and the Artists of the Russian Jewish Theater*. New York and New Haven, 2008.

Tumarkin Goodman, Susan, ed., *The Emergence of Jewish Artists in Nineteenth-Century Europe*. London, 2001.

Young, James E., *At Memory's Edge: After-Images of the Holocaust in Contemporary Art and Architecture*. New Haven and London, 2000.

1789–99 French Revolution

1808 Goethe, *Faust*

1823 Heinrich Heine converts
to Christianity

1804 Napoleon Bonaparte becomes
French emperor

1750 1755 1760 1765 1770 1775 1780 1785 1790 1795 1800 1805 1810 1815 1820 1825 1830 1835

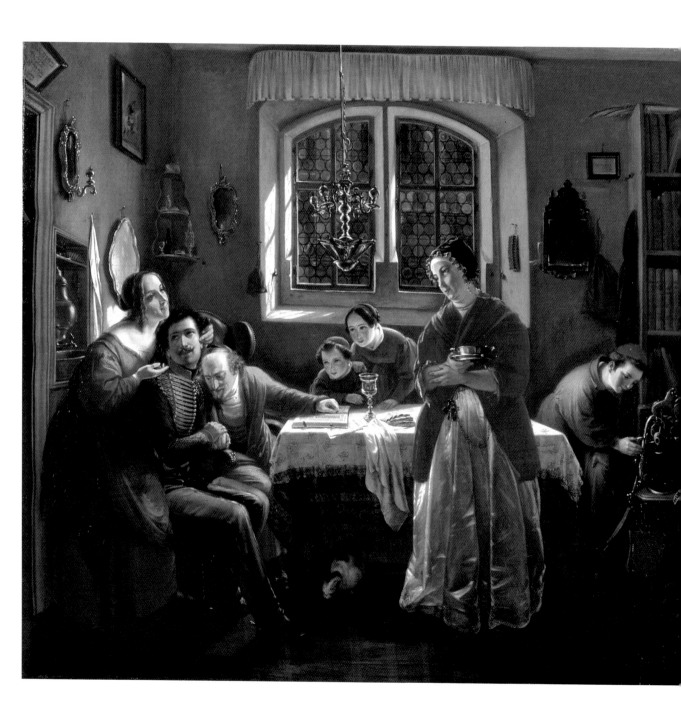

1848 Karl Marx and Friedrich Engels
publish the *Communist Manifesto*

1871 Equal rights for Jews in Germany

1896 Theodor Herzl writes
The Jewish State

1909 Tel Aviv founded

1863 Édouard Manet, *Déjeuner sur l'Herbe*

1914–18 World War I

1840 1845 1850 1855 1860 1865 1870 1875 1880 1885 1890 1895 1900 1905 1910 1915 1920 1925

MORITZ DANIEL OPPENHEIM

Considered Germany's first Jewish painter of the modern era, Moritz Daniel Oppenheim was famous for his paintings of traditional Jewish life. He became "the painter of the Rothschilds" and was called "the Rothschild of painters" because of his early success and later wealth.

"Pairing enthusiastic love for the fatherland with deep devotion to religious family life."

Moritz Daniel Oppenheim (1800–1882) was born in the ghetto of Hanau near Frankfurt. From early childhood his parents encouraged him to pursue his artistic talents, and after studying in Munich—and travels to Paris and Italy—he moved to Frankfurt in 1825.

The *Return of the Jewish Volunteer from the Wars of Liberation to His Family Still Living in Accordance with Old Customs* (1833–34) shows a traditional Jewish home on the Sabbath, the weekly day of rest. A soldier returns safely to his family after contributing to the defeat of Napoleon and the liberation of Germany in 1813. As he is embraced by his sister, his mother and the two youngest children look at him in admiration. His father stares bewildered at the Iron Cross his son received for bravery, and his helmet and sword enthrall another brother. All men except the returning volunteer wear skullcaps. The mother's head is covered, as tradition prescribes for married Jewish women. The wine cup over which the Sabbath is sanctified and the *challah* (braided bread) are on the table, above which hangs a brass Sabbath lamp. Next to a bookcase hangs a plaque indicating the direction of prayer, and a Chanukah lamp. On the bottom shelf in the left corner stands a spice tower used at the end of the Sabbath. On the left wall hangs, as an allusion to the family's allegiance to Germany, an equestrian portrait of Fredrick the Great of Prussia, the eighteenth-century soldier-king who promoted religious tolerance. The modernity of

the family is further pointed out by a copy of a German newspaper under the Hebrew book the father was reading.

A Political Statement

Lithographs and postcards attest to the immediate success of the Return. The painting would be included in one of Germany's most popular Jewish books: *Scenes from Traditional Jewish Family Life*, reprinted numerous times since 1866. Despite its old-fashioned attire, the Return is a political statement: it was commissioned by the Jewish community of Baden and donated to Gabriel Riesser in gratitude for his help securing their equal rights. The principles of Oppenheim and Riesser, the political spokesman of German Jewry, coincided: "yes" to emancipation but "no" to religious surrender in the form of conversion or assimilation. The work supports the message that loyalty to both the Jewish faith and the German fatherland need not be in conflict. The decade in which it was painted, the 1830s, marked the years in which the French revolutionary ideas of "liberty, equality, and fraternity" were threatened by restoration and reaction. The 1860s, when the Return first appeared in print, witnessed a new dawn of these ideas and the fulfillment of their promise: Jews were for the first time granted equal rights in the united Germany (1871).

By placing the fancily dressed mother, the guardian of Jewishness, in the center of his composition, Oppenheim emphasizes that Jews successfully acquired (German) middle-class values—as he did in his many works on the Jewish festivals and life-cycle events. For him, the new Jewish quarter is no longer the recently abolished ghetto, but the synagogue and particularly the sheltered bourgeois living room in which timeless ancient rites are meaningful models for the present. An honorable past serves as a guarantee for the self-assurance of Jews who considered themselves German citizens of the Mosaic persuasion.

1800 Born on January 7/8 in Hanau near Frankfurt, the youngest of six siblings
1810 After studying at the gymnasium he attends the Hanau Academy of Drawing
1817 Studies at the Art Academy in Munich
1821–25 Italy; first contacts with the Rothschild family of bankers
1825 Established in Frankfurt, he paints portraits of famous contemporaries and Jewish notables and becomes widely recognized for his Biblical scenes
1835 In Paris, visits the Rothschilds, Heinrich Heine, painter associates, and composers Chopin and Meyerbeer
1840 The City of Frankfurt commissions imperial portraits
1845 Acquires a collection of Dutch masters in Holland on behalf of the Rothschilds
1851 After several refusals, becomes a citizen of Frankfurt
1856 Paints *Lavater and Lessing Visiting Moses Mendelssohn*
1863–82 A series of paintings depicting Jewish family life establishes his popularity
1882 Dies of a stroke on February 26 in Frankfurt

LITERATURE
Georg Heuberger and Anton Merk, eds., *Moritz Daniel Oppenheim: Jewish Identity in Nineteenth Century Art*, exh. cat. Jewish Museum (Frankfurt am Main, 1999).

left page
Moritz Daniel Oppenheim, *Return of the Jewish Volunteer from the Wars of Liberation to His Family Still Living in Accordance with Old Customs*, 1833–34, oil on canvas, 86.4 x 91.4 cm, The Jewish Museum, New York. Gift of Mr. and Mrs. Richard D. Levy

right
Moritz Daniel Oppenheim, *Self-Portrait in the Studio* (detail), 1877, The Israel Museum, Jerusalem

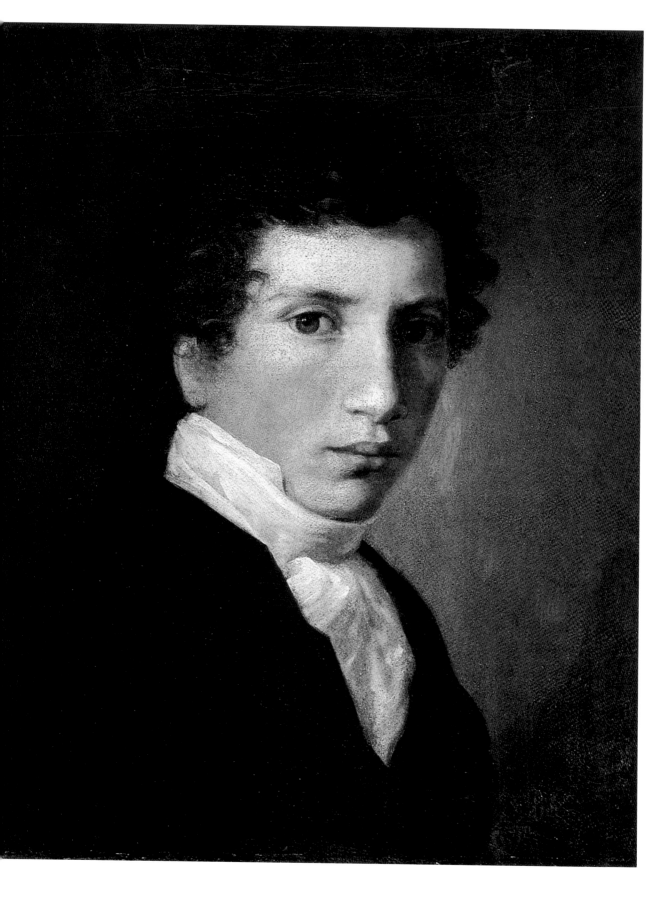

left page
Moritz Daniel Oppenheim, *Self-Portrait*,
1822, oil on canvas, 44 x 36.5 cm,
The Israel Museum, Jerusalem. Gift of
Dr. Arthur Kauffmann, London, Through
the British Friends of the Art Museums
of Israel

below
Moritz Daniel Oppenheim, *Charlotte von
Rothschild as Bride*, 1836, oil on canvas,
119 x 103 cm, The Israel Museum,
Jerusalem. Received through IRSO

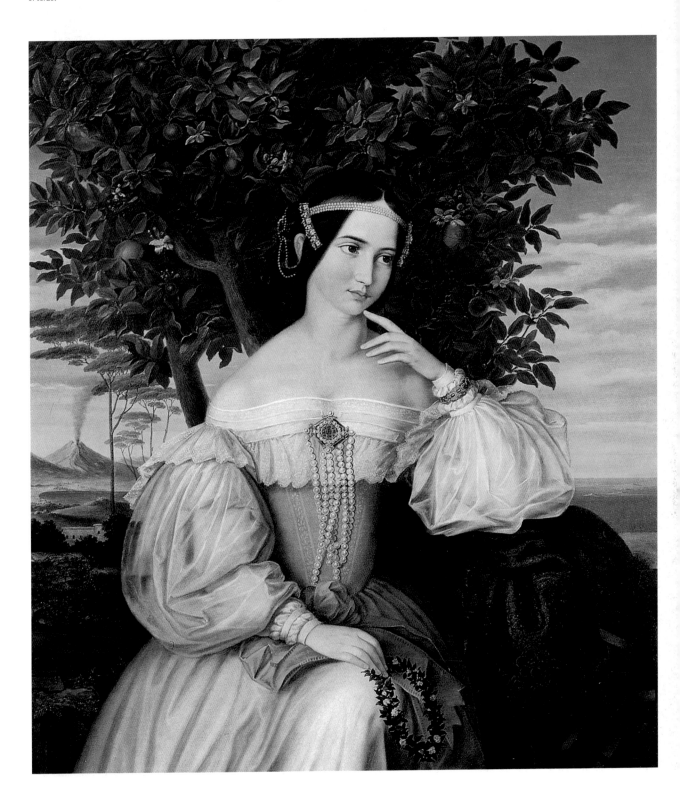

1749 *Johann Wolfgang von Goethe

1776 American Declaration
of Independence

1805 Battles of Trafalgar and Austerlitz

| 1755 | 1760 | 1765 | 1770 | 1775 | 1780 | 1785 | 1790 | 1795 | 1800 | 1805 | 1810 | 1815 | 1820 | 1825 | 1830 | 1835 | 1840 |

Solomon Alexander Hart, *The Feast of
Rejoicing of the Law at the Synagogue of
Leghorn (Livorno)*, 1850, oil on canvas,
141.3 x 174.6 cm, The Jewish Museum,
New York. Gift of Mr. and Mrs. Oscar
Gruss

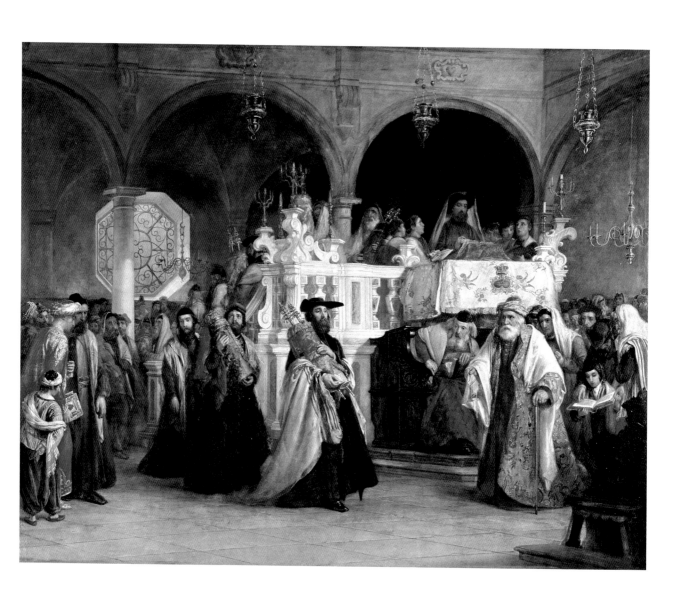

1866 Equal rights for Jews in the United Kingdom

1851 First World's Fair in London

1868 Benjamin Disraeli, baptized at 13, becomes prime minister of the United Kingdom

1904 Jewish Museum, New York founded

1895 First Venice Biennale

1893 Edvard Munch, *The Scream*

1921 Einstein awarded Nobel Prize

1845 1850 1855 1860 1865 1870 1875 1880 1885 1890 1895 1900 1905 1910 1915 1920 1925 1930

SOLOMON ALEXANDER HART

The first Jewish member of the British Royal Academy, Solomon Alexander Hart was a historical painter renowned for his scenes of the Jewish ceremonial, celebrating the religion's pageantry at a time when adherents were seeking to reconnect with their past.

Solomon Alexander Hart (1806–1881) was born in Plymouth and lived from 1820 in London, where he first apprenticed to an engraver before entering the Royal Academy as a student in 1823. He was the first Jew to become a full member of this prestigious Academy in 1840, where he would teach between 1854 and 1863 and later serve as a librarian. Hart focused on history painting: famous episodes from British history and Shakespeare, but also frequently chose Jewish themes. He remained an observant Jew all his life.

Inspired by his visit to Italy in 1841–42, Hart painted *The Feast of Rejoicing of the Law at the Synagogue of Leghorn (Livorno)* in 1850. Joy resounds when the Jewish community celebrates this festival (*Simchat Torah*), which forms the conclusion of Tabernacles and marks the end of the annual cycle of readings from the Torah (the scroll with the Hebrew text of the Pentateuch, the five books of Moses). In the synagogue, the cantor stands on an elevated marble platform (*bimah*) leading the congregation in song as the Torah scrolls are removed from the Ark to become the focus of rejoicing. Young and old parade around and look in reverence at the sacred text. During the service, all those present, even children, receive the honor of being called up to the bimah to recite the blessing over the Torah reading. At the close of the ceremony, two people are honored with reading, respectively, the last verses from Deuteronomy 34 (the last book and chapter of the Pentateuch), and immediately thereafter the first chapter of Genesis. These honorees, the center of the composition, are called bridegrooms, evoking the symbols of marriage and the covenant between Jews and the Torah.

Rejoicing in Splendor
The procession takes place in one of Europe's largest and most beautifully decorated synagogues, that of Livorno. This main port of Tuscany owed its prominence and its Jewish community to the magnanimity of Ferdinand de Medici, who developed the town and who, in 1593, granted liberty to the Jewish refugees from Spain. Centuries later, their turbans and exotic dress reflect the family ties and commercial contacts with other Mediterranean towns in North Africa and Turkey. We see the rabbi in his red robe rising from his seat below the *bimah*. The synagogue itself, in size and grandeur only comparable to the equally magnificent Spanish-Portuguese sanctuary in Amsterdam (1672), was built in 1693 and embellished during the following century. The beautiful polychrome marble platform and balustrade, prominently featured in the painting, was installed in 1745. The building reached its most glorious phase in 1789 with an even larger *bimah*, arches supporting two galleries for the women, and a truly monumental marble Ark. The Jewish population of over four thousand represented one-eighth of Livorno's inhabitants, who justifiably prided themselves on being the only Italian town without a ghetto. Unfortunately, the synagogue was destroyed by the Nazis during World War II.

The painting reflects the then glorification of Spanish Jewry and its descendants in an age when Jews were looking to identify positively with their past, to counter the view that the Jewish religion was primitive and Jewish history one of suffering alone.

1806 Born in April in Plymouth, England, the son of a goldsmith and Hebrew teacher
1820 Moves to London
1823 Enters the Royal Academy as a student
1830 Paints *Interior of a Polish Synagogue*
1840 Becomes a member of the Royal Academy
1841–42 Visits Italy
1850 Paints *The Feast of Rejoicing of the Law*
1878 Exhibits *The Temple of the Jews at Shilo: Hannah Presenting Samuel to the High Priest Eli*
1881 Dies on June 11 in London

LITERATURE
Norman l. Kleeblatt, in Maurice Berger and Joan Rosenbaum, *Masterworks of The Jewish Museum* (New Haven and London, 2004), pp. 126–27.
Susan Tumarkin Goodman, ed., *The Emergence of Jewish Artists in Nineteenth-Century Europe* (London, 2001).

Solomon Alexander Hart, *Self-Portrait*, ca. 1860, oil on canvas, 61 x 55 cm, Royal Academy, London

JOZEF ISRAËLS ━━━━━━━━━━━━━━━━━━━━━━━━━━

MAX LIEBERMANN ━━━━━━━━━━━━━━━━━

JEAN-FRANCOIS MILLET ━━━━━━━━━━━━━━━━━━━━━━━━━━━━━━━━

1781 Immanuel Kant publishes the
Critique of Pure Reason

1848–49 Revolutions in numerous
European countries; countles
Jews participate

1796 Equal rights for Jews in
the Netherlands

1815 Napoleon defeated at Waterloo

1855 *Realism exhib
of Courbet*

| 1775 | 1780 | 1785 | 1790 | 1795 | 1800 | 1805 | 1810 | 1815 | 1820 | 1825 | 1830 | 1835 | 1840 | 1845 | 1850 | 1855 | 1860 |

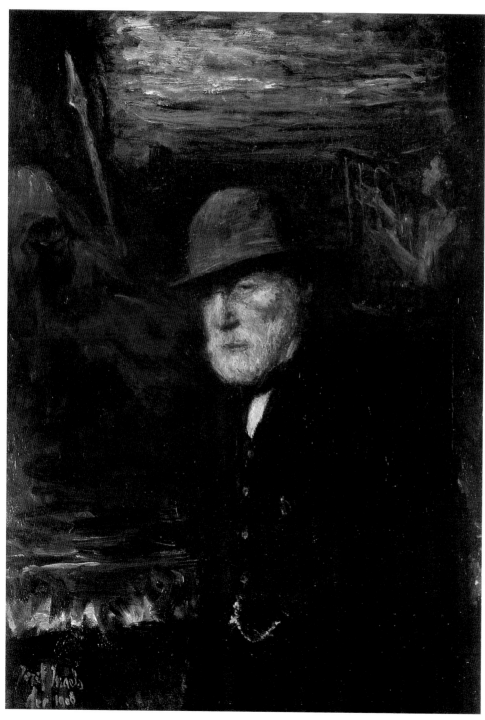

Jozef Israëls, *Self-Portrait (with Saul
and David in the Background)*, 1908,
oil on canvas, 96.5 x 68.5, Stedelijk
Museum, Amsterdam

1–65 American Civil War

1886 Statue of Liberty erected
in the port of New York

1929–LATE 1930S Great Depression

1917 October Revolution in Russia

1939–45 World War II

1865 1870 1875 1880 1885 1890 1895 1900 1905 1910 1915 1920 1925 1930 1935 1940 1945 1950

JOZEF ISRAËLS

Considered one of the founders of the Hague School and one of the most respected painters of the late nineteenth century, Jozef Israëls' later Jewish-themed work earned him the sobriquet of the "Jewish Rembrandt."

Jozef Israëls (1824–1911) was born in Groningen, the Netherlands into an observant middle-class Jewish family. Israëls studied in Amsterdam with Jan Adam Kruseman, and spend some time in Paris before settling in The Hague in 1871. During his lifetime, and especially in its final decades, contemporaries were fascinated as much by Israëls' attempts to emulate his idol Rembrandt as his identity as a Jew, even though paintings with Jewish themes comprise only a small fraction of his oeuvre, which tended to focus on the lives of poor fishermen and farmers. His immensely popular Jewish-themed works were all created towards the end of his life, and include the *Son of the Ancient People* (1889), *The Torah Scribe* (1902), *The Jewish Wedding* (1903), and a *Self-Portrait Before Saul and David* (1908), as well as portraits of Jewish relatives and prominent contemporaries. It is therefore remarkable that he made his name not just as a celebrated representative of the impression-ist Hague School or the "Rembrandt of the nine-teenth century," but as a Jewish painter. It was the Jewish identity of this Rembrandt reborn that drew the particular attention of his admirers.

A Jewish Rembrandt

Israëls dates his love for Rembrandt to the 1840s when he moved to Amsterdam: "I lived a few houses away from the famous one where Rembrandt had worked for so many years. I viewed the picturesque masses, the bustle, the warm-blooded faces of the Jewish men with their gray beards; the women with their reddish hair, the carts full of fish and fruits and other wares, the air—everything was Rembrandt, everything Rembrandtesque."

Certainly familiar with second-hand dealers from the Amsterdam and Hague Jewish quarters, Israëls saw Jews through the eyes of his artistic inspiration Rembrandt. The seated man with arms folded in *Son of the Ancient People* was clearly inspired by Rembrandt's *Portrait of an Old Man* of 1654 (The Hermitage, St. Petersburg). His *Saul and David* (1899)

suggests Rembrandtesque aspirations; Rembrandt's painting of the same title had in fact been purchased by the Mauritshuis in The Hague the year before. Likewise in his *Jewish Wedding* (1903) does Rem-brandt emerge as the source of inspiration: the painting long known as *The Jewish Bride* (Rijks-museum, Amsterdam).

The Jewish themes struck a chord among Jews, and they were among the earliest collectors of his paintings. Israëls made copies of his *Son of the Ancient People* for the American art market. Etchings and engravings further contributed to the popularity of this work. Once his name had been established, Israëls became a source of pride for Jews. His popularity goes hand in hand with the Jewish fascination for Rembrandt, the painter who after all had lived in the Jewish quarter of Amsterdam and who expressed his love for the sons and daughters of the ancient people in numerous Old Testament paintings and in portraits, which up to only very recently were described by art historians as rabbis, Jewish brides, Jewish scholars, or Jewish Jesuses.

1824 Born on January 27 in Groningen, Netherlands, the third of eight children
1836 First drawing lessons
1842–46 Studies in Amsterdam and Paris
1847 Settles in Amsterdam, not far from the Jewish Quarter
1852 First success as a history painter and increasingly popularity for scenes of poor fishermen
1863 Marries Aleida Schaap; their son Isaac (1865–1934) would also became a renowned painter
1871 Moves to a monumental house with a studio in The Hague
1881 Becomes acquainted with the painter Max Liebermann
1889 *Son of the Ancient People* bought upon completion by Stedelijk Museum, Amsterdam
1902 Paints *Torah Scribe*
1903 *Jewish Wedding*, an immediate success, was exhibited in London and Paris
1906 Plays a prominent role in the celebration of the 400th anniver-sary of Rembrandt's birth
1908 Finishes *Self-Portrait before Saul and David*
1911 Dies on August 12; after a state funeral, he is buried at the Jewish cemetery in The Hague

LITERATURE
Dieuwertje Dekkers et al., eds., *Jozef Israëls, 1824–1911*, exh. cat. Groninger Museum / Jewish Historical Museum Amsterdam (Zwolle, 1999).

Photograph of Jozef Israëls

right page
Jozef Israëls, *Son of the Ancient People*,
1889, oil on canvas, 178.5 x 137.5 cm,
Stedelijk Museum, Amsterdam

below
Jozef Israëls, *A Jewish Wedding*, 1903, oil
on canvas, 137 x 148 cm, Rijksmuseum,
Amsterdam

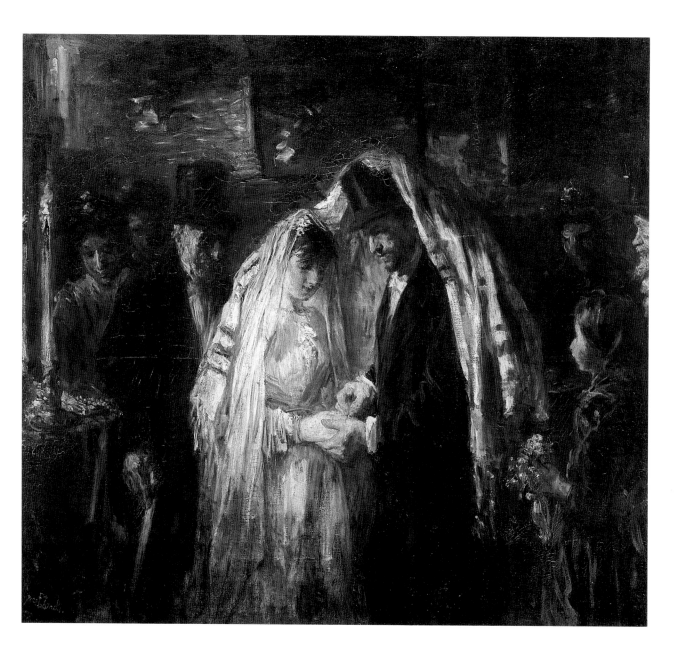

1791 Equal rights for Jews in France

1857 Gustave Flaubert,
Madame Bovary

1780 1785 1790 1795 1800 1805 1810 1815 1820 1825 1830 1835 1840 1845 1850 1855 1860 1865

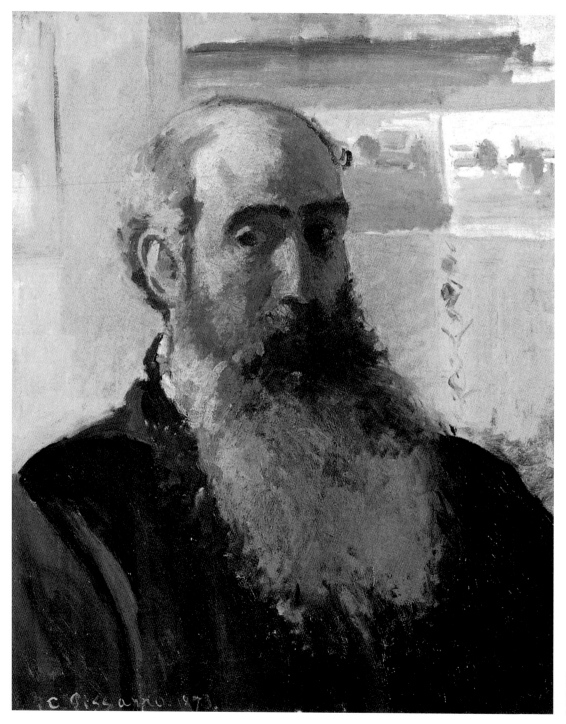

Camille Pissarro,
Self-Portrait, 1875,
oil on canvas,
55 x 46 cm, Musée
d'Orsay, Paris

1881–84 Russian pogroms cause mass emigration to the United States

1873 Monet, *Impression, Sunrise*

1887–89 Eiffel Tower built in Paris

1918–19 German revolution

1874 First Impressionist exhibition in Paris

1897 The First Zionist Conference held in Basel

1919–33 Weimar Republic in Germany

1880s Anti-Semitic movement in Germany and France

1870 1875 1880 1885 1890 1895 1900 1905 1910 1915 1920 1925 1930 1935 1940 1945 1950 1955

CAMILLE PISSARRO

A founding member of the French Impressionists, Camille Pissarro, though often in the shadows of his more acclaimed colleagues, has left us a remarkable chronicle of the streets and cityscapes of modern Paris.

"We [acculturated French Jews] are only expressing a preference for subjects of a general order and universal spirit." —Isidore Cahen reviewing the Salon of 1874

Camille Pissarro (1830–1903) was the only artist to have participated in all eight Impressionist exhibitions held between 1874 and 1886. Though his Caribbean extraction is widely known, his Jewish descent is not. Born Jacob Pizarro on the West Indies island of St. Thomas, son of a successful businessman originally from Bordeaux, a Sephardic Jew of Portuguese descent, he studied in Paris from 1841 to 1847 and moved to France permanently in 1855.

Pissarro was a decidedly modern artist whose importance was increasingly overshadowed by his friend and colleague Paul Cézanne, and by younger artists like Gauguin and van Gogh, to whom he was a mentor and fatherly advisor. His role in the first modern art movement, originally minimized by the destruction of an estimated 1,500 of his earlier works during the German invasion of France in 1870 (he escaped to London), has recently been re-evaluated.

Pissarro: The Secular Jewish Painter

In around 1900, when Jewish thinkers began to promote Jewish art as a distinct category, his Jewish ancestry was mentioned more often. Though included in Jewish art exhibitions in Basel, Berlin, and London, Pissarro never depicted (nor actively participated in) Jewish life, and consequently was not perceived by Jewish art historians in the same way as, for example, Jozef Israëls, "the Jewish Rembrandt," or Moritz Daniel Oppenheim, "the first Jewish painter" of Germany. Rather, Pissarro was fascinated with pure observation, the depiction of visual sensation, and empirical experience. He turned increasingly to the depiction of complex cityscapes—life in the modern metropolis of Paris with its traffic and people on the newly designed grand boulevards and squares. Celebrated for his observation of light, color, and atmosphere, Pissarro became the precursor of the secular and modern painter for whom artistic success supersedes, but does not repudiate, ethnic descent.

Pissarro considered religion, including Judaism, contrary to "our modern philosophy which is absolutely social, anti-authoritarian and anti-mystical." Much like him, acculturated French Jews were not interested in religious art, and preferred subjects of universal interest. Though Pissarro was not religious, and married a Catholic woman, he never denied his Jewish identity—on the contrary, he enjoyed being affectionately described as "Jew," or greeted as "Moses," which with his long, flowing white beard came as no surprise. Though Pissarro felt that "race is a fiction," he too was affected by the anti-Semitic sentiment endemic to all social classes in 1860s France, and increasingly in the 1890s during the Dreyfus affair, when a French Jewish artillery officer was arrested for treason (only in 1906 was he pardoned and exonerated). Even his avant-garde artist colleagues were tinged by prejudice; his old friends Renoir and Degas did not want to be associated with the "Israelite Pissarro." Impressionists in general and Pissarro in particular were accused by some critics of being color blind, a disease believed to afflict Jews in particular. None of this plays a role anymore: Pissarro has been re-discovered and is now appreciated as one of the preeminent Impressionists.

Camille Pissarro, ca. 1895

1830 Born on July 10 into a Sephardic family on the then Danish island of St. Thomas, Virgin Islands

1851 Danish artist Fritz Melbye becomes his teacher and friend

1855 Moves to Paris, where he studies with David Jacobson, a Danish Jewish artist, and is inspired by artists like Gustave Courbet and Camille Corot

1859 Becomes friends with Claude Monet and Paul Cézanne

1870 As a Danish citizen moves at the outbreak of the Franco-Prussian war to a village near London, where he becomes familiar with the works of John Constable and J. M. W. Turner

1871 Upon returning to Paris, discovers that soldiers had damaged or destroyed about 1,500 of his works; only 400 remain; marries his mother's maid, Julie Vellay

1873 Founding father of a collective of fifteen artists, the Impressionists

1874–86 Participates in all eight Impressionist exhibitions in Paris

1884–88 As a result of meeting Georges Seurat and Paul Signac, works in the pointillist style

1890s Supports his fellow Jew Alfred Dreyfus during the Dreyfus affair

1903 Dies on November 13 in Paris; Jewish publications all over the world mourn his passing

LITERATURE
Joachim Pissarro and Claire Durand-Ruel Snollaerts, *Pissarro: Critical Catalogue of Paintings* (Milan, 2005).

Camille Pissarro, *La Place du Théâtre Français*, 1898, oil on canvas, 72.4 x 92.7 cm, Los Angeles County Museum of Art, Los Angeles

MAX LIEBERMANN

EDGAR DEGAS

ÉDOUARD MANET

1870–71 Franco-Prussian Wa

1871 Charles Darwin publis
The Descent of Man

| 1795 | 1800 | 1805 | 1810 | 1815 | 1820 | 1825 | 1830 | 1835 | 1840 | 1845 | 1850 | 1855 | 1860 | 1865 | 1870 | 1875 | 1880 |

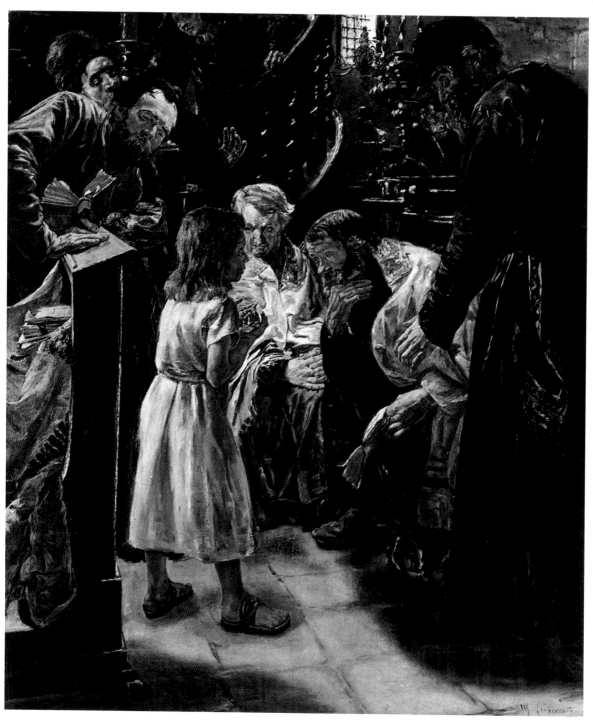

1889 Vincent van Gogh, *Starry Night*

1900 Freud publishes *The Interpretation of Dreams*

1897 Tate Gallery is founded in London

1911 Blauer Reiter group is founded in Munich

1936–39 Spanish Civil War

1945 Beginning of Cold War

1935 Nuremberg racial laws deprive Jews of their civil rights

1885 1890 1895 1900 1905 1910 1915 1920 1925 1930 1935 1940 1945 1950 1955 1960 1965 1970

MAX LIEBERMANN

Max Liebermann was one of Germany's most famous artists and a prime mover of the avant-garde as co-founder of the Berlin Secession. His important collection of French Impressionist art was a clear influence on his work.

"I cannot eat as much as I can throw up" —Max Liebermann commenting on the Nazis marching through Brandenburg Gate in 1933

Max Liebermann (1847–1935), one of Germany's most famous artists, grew up in a traditional Jewish home in Berlin, belonging economically as well as culturally to the Jewish upper class, the family actively involved in religious and social Jewish life. Liebermann inherited a monumental home on Pariser Platz next to Brandenburg Gate, where he and his wife lived until his death, surrounded by an art collection that included numerous important French Impressionist paintings. They spent summers at their villa on Wannsee, a lake just outside the city. In addition to Dutch art of the Golden Age, French art served as a major inspiration for the realistic style that earned him fame as a painter and also, in 1898, as co-founder and founding president of the Berlin Secession, the German Impressionist alternative to the then current academic style of painting.

Self-Portrait with Kitchen Still Life (1873), an early work, reveals Liebermann's love for the kitchen still lifes of the Dutch masters, as well as the portraits of Frans Hals. He loved the liberal spirit of Netherlands, a country he visited regularly. His long-time friend Jozef Israëls (1824–1911) introduced him to Amsterdam's famous Jewish quarter.

The *Still Life* has an interesting detail the artist Hermann Struck pointed out during the Liebermann commemorative exhibition in Tel Aviv in 1935: "In order to please his pious mother, Liebermann painted on the foreground a kosher slaughtered chicken with a kosher seal." Here a son honors his mother and the Jewish kitchen and its ingredients, including the kosher chicken for the much-praised chicken soup. As "the Jewish penicillin," chicken became the

touchstone of Jewish devotion and sentiment, even at times when other tokens of religious observance were on the decline. This painting is a testimony of Jewish love for food.

Kosher Food, Kosher Behavior

With his background, it is no surprise Liebermann would be familiar with the Jewish dietary laws that determine so much of daily life. Kosher, meaning fit or proper, refers primarily to food. These laws are of Biblical origin (Leviticus 11, Deuteronomy 14): permitted are mammals with split hooves that chew their cud, such as cows and goats; certain fowl; and fish with both fins and scales. Pigs are forbidden because they don't chew their cud. Crustaceans and mussels are prohibited. Vultures are not kosher, but birds like turkey, goose, duck, and chicken are. In order to ensure the animal or bird dies instantly and without pain, they must be slaughtered kosher (a split-second cutting of the throat). Based on the biblical verse, "You shall not boil a kid in its mother's milk" (Exodus 34:26), Jewish dietary law requires a separation of milk and meat-based products. A meal is either *fleischig* (meat-based) or *milchig* (milk-based).

In popular speech "kosher" can also refer to behavior and people. Liebermann wasn't exactly treated kosher. He, "the Jew incarnate," for whom Judaism was a private matter of home and family, regularly faced anti-Semitism even though he "had felt himself a German all his life." When the Nazis took power in 1933, the once celebrated artist and honorary citizen of Berlin resigned from the Prussian Academy of Sciences he had served as president for many years. His paintings were then considered degenerate, confiscated, and removed from public collections. Very few of his colleagues stood by his side, just as few attended his funeral in 1935. His widow, forced out of the family home upon his death, poisoned herself in 1943 after receiving an order for deportation to Theresienstadt.

1849 Born on July 20 in Berlin
1859 Moves to 7 Pariser Platz
1865 Portrait of his brother Felix
1871 Visits the Netherlands for the first time; admires the work of Frans Hals
1881 Meets Jozef Israëls
1884 Marries Martha Marckwald; their daughter Käthe is born
1898 President of the Berlin Secession
1902 Commission for the Hamburger Kunsthalle
1907 Large solo exhibitions in Berlin, Frankfurt, and Leipzig
1910 Summer residence at Lake Wannsee near Berlin
1913 Attends the funeral of his friend Jozef Israëls in The Hague
1920–32 President of the Prussian Academy of Arts
1933 Hitler takes power; Liebermann resigns his official functions; works are removed from museums
1935 Dies on February 8 in Berlin; buried in the family plot at the Jewish cemetery on Schönhauser Allee

LITERATURE
Barbara Gilbert, ed., *Max Liebermann: From Realism to Impressionism*, exh. cat. Skirball Museum (Los Angeles, 2005).

Max Liebermann, *Self-Portrait with Straw Hat (Panama Hat)*, 1911, oil on wood, 80.8 x 64.8 cm, Akademie der Künste, Berlin. Acquired with support of BHF-BANK Aktiengesellschaft Berlin and the society of friends of the Akademie der Künste, Berlin

Max Liebermann, *The Twelve-Year-Old Jesus in the Temple*, 1879, oil on canvas, 150.5 x 132 cm, Kunsthalle, Hamburg

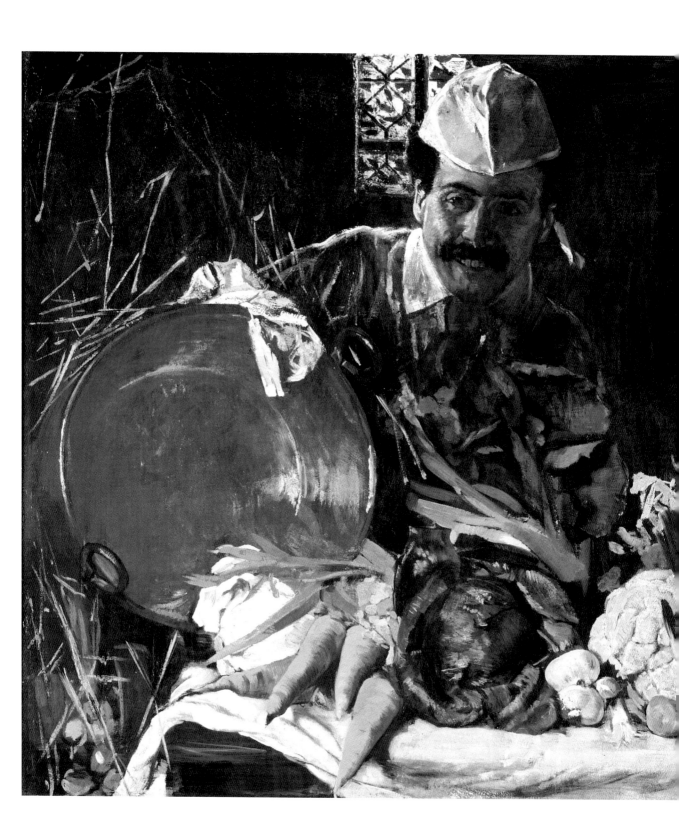

Max Liebermann, *Self-Portrait with Kitchen Still Life*, 1873, oil on canvas, 85.3 x 139 cm, Städtisches Museum Gelsenkirchen, Germany

1848–49 Revolutions in numerous European countries; countless Jews participate

1867 Equal rights for Jews in Austria

1879 Wilhelm Marr introduces the term "anti-Semitism"

1883–85 First sky-scrapers in Chica

1805 1810 1815 1820 1825 1830 1835 1840 1845 1850 1855 1860 1865 1870 1875 1880 1885 1890

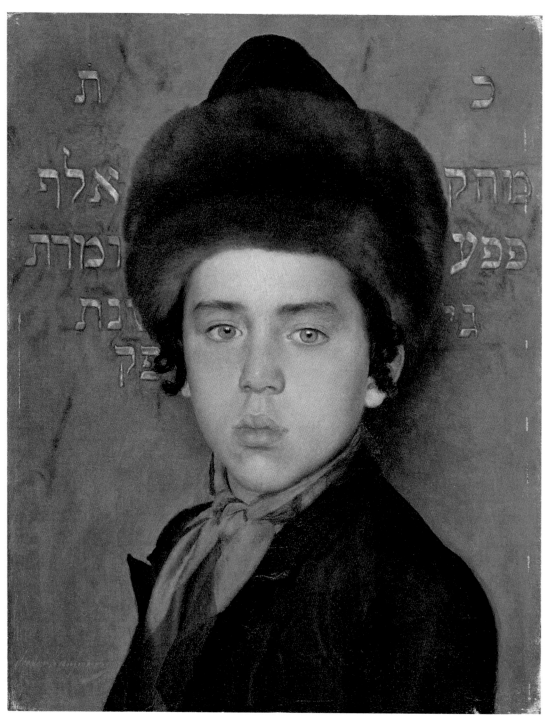

Isidor Kaufmann,
Portrait of a Boy,
ca. 1900, oil on wood,
27 x 21.2 cm, Joods
Historisch Museum,
Amsterdam. Donated
in memory of Josée
Schelvis

1914 Assassination of Archduke Franz
Ferdinand of Austria on June 28;
World War I breaks out

1939–45 World War II

1919–33 Weimar Republic in Germany

1904 Jewish Museum, New York
founded

1921 Einstein awarded Nobel Prize

1895 1900 1905 1910 1915 1920 1925 1930 1935 1940 1945 1950 1955 1960 1965 1970 1975 1980

ISIDOR KAUFMANN

"I became the painter of Judaism. I have always pursued the vision of glorifying and exalting Judaism. I strove to reveal its beauties and nobilities ... accessible for gentiles as well."—Isidor Kaufmann, 1917

At the age of twenty-three, Hungarian-born Isidor Kaufmann (1853–1921) moved permanently to Vienna from his native Arad, then part of the Habsburg Monarchy (now Romania). Today he is one of the most celebrated painters of Jewish life. Already during his lifetime, his works were shown at numerous exhibitions, both in Vienna and abroad, from Munich and Berlin to Chicago. His painting *The Rabbi's Visit* was acquired by emperor Franz Joseph for the Imperial Collections.

Kaufmann primarily concentrated on one topic: portraying Jews and Jewish life in the shtetls he loved to visit in Hungary, Galicia, Ukraine, and Poland. His clientele was and still is predominantly Jewish, initially of the Viennese bourgeoisie, but today includes all those who look for authentic images of Jews in art.

For this *Portrait of a Boy*, a young Hasidic boy with a scarf, *spodik* (tall fur hat), and black kaftan, Kaufmann depicts his third son Eduard (born 1890), who later escaped the Nazis and settled in New York to become a lawyer.

Jews in Fin-de-Siècle Vienna

In 1890, when Kaufmann's career took off, 118,500 Jews lived in Vienna, constituting 8.7 percent of the population, and one third of the students. Despite the onset of industrialization and the dawn of liberal values, Viennese society was shaped by the aristocracy, workers, and Catholic values, remaining ambivalent or even openly hostile to Jews. Only in 1867 were Jews granted civil rights, but still the path to full acceptance proved difficult: admission to government positions and university careers remained the exception. In fin-de-siècle Vienna, the Jewish bourgeoisie, assimilated but plagued by anti-Semitism, was torn by an ambivalence about the overt Jewishness of their parents. In this conflict—that marked the lives of psychoanalyst Sigmund Freud, composers Gustav Mahler and Arnold Schoenberg, and writer Arthur Schnitzler—

Kaufmann filled a gap. He depicted not only the pious religiosity but first and foremost the humanity and beauty of shtetl life as it used to be, before the fathers left it for a burgeoning metropolis.

Kaufmann was not an artistic innovator like Paul Gauguin, enthralled by the pure life of Bretagne farmers or the locals in Tahiti. Neither was he interested in the groundbreaking experiments of his contemporaries at home, like Gustav Klimt, Egon Schiele, or Oskar Kokoschka. Modern art , for so long synonymous with abstraction, has increasingly come to appreciate the realism of Isidor Kaufmann.

1853 Born on March 22 in Arad, an Austrian-Hungarian border town (now Romania)
1875 Moves to Vienna; refused to the Academy, takes private lessons
1883 Marries Juliette Bauer, sister of Vienna's later chief cantor
1888 Becomes a member of the Künstlerhaus, Vienna's dominant artist's society till a number of modern artists founded the Secession in 1897; birth of son Philipp Friedrich, also a painter (died in London in 1969)
1895–96 First visits to Holešov (now Czech Republic), where he became fascinated by the "old synagogue," and to Cracow
1897 Visits Jewish towns around Czernowitz (Chernivtsi), which he considers his "promised land"
1899 *The Rabbi's Visit* acquired by Emperor Franz Joseph II for his imperial art collections (later removed by the Nazis, and now in a private collection)
1900 Paints Jews in Klausenberg (now Cluj, Romania)
1904–6 Regular trips to Brody (now Ukraine)
1907 Participates in an exhibition of "Jewish artists" in Berlin
1921 Dies on November 14 in Vienna; chief rabbi Zwi Peres Chajes delivers the funeral oration

LITERATURE
G. Tobias Natter, ed., *Isidor Kaufmann*, exh. cat. Jüdisches Museum der Stadt Wien (Vienna, 1995).

Portrait of Isidor Kaufmann

1826 Joseph Nicéphore Niépce
invents photography

1867 Equal rights for
Jews in Austria

1879 Wilhelm Marr introduces
the term "anti-Semitism"

1857–68 Charles Baudelaire,
Les Fleurs du Mal

1872 Abraham Geiger founds the Liberal Semin
for the Science of Judaism in Berlin

| 1805 | 1810 | 1815 | 1820 | 1825 | 1830 | 1835 | 1840 | 1845 | 1850 | 1855 | 1860 | 1865 | 1870 | 1875 | 1880 | 1885 | 1890 |

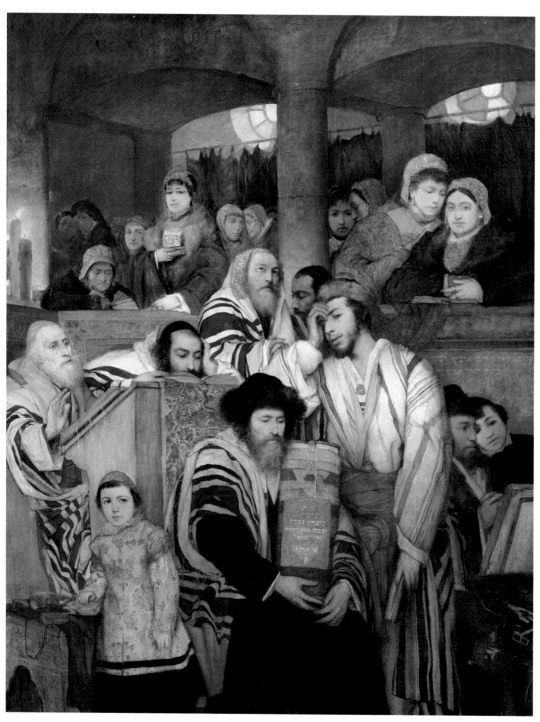

1907 Pablo Picasso, *Les Demoiselles d'Avignon*

Construction of Trans-Siberian **1914–18** World War I **1937** Degenerate "Art" exhibition
Railway started in Munich
 1901 Exhibition of Jewish art during
 Fifth Zionist Congress in Basel

1895 1900 1905 1910 1915 1920 1925 1930 1935 1940 1945 1950 1955 1960 1965 1970 1975 1980

MAURYCY GOTTLIEB

Maurycy Gottlieb, a German-speaking Polish nationalist deeply connected to his Jewish roots, imbued his historically themed works with a truly revolutionary spirit.

Maurycy Gottlieb (1856–1879) was a child prodigy born in Drohobycz (now Drohobych, Ukraine) and sent at age thirteen to study art in Lemberg (now Lvov), and later at art academies in Vienna, Cracow, and Munich. In Munich he visited the Pinakothek, discovered Rembrandt, and read and illustrated Gotthold Lessing's *Nathan the Wise*, the famous play about religious tolerance. The young Gottlieb was inspired by Heinrich Graetz's then recent historical descriptions of the courageous Jewish struggle for survival and their suffering in Exile, particularly under Christianity. Gottlieb interpreted historical themes such as *Shylock and Jessica and Christ before His Judges* in a revolutionary manner: Shylock and Jesus are no longer the despicable figures Christian artists had portrayed them as in past centuries, but honorable and sympathetic contemporary Jews—counter-images in the spirit of the new Jewish historians. Although German-speaking, Gottlieb was a fierce Polish nationalist, and at the same time fascinated by his Jewish roots.

The Artist as a Pious Jew

Jews Praying in the Synagogue on Yom Kippur (1878) was painted at the end of his brief career as an artist at the threshold of Jewish modernity. The women are separated in an elevated gallery—immersed in prayer, looking around, or talking. The men are wrapped in traditional striped prayer shawls. In the middle, the young artist depicts himself with his head covered by a fur hat. Strikingly, the old man seated next to him carries a Torah scroll with a Hebrew text commemorating Gottlieb as if he had already died (which he would a year later). Deeply aware of the conflicts between Jewish and the broader European culture, Gottlieb here identified himself with the age-old chain of Jewish tradition.

The synagogue in which Gottlieb stands is not an actual building, but reconstructed from the memories of his birthplace, Drohobycz in Galicia—at that time part of the Austro-Hungarian Empire,

later Poland, and currently the Ukraine. Pious Hasidic Jews and enlightened German-speaking Jews lived side by side in this provincial town, where about half of the population was Jewish.

The Holiest Day in the Jewish Calendar

Yom Kippur (the Day of Atonement), a Jewish holy day with no exact equivalent in either the Christian or Muslim calendars, is a full day of fasting and prayer, which starts at sundown and ends twenty-five hours later when it is completely dark. Repentance is the major theme of this holiest of days in the Jewish calendar, set apart in dedication to the return of men to his fellow human beings, and ultimately to God. During Yom Kippur, even the most assimilated Jew feels compelled to maintain ties with ancestral traditions, and this unique day of observance has become a touchstone for Jewish identity. Particularly beloved is the "Kol Nidre," with its haunting melody traditionally sung three times during the evening. Composers such as Max Bruch, in 1880, and Arnold Schoenberg, over fifty years later, used this melody as a motif in their compositions. The philosopher Franz Rosenzweig, who in 1913 was on the brink of converting to Christianity, re-examined his decision after attending a *Kol Nidre* service. Yom Kippur was to inspire many artists, but Gottlieb was the first Jewish artist to directly portray the intimacy of this most solemn Jewish festival, daringly presenting himself as part of the Jewish people.

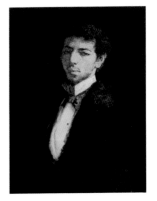

1856 Born on February 21 in then Austrian Drohobycz into a middle-class German-speaking family
1869 Studies art in Lemberg
1871–72 Studies at the Vienna Art Academy, visits museums, and becomes acquainted with the work of Jan Matejko
1873 Studies in Cracow under Matejko, who awakens his Polish patriotism; paints *Self-Portrait in Polish Attire*
1875–76 Anti-Semitism forces him to leave Cracow for Vienna; studies in Munich, becomes inspired by Rembrandt; identifies with Judaism and paints *Self-Portrait as Ahasuer*; his *Shylock and Jessica* earns him renown; graduates in Munich
1877 Paints *Uriel Acosta and Judith van Straaten*, and starts on *Christ before his Judges*; becomes engaged to Laura Rosenfeld (1857–1944)
1878 Visits the Jewish communities of Venice and Rome; starts working on *Christ Preaching in Capernaum*
1879 Returns to Cracow, where he dies; is buried in the Jewish cemetery of Cracow

LITERATURE
Nehama Guralnik, *In the Flower of Youth: Maurycy Gottlieb, 1856–1879*, exh. cat. Tel Aviv Museum of Art (Tel Aviv, 1991).
Ezra Mendelsohn, *Painting a People: Maurycy Gottlieb and Jewish Art* (Hanover, 2002).

left page
Maurycy Gottlieb, *Jews Praying in the Synagogue on Yom Kippur*, 1878, oil on canvas, 245 x 192 cm, Tel Aviv Museum of Art, Tel Aviv. Gift of Sidney Lamon, New York

above
Maurycy Gottlieb, *Self-Portrait*, 1878, oil on canvas, 79.8 x 63.9 cm, Weizmann Institute of Science, Rehovot, Israel. Gift of the Michael and Dora Zagaysky Foundation

1893 Central Union of German Citize
of the Jewish Faith founded in
Berlin to combat anti-Semitisn

1865 Slavery abolished in the U.S.

1883–85 First skyscrapers
in Chicago

1810 1815 1820 1825 1830 1835 1840 1845 1850 1855 1860 1865 1870 1875 1880 1885 1890 1895

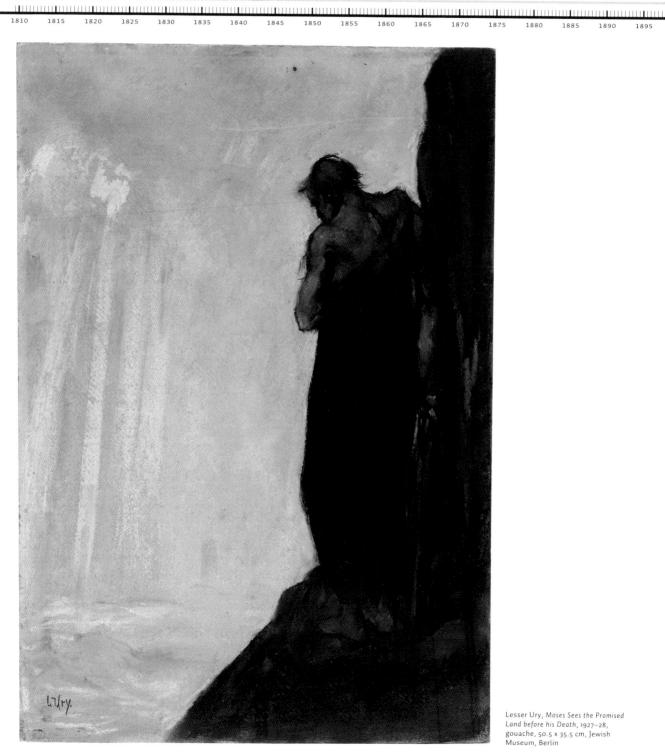

Lesser Ury, *Moses Sees the Promised
Land before his Death*, 1927–28,
gouache, 50.5 x 35.5 cm, Jewish
Museum, Berlin

1907–8 Gustav Klimt, *The Kiss* 1925 Francis Scott Fitzgerald, *The Great Gatsby*

1919 Rosa Luxemburg and Karl Liebknecht assassinated 1937 Picasso's *Guernica*

1911 Ernest Rutherford develops his model of the atom 1927 Charles Lindbergh flies nonstop from New York to Paris 1948 Declaration of Independence of the State of Israel, May 14

1900 1905 1910 1915 1920 1925 1930 1935 1940 1945 1950 1955 1960 1965 1970 1975 1980 1985

LESSER URY

Modern and traditional, German and Jewish, Lesser Ury captured both modern, metropolitan Berlin and the Old Testament with exemplary artistry.

Lesser Ury (1861–1931), praised in Jewish circles for his monumental treatment of Old Testament figures, was the first artist who celebrated Berlin's vibrant metropolitan life in his cityscapes done in the spirit of the French Impressionists. His later, more expressionist paintings were, together with the works of Jewish artists like Jozef Israëls and Isidor Kaufmann, included in an exhibition of Jewish artists organized by Martin Buber and artist Ephraim Moses Lilien in connection with the Fifth Zionist Congress in Basel (1901). His work reflects both Jewish and German values.

Moses, or Dreams of Emancipation

Lesser Ury's *Moses Sees the Promised Land before his Death* (1927–28) is a preliminary sketch for a now-lost monumental painting and is one of many Biblical works that Ury created during his career. It perfectly captures the most tragic moment in Moses' life. Moses, standing alone on Mount Nebo, bent over, stares gloomily down yet unbroken. He is not allowed to bring the people he had liberated from Egyptian slavery into the Promised Land, and will have to die before his mission is fulfilled.

The work is simultaneously both authentic and modern, and as such characteristic of Jewish culture during the Weimar Republic. Anti-Semitism in the wake of World War I created a renewed sense of community amongst German Jews, and a Jewish Renaissance of learning and culture was then taking root. Zionist philosopher and writer Martin Buber (1878–1965) had been one of its main proponents; he had not only revived interest in the stories of Eastern European Hasidic rabbis, but also emphasized the relevance of Biblical leaders like Moses to modern Jewish self-awareness. Contemporary writers and artists were particularly struck with Moses' historical alter ego: Theodor Herzl (1860–1904), whom Lilien (1874–1925) photographed in 1903 as the visionary of a Jewish state overlooking the Rhine from the balcony of his Basel hotel. That

photo was to become an icon of Zionism: Lesser Ury paints Moses in the same position as Herzl, and like Herzl Moses gazes towards an unknown future.

In 1933, when the original Berlin Jewish Museum opened its doors, one week before Hitler took power, its entrance hall illustrated how German Jewry then defined itself. It displayed the busts of two prominent German Jews, Moses Mendelssohn (1729–1786) and Abraham Geiger (1810–1874), celebrating, respectively, the advocate of civil rights and the pioneer of Liberal Judaism. In addition, four biblical-themed works emphasized the new Jewish self-esteem: a sculpture of the young David with his sling ready to kill Goliath and three paintings—two tormented prophets seeking to bring justice to an already threatened world, and Lesser Ury's *Moses*. Just as Moses was not allowed to enter the Promised Land, Jews in Germany began to realize that they would not see their dream fulfilled: to live as equal citizens in a country to which they had contributed so much—as soldiers and scholars, workers and entrepreneurs—a fatherland they loved.

With the rise of Nazism, Germany no longer looked for visions of justice and compassion anymore, and as a result Moses became the biblical model for Jewish leaders looking to solve the historical dilemma of a homeland for their people. Sigmund Freud (1856–1939) explored this subject from another angle in his famous study *Moses and Monotheism*, which he published during his London exile in 1939. The Jewish hopes placed in Germany were dashed, but the vision of a just society shared by so many pioneers of the twentieth century remained alive.

Photograph of Lesser Ury

1861 Born Leo Lesser Ury on November 7 in Prussian Birnbaum near Posen (now Miedzychód, Poland), the son of a baker
1873 After his father's death, the family moves to Berlin
1879–87 Studies in art academies in Düsseldorf, Brussels, Paris, Stuttgart, and Munich before returning to Berlin
1893 First major solo exhibition
1901 Works included in an exhibition of Jewish art during the Fifth Zionist Congress in Basel
1907 Exhibition of Jewish art in Berlin included a number of works by Ury (and Jozef Israëls)
1915 First exhibition at the Berlin Secession
1916 Large retrospective at the Paul Cassirer Gallery in Berlin
1917 Exhibits work at Thannhauser Gallery in Munich
1922 Large show at the Berlin Secession with 150 paintings
1931 Dies of heart failure on October 18 and is buried in the Berlin Jewish cemetery Weissensee; a memorial exhibition is mounted at Berlin's National Gallery

LITERATURE
Emily Bilski, *Berlin Metropolis: Jews and the New Culture, 1890–1918*, exh. cat. The Jewish Museum (New York and Berkeley, 1999).
Susan Tumarkin Goodman, ed., *The Emergence of Jewish Artists in Nineteenth-Century Europe* (London, 2001).

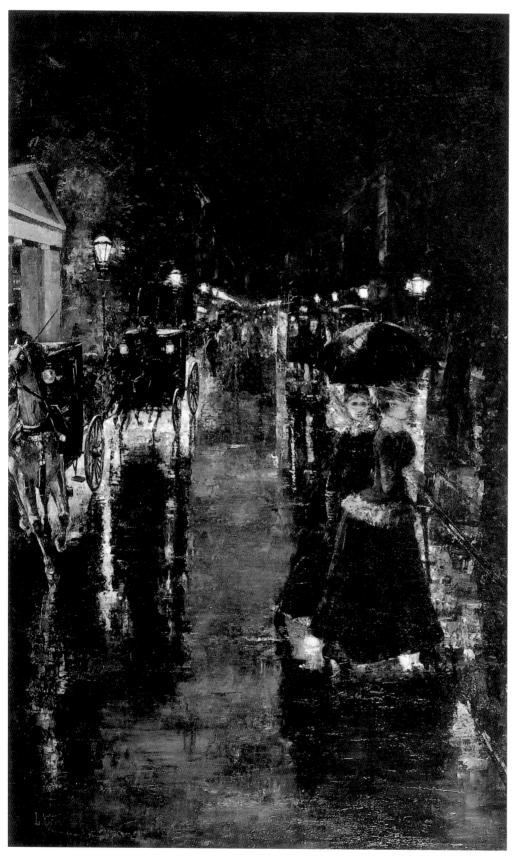

left
Lesser Ury, *Berlin Street Scene
(Leipziger Strasse)*, 1889, oil on
canvas, 107 x 68 cm, Berlinische
Galerie – Landesmuseum für
Moderne Kunst, Fotografie und
Architektur, Berlin

right page
Lesser Ury, *Friedrichstrasse
Railroad Station*, 1888, grisaille
on cardboard, 65.5 x 46.8 cm,
Berlin Museum, Berlin

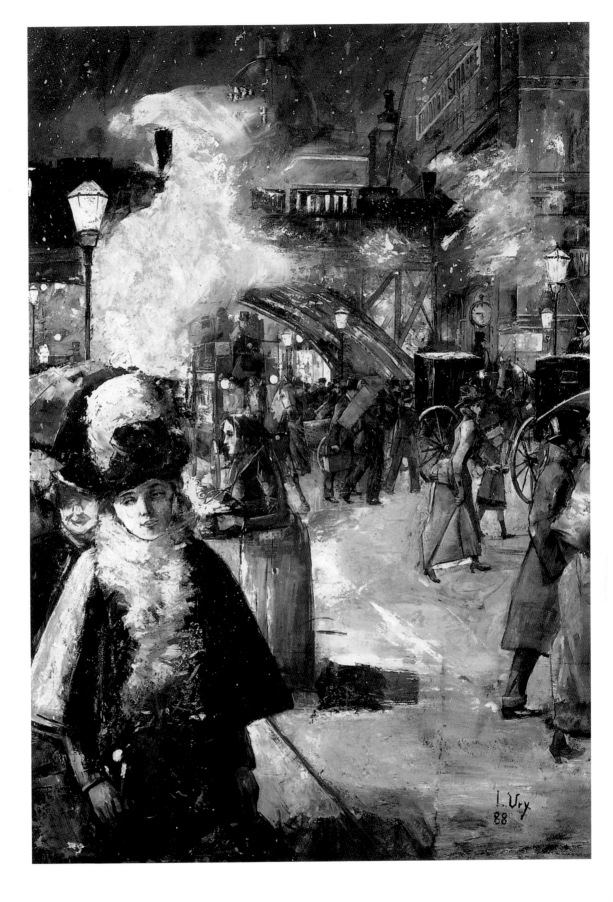

1891 Construction of Tran
Siberian Railway beg

1884 George Seurat,
Bathers at Asnières

1896 Theodor
writes *The
Jewish Sta*

1815 1820 1825 1830 1835 1840 1845 1850 1855 1860 1865 1870 1875 1880 1885 1890 1895 1900

Samuel Hirszenberg, *Portrait of a Jewish
Writer*, 1903, oil on canvas, 42.5 x 105 cm,
Musée d'art et d'histoire du Judaïsme,
Paris, France

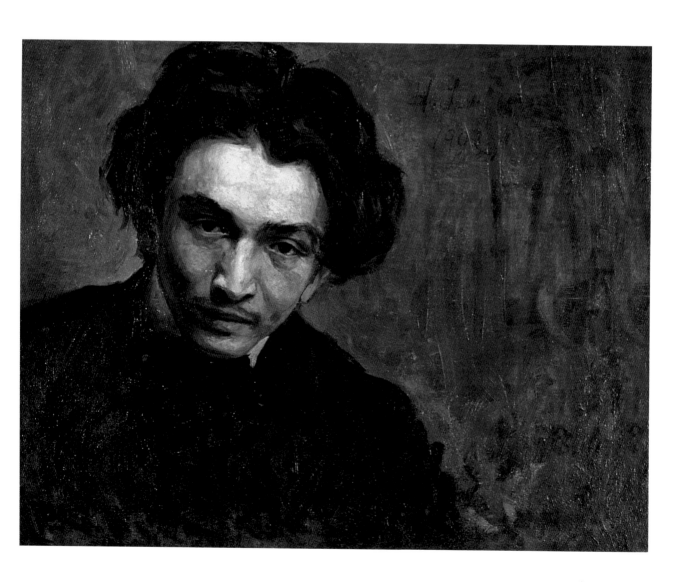

1905 Publication of the
anti-Semitic
pamphlet *Protocols
of the Elders of Zion*

Pogrom in Kishinev
(now Chișinău, Moldova)

1914–18 World War I

1917 British foreign secretary Arthur Balfour favors a national
home for the Jewish people in Palestine
Russian Revolution; Jews receive equal rights
(until Communists take power)

1939–45 World War II

1948 Declaration of Independence of
the State of Israel, May 14

1905 1910 1915 1920 1925 1930 1935 1940 1945 1950 1955 1960 1965 1970 1975 1980 1985 1990

SAMUEL HIRSZENBERG

*Samuel Hirszenberg responded through art to increasing anti-Semitism and nationalism in Poland and Eastern Europe
with Jewish-themed works of evocative sensitivity.*

A Wandering Jew

The Polish artist Samuel Hirszenberg (1866–1908)
became renowned for his pictures of Jewish
suffering. He primarily worked in his native Lodz and
in Cracow. Hirszenberg began his studies at the
Academy of Fine Arts in Cracow, where he was
influenced by the realistic painting of Jan Matejko,
who had previously taught Maurycy Gottlieb.
Matejko, an influential Polish painter, focused on
national themes and had several Jewish students.
That did not prevent him from addressing them with
the following words: "You Hebrew students who
come to our school, must bear in mind that art is
not some kind of trade speculation or business....
If you, Hebrews, having lived in this country for
centuries do not feel the need to perform some
more noble deeds for this land, then get out of this
country." Despite protests in the Jewish press,
Matejko did not withdraw his views. Hirszenberg's
work is a good example of the Jewish artistic
response to the rising nationalism in Poland and
Eastern Europe, which was all too often accompa-
nied by anti-Semitism.

A Creative Response

In the wake of the emerging nationalism, Jewish
political ideologists as well as Jewish artists like
Hirszenberg tried to raise Jewish national self-
consciousness. At the same time, Jewish writers
revived Yiddish and Hebrew as languages for secular
literature. Sholem Aleichem (1859–1916), the author
of *Tevye* (on which the musical *Fiddler on the Roof*
was based), and Isaac Bashevis Singer (1904–1991)
became household names with their often humorous
Yiddish stories; and Achad Ha'am (1856–1927)
and Haim Bialik (1873–1934) modernized Hebrew
literature. Hirszenberg's *Sabbath Rest* (1894) shows a
young man reading a pamphlet, rather than study-
ing a religious text, thus considering political
alternatives to the dire fate of his family. In his
Wandering Jew (1899), a Christ-like figure emerges

from a valley of death, escaping, but only physically,
from the persecution that has characterized so
much of Jewish history in Eastern Europe. Here
Hirszenberg appears to go along with the lachry-
mose concept of Jewish history that had begun to
be challenged by Jewish historians and ideologists
such as Leon Pinsker in his *Self-Emancipation* (1882),
or Theodor Herzl in his call for a Jewish national
solution (1897).

Undoubtedly influenced by the Kishinev and
Homel pogroms of 1903, and the then recent
founding of the right-wing anti-Semitic Union of the
Russian People, Hirszenberg painted *The Black
Banner* (1905), which depicted terrified black-clad
Hasidim carrying a dark coffin with an open book. In
1907 he accepted an invitation to become a teacher
at the recently founded Bezalel School of Arts and
Crafts (now Bezalel Academy of Arts and Design),
and immigrated to Palestine, where the Orient
inspired him in the final year before his death. His
Wandering Jew hung in a central location at the
Bezalel Museum, the precursor of the Israel
Museum, and often served as a backdrop for photo-
graphs of famous visitors. The artist who so power-
fully focused on contemporary Jewish struggles
died a year later, mourned by Hebrew writers as a
pioneer of Jewish artistic revival.

1866 Born on February 22 in Lodz,
Poland, the eldest son of a
weaving mill worker
1881–85 Studies at the Academy of
Fine Arts, Cracow
1885–89 Studies at the Royal Academy
of Arts, Munich
1889 Studies at the Académie
Colarossi, Paris.
1891 Returns to Cracow
1893 Moves back to his native Lodz
1894 Wins prizes for his work in Berlin,
Warsaw, and Cracow
1899 Paints *Wandering Jew*
1904 Moves to Cracow
1907 Immigrates to Palestine; teaches
at the Bezalel School of Arts and
Crafts (now Academy of Arts and
Design), Jerusalem
1908 Dies on September 15 in
Jerusalem

LITERATURE
Richard I. Cohen, "Samuel Hirszen-
berg's Imagination," in *Texts and
Contexts: Essays in Modern Jewish
History and Historiography in Honor of
Ismar Schorsch*, ed. Eli Lederhendler
and Jack Wertheimer (New York, 2005),
pp. 219–55.
Richard I. Cohen and Mirjam Rajner,
"The Return of the Wandering Jew(s) in
Samuel Hirszenberg's Art," *Ars Judaica*
7 (2011), pp. 33–56.

Samuel Hirszenberg, *Self-Portrait*, 1908

1890–92 Paul Cézanne,
The Card Players

1903 Henry Ford esta
the Ford Motor
Company in De

1867 Equal rights for Jews in Austria

1900 Freud publishes *The Inter
pretation of Dreams*

1825	1830	1835	1840	1845	1850	1855	1860	1865	1870	1875	1880	1885	1890	1895	1900	1905	1910	

left
Arnold Schoenberg,
Red Gaze, 1910, oil on card-
board, 32 x 25 cm, Arnold
Schoenberg Center, Vienna

right page
Arnold Schoenberg,
Rockingham Avenue, Los
Angeles, 1945

1914 Assassination of Archduke Franz Ferdinand of
Austria on June 28; World War I breaks out

1942 Edward Hopper, *Nighthawks*

9-10 Henri Matisse, *La Danse*

1919-34 First Austrian Republic

1915	1920	1925	1930	1935	1940	1945	1950	1955	1960	1965	1970	1975	1980	1985	1990	1995	2000	

ARNOLD SCHOENBERG

A true musical revolutionary, Arnold Schoenberg briefly dedicated himself to the production of astounding works of art that, much like his compositions, exactingly captured the modern psyche.

Musical Visions

The composer and painter Arnold Schoenberg (1874–1951) was born in Vienna to Bohemian Jewish immigrants. Though his circumcision was registered with the Jewish community, his family belonged to the assimilated Jewish middle class and he received little formal religious education. Raised in Austria and taught music by his future brother-in-law Alexander von Zemlinsky, Schoenberg admired German composers Brahms and Wagner, but must have sympathized with his friend and colleague Gustav Mahler, who once said, "I am thrice homeless: a native of Bohemia in Austria, an Austrian amongst Germans, and Jew throughout the world: always an intruder, never welcomed." While Mahler converted to Catholicism in 1897 to gain access to the Viennese musical scene, Schoenberg was baptized Lutheran a year later, a minority in Catholic Vienna.

His new religion didn't protect him from prejudice: in 1921 he and his family, as "non-Aryans," were denied permission to stay in a holiday town near Salzburg. In 1923 he learned of anti-Semitic tendencies at the Bauhaus, including his friend Kandinsky (who showed Schoenberg's *Red Gaze*, 1910, in the *Blaue Reiter* exhibition in Munich). Anti-Semitism pursued Schoenberg—as it had emancipated German and Austrian Jews after receiving legal rights in the nineteenth century (Austria in 1867)—and in 1933 he fled Austria for France where, in a Reform synagogue of Paris, he reconverted to Judaism (though rejecting all official forms of it, religious or national). He reached the United States the same year on a Czech passport, and in 1944 became a U.S. citizen, changing musical history in the New World as he had in the Old.

Abstraction

At the outset of the twentieth century, abstract art was in the air, as was musical experimentation; Arnold Schoenberg was involved in both. Most people know him as an composer but for a short time he also painted. He wrote to his painter colleague and avid music lover Wassily Kandinsky, echoing his fellow Viennese Sigmund Freud, "Art belongs to the unconscious." Even before they met in 1911, Kandinsky's road to abstraction was inspired by Schoenberg's music and ran parallel to Schoenberg's revolutionary compositions. Only a short time before, in 1908, after finishing *Gurrelieder* and *Transfigured Night*, Schoenberg had taken up painting, the rudiments of which he learned from a talented young artist, Richard Gerstl. It was also then he took his first steps towards atonal composition. The hostility from both music critics and the public towards this revolutionary break from tonality nearly convinced Schoenberg to devote himself to painting.

Red Gaze is an astounding, almost abstract, painting—a frontal icon-like portrait intensely focused on the face, a haunting stare in the angst-ridden, red-rimmed eyes. Schoenberg struggled in art as much as music. In his opera *Moses und Aron*, dating from the period before his return to Judaism, Schoenberg struggled with the dichotomy between Moses, with divinely inspired ideas but unable to speak, and his brother Aaron, who didn't understand those ideas but was a gifted orator. This dichotomy represented two equally valid approaches in dealing with the Jewish people's fate. He dealt with this question from continually changing perspectives, but, just as the composition was never finished, the problem remained unresolved.

Despite offers to return to Vienna or immigrate to Israel, Schoenberg decided to remain in exile, at home in "wasteland" America. Many people change and choose new identities—voluntarily or not. As Freud once commented about the Jews, one has to be both an insider and an outsider to develop new visions. *Red Gaze*—and Schoenberg's personal history—shows this sometimes hurts.

1874 Born on September 13, the son of a shoemaker
1882 Learns to play violin; writes his first compositions
1898 Converts to Protestantism
1901 Marries Mathilde Zemlinsky in the Lutheran Church
1907 Begins to paint, stimulated by his friend Richard Gerstl
1911 Four paintings in the *Der Blaue Reiter* exhibition at Gallery Thannhauser, Munich
1921 Formulates the twelve-tone method of composition
1923 Death of Mathilde
1925 Appointment at Berlin's Prussian Academy of Arts prompts anti-Semitic reactions
1927 Completes *The Biblical Way*
1928 Starts *Moses und Aron*
1933 Leaves Germany; reconverts to Judaism in Paris; moves to Los Angeles with second wife Gertrud and daughter Nuria
1938 Composes *Kol Nidre* and conducts the premiere a day before the start of the High Holy Days
1947 Composes and writes text for the cantata *A Survivor from Warsaw*
1951 Dies on July 13 in Los Angeles

LITERATURE
Esther da Costa Meyer and Fred Wasserman, *Schoenberg, Kandinsky and the Blue Rider*, exh. cat. The Jewish Museum (New York, 2003). Christian Meyer and Thérèse Muxenerder, eds., *Arnold Schönberg: Catalogue Raisonné* (Vienna, 2005).

1915 Kazimir Malevich,
*From Cubism and
Futurism to Supreme*

1911 Wassily Kandinsky,
Impression III

1830 1835 1840 1845 1850 1855 1860 1865 1870 1875 1880 1885 1890 1895 1900 1905 1910 1915

1925/26 Walter Gropius, Bauhaus, Dessau

Albert Einstein, Theory of Relativity

–22 Dada movement

1940 German occupation of France
The Nazis establish ghettos in Eastern Europe

1939–45 World War II

1937 Degenerate "Art" exhibition in Munich

1945 Liberation of Auschwitz concentration camp

| 1920 | 1925 | 1930 | 1935 | 1940 | 1945 | 1950 | 1955 | 1960 | 1965 | 1970 | 1975 | 1980 | 1985 | 1990 | 1995 | 2000 | 2005 |

OTTO FREUNDLICH

A pioneering abstract artist, Otto Freundlich had the unenviable distinction of providing the cover art for the Nazis' Degenerate "Art" brochure, a fascinating work unfortunately lost to the vicissitudes of its time.

Defamed Art

Otto Freundlich (1878–1943) was one of the first abstract artists. Born in German Pomerania, he studied in Berlin and Munich before moving in 1909 to Paris, where he became friendly with the avant-garde artists of Montmartre. He would go on to participate in groundbreaking exhibitions in Berlin, Munich, and Paris. When France was occupied in 1940, Freundlich was arrested by the French authorities as a German national. He was imprisoned but managed to escape. He fled to the Pyrenees, but was betrayed and deported via Paris to Majdanek, an extermination camp outside Lublin, Poland, where he was murdered on March 9, 1943, shortly after arrival.

Influenced as much by the colorful, lyrically abstract compositions of Robert Delaunay as the magnificent stained-glass windows of Chartres Cathedral he greatly admired, Freundlich created his first purely abstract works in 1911. His rigorously organized abstract *Composition* dated 1938 demonstrates an ability to reach great optical and lyrical intensity with a vibrant patchwork of color. That same year his works were exhibited together with those of Kandinsky and other moderns in Paris, and also included in the international *Abstract Art* exhibition in Amsterdam. By that time it was clear he couldn't return to Germany: modern art was increasingly and openly attacked by the Nazis, causing a veritable exodus of artists, architects, writers, and scholars.

"Degenerate" Art

In 1937, Freundlich had the dubious honor of being included in the *Degenerate "Art"* exhibition in Munich's Archeological Institute. His sculpture *Der neue Mensch* (The New Man) was positioned in a foyer opposite a wooden sculpture by Ernst Ludwig Kirchner. The work was described as "fantasized by the Jew Freundlich, the anarcho-fascist." The heavily shadowed lighting of *Der neue Mensch* on the cover of the exhibition brochure accentuated the "racial" features of the figure. The work, idealistically conceived by Freundlich as the embodiment of a new humanity, was denounced by Nazi art critics as "primitive," "Negroid," "sick," and "Jewish."

Created in 1912, *Der neue Mensch* belonged to the Hamburg Museum of Arts and Crafts until 1937, when it was confiscated by the Nazis as part of a nationwide cleansing policy in which over 12,000 printed works and 5,000 paintings and sculptures were confiscated as "degenerate." The *Degenerate "Art"* exhibition displayed some 600 works by 110 modern artists in a deliberately chaotic fashion— the pieces placed one above the other in crowded, narrow rooms. The installation stood in stark contrast to the orderly *German Art* exhibition, personally opened by Adolf Hitler in the recently inaugurated House of German Art in Munich. The three and a half months of the *Degenerate "Art"* exhibition witnessed over two million visitors. The subsequent showings in Berlin, Hamburg, and Düsseldorf saw similar attendance. After the exhibition closed, the sculpture *Der neue Mensch* disappeared. It remains, however, a symbol for the Nazi persecution of modern art and its creators, both Jews and non-Jews alike.

1878 Born on July 10 in German Stolp (now Slupsk, Poland)
1902 After working in commerce, studies art history in Berlin, Munich, and Florence
1907 Private art courses with Arthur Levin-Funke and Lovis Corinth
1909 Moves to Paris; first works influenced by Picasso and the Cubists
1911 First abstract works
1913 Exhibits in the Der Sturm Gallery in Berlin
1914 Moves to Cologne
1918 Becomes a member of the November Group of avant-garde artists in Berlin
1919 Organizes with Max Ernst the first Dada exhibition in Cologne
1924 Moves to Paris
1931 Joins the group Abstraction-Création
1940 Interned as a German citizen at the outbreak of World War II, but released thanks to Picasso; flees to the Pyrenees
1943 Betrayed and arrested by the Nazis and deported to the Majdanek concentration camp near Lublin, Poland, where he is killed on March 9

LITERATURE
Stephanie Barron, ed., "Degenerate Art": The Fate of the Avant-Garde in Nazi Germany, exh. cat. Los Angeles County Museum et al. (New York, 1997). Christophe Duvivier, Otto Freundlich, 1878–1943, exh. cat. Musée Tavet-Delacour, Pontoise (Paris, 2009).

left page
Otto Freundlich, *Composition*, 1938, tempera on cardboard, 54.5 x 45 cm, Jewish Museum, Berlin

above
Otto Freundlich, ca. 1925

left
Exhibition brochure *Entartete "Kunst"* (Degenerate "Art"), Munich 1937, with the sculpture *Der neue Mensch* (The New Man) by Otto Freundlich.

right page
Otto Freundlich, *Composition*, 1938–41, stained glass, 65 x 50 cm, Musée de Pontoise, Donation Freundlich

1895 First Venice Biennale **1909** Tel Aviv found

1881–84 Russian pogroms cause mass
emigration to the United States

1905 German Expressionist
group Die Brücke is
founded in Dresden

1830 1835 1840 1845 1850 1855 1860 1865 1870 1875 1880 1885 1890 1895 1900 1905 1910 1915

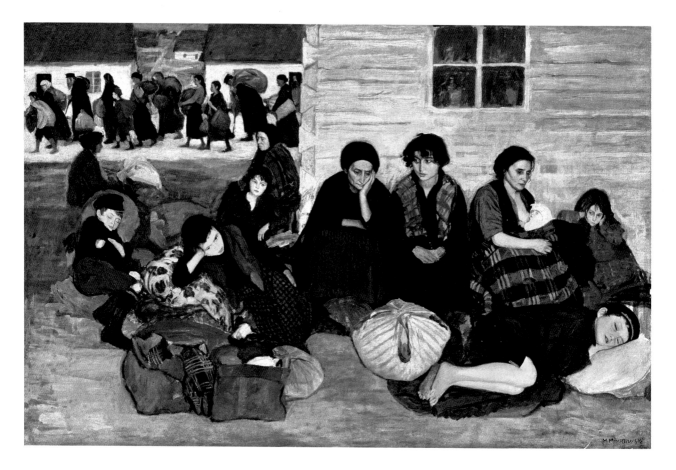

Maurycy Minkowski, *After the Pogrom*,
ca. 1910, oil on canvas, 103.9 x 152.4 cm,
The Jewish Museum, New York. Gift of
Lester S. Klein

1924 André Breton, "First Surrealist Manifesto"
1925 Francis Scott Fitzgerald, *The Great Gatsby*

Anti-Defamation League **1929** Stock market crash heralds **1939–45** World War II
founded in Chicago to global economic crisis
combat anti-Semitism **1937** Picasso's *Guernica*

| 1920 | 1925 | 1930 | 1935 | 1940 | 1945 | 1950 | 1955 | 1960 | 1965 | 1970 | 1975 | 1980 | 1985 | 1990 | 1995 | 2000 | 2005 |

MAURYCY MINKOWSKI

Maurycy Minkowski depicted the despair and frightening hopelessness of Jewish refugees during the Eastern European pogroms at the dawn of the twentieth century. A material witness to these violent acts that threw the lives of an entire people into upheaval, his work would be forever changed as a result.

Maurycy Minkowski (1881–1930) was born in Warsaw and graduated from the Cracow Academy of Fine Arts. He was a firsthand witness to the pogroms that broke out in Bialystok and elsewhere following the aborted Russian revolution of 1905. These events marked a turning point in his artistic career, as he began to depict the vicissitudes of the Jewish refugees and their religiosity. In the 1920s Minkowski became increasingly popular in Poland, had several solo exhibitions in Europe, and in August 1930 traveled with his wife to Buenos Aires, the "Paris of South America," for an exhibition opening in September. He died tragically that November, and his memory fell into near obscurity until recently.

From Anti-Judaism to Anti-Semitism
After the Pogrom shows how the harsh reality of persecution—the subject of many Jewish religious and secular texts—began to influence the visual arts. Over the centuries, Jews had regularly been the victim of hatred and enmity, as Jewish and non-Jewish sources amply testify. Already in pagan antiquity, the Jews, a monotheistic minority adhering to its own customs, were resented for their refusal to assimilate, intermarry, and eat and drink with the gentiles. Christianity, while recognizing the Jews as keepers of the authentic Hebrew text of the Old Testament, resented their refusal to recognize Jesus as their messiah. They not only accused them of murdering Jesus, but considered the New Testament the fulfillment of the Old, marginalizing the Jews, rejected by God and condemned to eternal wandering. Medieval Christians exacerbated these prejudices by accusing Jews of poisoning wells, defiling the host, and the ritual murder of Christian children (blood libel). For every natural or economic disaster, Jews were to blame.

Although the eighteenth-century Enlightenment promoted equality for all humanity and ultimately led to Jewish emancipation, its vitriolic critique of religion, especially the supposedly backward and particularistic Judaism, created the roots of secular anti-Semitism. In the 1870s, the religious hatred of Jews, envy of the success of a few Jewish entrepreneurs, and revulsion of the poor Jewish masses unable or unwilling to assimilate, culminated in racial anti-Semitism, directed against Jews as a whole, religious or not. Jews were considered racially inferior, capitalist or socialist conspirators striving to rule the world.

Tsarist Russia, where millions of Jews were forced to live in the Pale of Settlement, posed the greatest problem. State-sponsored discriminatory measures—limiting the Jews to certain professions, censuring Jewish culture, and military conscription to enforce assimilation—created a climate in which the resentment of the farmers against the Jewish middlemen, of the clergy against the Jewish religion, and of the nationalists against the Jews as a people culminated in pogroms (Russian for massacre and destruction). The bloodiest pogroms took place after tsar Alexander II was killed in 1881, and they spread to other Eastern European countries. In these popular riots, Jewish property was destroyed, women raped, and hundreds of thousands of people were brutally killed or forced to flee. The result was a mass exodus of Jews, primarily to the United States, where over 1.5 million Eastern European Jews found refuge. Others emigrated to the "Promised Land," or fled elsewhere. However hard life was in their new homes, most refugees did not want to be reminded of life in "the old country."

1881 Born in Warsaw the son of an educated bourgeois Jewish family
1886 Suffers an accident and becomes deaf and mute
1890–94 Studies at the Academy of Fine Arts in Cracow
1905 Witnesses pogroms in Bialystok, which mark his future artistic career
1920s First successful exhibitions
1930 Arrives in Buenos Aires in August, accompanied by his wife Rachel Marshak, with numerous artworks; in September a major show by the first famous Jewish artist to visit the country opens, scheduled to tour worldwide; in November, he dies of a car accident in Buenos Aires; supporters and friends found the Museo Minkowski
1994 A terrorist attack against the Jewish community center in Buenos Aires kills dozens of Jews and destroys many works in the Museo Minkowski

LITERATURE
Susan Tumarkin Goodman, ed., *The Emergence of Jewish Artists in Nineteenth-Century Europe* (London, 2001).

Photograph of Maurycy Minkowski

AMEDEO MODIGLIANI ━━━━━━━━━━━━━━━━━━━━━━━━━

CONSTANTIN BRANCUSI ━━

PAUL CÉZANNE ━━━━━━━━━━

1894 Henri de Toulouse-Lautrec,
Salon de la Rue des Moulins

1870 Equal rights for Jews in Italy

1914 Marcel Ducha
first readyma
Bottle Rack

1888 Vincent van Gogh,
The Night Café

1905–07 Les Fauves

1835	1840	1845	1850	1855	1860	1865	1870	1875	1880	1885	1890	1895	1900	1905	1910	1915	1920	

1946 UNESCO founded

6 Cabaret Voltaire in Zurich

1950 Abolition of racial segregation
in the U.S.

1936–39 Spanish Civil War

1925 1930 1935 1940 1945 1950 1955 1960 1965 1970 1975 1980 1985 1990 1995 2000 2005 2010

AMEDEO MODIGLIANI

One of the best-known and most instantly recognizable artists of the early twentieth century, Amedeo Modigliani emerged from the fertile world of avant-garde Paris to produce a style that showed its influences but was uniquely its own.

Amedeo Modigliani (1884–1920) was born in Livorno into a prominent Sephardic family, and died in Paris of tubercular meningitis, an illness that had plagued him since youth. He received his artistic education in Italy, where he became acquainted with the Old Masters, but also with the moderns of his own time. He came to prominence in Paris, where he had lived since 1906, and where he became deeply influenced by artists like Henri de Toulouse-Lautrec, Paul Cézanne, and the still young Picasso. He earned fame for paintings and sculptures of sensuous, seductive women, their presumed Jewish carnality being as much a part of Jewish self-consciousness as of Parisian modernity. Due to his ill health, he produced a relatively few sculptures, though they do reveal the source of their inspiration: ancient Greek, African, and Egyptian art.

A Truly Modern Artist

One of his first paintings, *La Juive* (The Jewess, 1907–8), clearly betrays the influence of the Fauves and the blue period of Picasso. Paul Alexandre, his friend, first patron, and physician, encouraged Modigliani to exhibit it at the Salon des Indépendents (1908), and subsequently bought the painting. Alexandre introduced him in 1909 to the Romanian sculptor Constantin Brancusi, who would inspire Modigliani not only to sculpt, but also to remain independent from the then current artistic movements—he learned from Cubism, Fauvism, and Expressionism but maintained a certain distance that contributed to his uniqueness. With Picasso, Brancusi, and his friend Jacques Lipchitz, Modigliani shared his love for African, ancient Greek and Egyptian art, as can be seen in both his sculptures and his paintings: melancholic portraits of men and women, friends, colleagues, and patrons, including the art dealers Paul Guillaume and Leopold Zborowski.

In the Montmartre and Montparnasse neighborhoods, Modigliani met artists from all over the world, a group that included several recently arrived Eastern European Jews. The artists he portrayed include Juan Gris, Diego Rivera, Juan Gris, Picasso, Jacques Lipchitz and his wife, Moise Kisling, and Chaim Soutine. They were all much like Modigliani himself: newcomers and innovators, Jewish or non-Jewish, French but above all international, finding their way in the most important cultural center of the world.

Although his private life was overshadowed by poor health, extreme poverty, and by a fascination for women, drugs, and alcohol, as an artist Modigliani turned out to be a unique chronicler of *la vie bohème* in the City of Light, his portraits unmistakably modern but rooted in tradition.

1884 Born on July 12 in Livorno
1898–1900 Studies at the art academy of Livorno
1902 Studies at the Academia di Belle Arti, Florence
1903 Studies at the Instituto di Belle Arti in Venice
1906 Moves to Paris and settles in Montmartre; meets Soutine and Lipchitz
1908 Shows six works at the Salon des Indépendants, including *La Juive*
1909 Rents a studio in Montparnasse; meets Constantin Brancusi
1912 Exhibits sculptures at the Salon d'Automne
1914 Meets Beatrice Hastings, his future wife; Paul Guillaume arranges first sales; abandons sculpting for health reasons, focusing solely on painting
1917 First solo show at Galerie Berthe Weill closed after only a few hours because his nudes caused a public scandal
1920 Dies on January 24 in Paris from tuberculosis; buried at Père Lachaise Cemetery

LITERATURE
Kenneth Wayne, *Modigliani and the Artists of Montparnasse*, exh. cat. Albright-Knox Art Gallery, Buffalo (New York, 2003).
Mason Klein, ed., *Modigliani: Beyond the Myth*, exh. cat. The Jewish Museum (New York, 2004).
Werner Schmalenbach, *Modigliani: Paintings, Sculpture, Drawings* (Munich et al., 2005).

left page
Amedeo Modigliani, *The Jewess (La Juive)*, 1907–8, oil on canvas, 55 x 46 cm, Re Cove Hakone Museum, Kanagawa, Japan

above
Amedeo Modigliani, 1918

modigliani Z BOROWSKI

1916

right page
Amedeo Modigliani, *Seated Female Nude*, 1916, oil on canvas, 92 x 60 cm, Courtauld Institute of Art Gallery, London

left
Amedeo Modigliani, *Portrait of Leopold Zborowski*, 1916, oil on canvas, 65 x 42 cm, Israel Museum, Jerusalem. Permanent loan from the Dr. Georg and Josi Guggenheim Foundation, through Schweizer Vereinigung der Freunde des Israel Museum in Jerusalem

1893 Edvard Munch, *The Scream* **1909** Ballets Russes founded by Sergei Diaghilev

1886 Edouard Drumont publishes anti-Semitic book *La France juive*

1903 Pogrom in Kishinev (now Chişinău, Moldova)

1914 World War I breaks out

1835 1840 1845 1850 1855 1860 1865 1870 1875 1880 1885 1890 1895 1900 1905 1910 1915 1920

Marc Chagall, *The Yellow Crucifixion*, 1942, oil on canvas, 140 x 101 cm, Centre Pompidou, Paris. Musée National d'art moderne/Centre de creation industrielle

1924 André Breton, First *Surrealist Manifesto*
Treaty of Versailles officially
ends World War I **1939–45** World War II **1969** Woodstock Festival

1 Arnold Schoenberg invents
twelve-tone music **1945** Atom bomb dropped on
Hiroshima and Nagasaki

| 1925 | 1930 | 1935 | 1940 | 1945 | 1950 | 1955 | 1960 | 1965 | 1970 | 1975 | 1980 | 1985 | 1990 | 1995 | 2000 | 2005 | 2010 |

MARC CHAGALL

The archetypical Jewish artist, Marc Chagall combined the cultural richness of his humble Jewish origins with the most modern of twentieth-century styles to produce a truly singular body of work. His vast oeuvre traces a colorful, vibrant path from the remote past through the last century and carries us into the very present.

Marc Chagall (1887–1985) was born into a poor family in Russian Vitebsk (now Belarus). Under the tsarist regime, Jewish culture and religion were suppressed, and most of the five million Jews had to live within a restricted area, the Pale of Settlement (extending from Lithuania to the Crimea). In cities such as Moscow or St. Petersburg, Jews could only settle with a permit from the tsar—a privilege reserved for the wealthy, and for talented artists like Chagall.

His work celebrates human love and Jewish life in the shtetls—small, predominantly Jewish, towns where most were overwhelmingly, oppressed, and marginalized. Despite discrimination and censorship, Jewish literature and folk culture flourished, including Yiddish theater. Jewish ethnographers revived interest in Jewish culture with trips within the Pale to document folk tales, manuscripts, synagogue paintings, decorated tombstones, and music. While keenly interested in Jewish folk art, Chagall was also inspired by the international avant-garde. In Paris, he became good friends with Robert Delaunay and his Russian wife Sonia Delaunay-Terk, and became acquainted with the Fauvists and the Cubism of Braque and Picasso.

Chagall's Box

Before the Communist-promoted Socialist Realism of the 1920s, the 1917 Russian Revolution ushered in a short-lived Jewish cultural renaissance. In late 1920, Chagall was commissioned to design the decor and costumes for the opening performance of the recently founded Moscow Jewish Theater, the main Yiddish theater in Russia. Chagall opted to paint the entire interior, creating a Gesamtkunstwerk: he designed the ceiling, the stage curtain, and seven large canvases completely covering the walls. The largest canvas, Introduction to the Jewish Theater, hung on the left-hand wall. On the wall beside the entrance could be seen Love on the Stage. On the window side on the right hung the Four Arts—*Literature, Drama, Dance,* and *Music*—and above, a long, narrow painting titled *The Wedding Table.*

When the curtain rose for the first time on January 1, 1921, the small theater and stage appeared as a visual whole. The ninety spectators stepped into the world of Chagall and became part of it, completely absorbed in the ambiance of a theater that, not surprisingly, was referred to as "Chagall's box."

Chagall's canvases are lavish and ebullient, a feast to behold, combining modern art's abstraction and color with traditional Eastern European Jewish folk motifs, and Jewish dramatic tradition with revolutionary ideas about the theater. These works, inaccessible until the 1989 collapse of the Soviet Union, count among the highlights of Chagall's vast oeuvre.

1887 Born Moishe Segal on July 7 in Vitebsk, the oldest of nine children
1907–8 Moves to St. Petersburg; attends Svanseva School, directed by Leon Bakst
1909 Meets in Vitebsk his future wife Bella Rosenfeld
1911 Moves to Paris and becomes friends with Delaunay, Modigliani, and Soutine
1914 Successful first major solo show in Herwarth Walden's Der Sturm Gallery, Berlin
1914–22 Lives and works in Vitebsk, where he founds an Art Academy in 1919, and Moscow
1922 Illustrates *My Life* in Berlin, and returns to Paris
1931 Travels to Palestine and is inspired to work in biblical themes
1937 His work is declared "degenerate" in Nazi Germany
1941–47 The MoMA invites him to go to New York
1948 Return to France; moves to Vence, France
1962 *Twelve Tribes,* stained-glass windows for the Hadassah Hospital in Jerusalem
1973 Visits Leningrad (St. Petersburg) and signs his Jewish Theater works; opening of the Musée Message Biblique Marc Chagall, Nice
1985 Dies on March 28 in Saint-Paul-de-Vence

LITERATURE
Jacob Baal-Teshuva, *Marc Chagall* (Cologne, 2000).

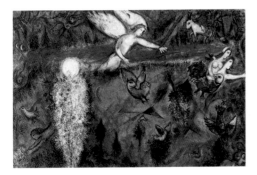

left
Marc Chagall, *Expulsion from Paradise,* 1961, oil on canvas, 190.5 x 283.5 cm, Musée National Marc Chagall, Nice

above
Franz Hubmann, Marc Chagall

Marc Chagall, *Introduction to the Jewish Theater*, 1920, tempera and gouache on canvas, 284 x 787 cm, The State Tretyakov Gallery, Moscow

1911 Wassily Kandinsky, *Concerning
the Spiritual in Art*

1897–1923 The Vitebsk Art School

1840 1845 1850 1855 1860 1865 1870 1875 1880 1885 1890 1895 1900 1905 1910 1915 1920 1925

1965–75 Vietnam War

1939–45 World War II
1936 Charlie Chaplin, *Modern Times*
1928 Stalin creates autonomous Jewish
region in Birobidzhan, Siberia

1953 Foundation of Yad Vashem,
Jerusalem, to commemorate
the Holocaust victims
1952 Show trials against Jews
in Soviet Union

1969 Neil Armstrong lands
on the moon

1989 Fall of the Berlin Wall

1930 1935 1940 1945 1950 1955 1960 1965 1970 1975 1980 1985 1990 1995 2000 2005 2010 2015

EL LISSITZKY

El Lissitzky left an indelible mark on the twentieth century as an artist, designer, photographer, typographer, theorist, and folklorist. He participated not only in the revival of Jewish folk culture but also in the dawn of a new graphic age from the front line of the Russian avant-garde.

"… and then came the fire and burnt the stick."

Eliezer "El" Lissitzky (1890–1941) grew up in the Pale of Settlement in the western part of tsarist Russia, between the Baltic and Black Seas, the only area where Jews were officially permitted until 1917. Forced assimilation, discrimination, and pogroms regularly shook the community. After reforms in 1905, all national and cultural minorities openly revived their own native traditions in art, music, and literature. But discrimination continued: Lissitzky was denied admission to the St. Petersburg Academy of Arts; he instead studied architecture in Darmstadt. In 1914, with the outbreak of World War I, he returned to Russia.

Modernity and the Revival of Jewish Culture
For the next few years, Lissitzky became involved in the rebirth of Jewish art and culture. He illustrated Yiddish stories and children's books, and, in 1916, took part in a Jewish ethnographic expedition organized by folklorist S. Ansky during which he documented synagogues. In May 1919, Chagall invited him to teach art and architecture in his newly founded Vitebsk Art Academy. After Chagall left later that year, Lissitzky became involved with the abstract avant-garde of Kazimir Malevich, who also taught briefly in Vitebsk.

Lissitzky would earn international fame as an experimental artist, photographer, and exhibition designer, developing close contacts with the Dutch De Stijl movement and the German Bauhaus. The prohibition of modernist and Jewish themes in Stalinist Soviet Union relegated his early Jewish work to oblivion. Yet it is here that his enthusiasm for revolutionary changes in style and content are discernable for the first time.

El Lissitzky, "and then came the fire and burnt the stick," a verse from the Passover song "Had Gadya" (the only kid), published in an edition of 75 by the Jewish Cultural League in Kiev, 1919, color lithograph on paper, 27.3 x 25.4 cm, The Jewish Museum, New York. Donated by Leonard and Phyllis Greenberg

Singing Jewish History
"Had Gadya" ("the only kid") is one of the favorite songs in the *Haggadah*, the book accompanying the Passover meal. The festival's central theme is one of oppression and liberation, with which all participants are expected to identify. Lissitzky's illustrations of Had Gadya (1919) in a separate booklet reflect his interest in the story as a metaphor of the liberation of the Jews from tsarist oppression. "Had Gadya," an enchanting ten-verse litany, tickles the fancy of children and adults alike: a little goat is bought for two silver coins, is devoured by a cat, who is gobbled up by a dog, who is beaten by a stick, which is burnt by a fire, which is quenched by water, which is drunk by an ox, who is slaughtered by a butcher, who is killed by the angel of death, who is, finally, slain by God himself. Jewish tradition identifies the kid as the Jewish people, acquired by God with the two tablets of the Law and subsequently victim to a long line of persecutors, beginning in the distant past and continuing until today. Ultimately, God will save His only kid. To make the message accessible to his fellow Eastern European Jews, Lissitzky used the vernacular Yiddish for the captions. The illustration of the fifth stanza, when fire burns the stick, is appropriately dominated by the color red, even in the Yiddish word for fire in the caption. Fire is symbolized by a red fire-breathing rooster (*royter henn* in Yiddish is also the term for arson). It consumes the stick and a building that resembles the synagogues Lissitzky documented, alluding both to pogroms and the burning of synagogues. The traditional interpretation of the song, the nations of the world persecuting the Jews, thus takes on contemporary relevance.

The years 1917 (when he had started work on it) and 1919 (the year of publication) marked sweeping changes: the Russian Revolution of 1917 meant the end of the Pale of Settlement, the tsarist regime, and the dawn of a new era of hope—however short-lived it turned out to be.

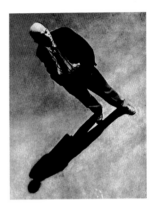

1890 Born Eliezer "Lazar" Mordechu-vich (Markovich) Lissitzky on November 22 in Pochinok in the Russian province of Smolensk
1909–14 Studies at Technical School in Darmstadt; travels to France, Italy, and Belgium
1914 Returns to Russia; studies architecture in Riga
1917–20 Illustrates Jewish books
1919–20 Creates his first Proun; becomes member of Unovis (affirmers of new art)
1920 Moves to Moscow, where he heads the faculty of architecture
1921–22 Moves to Berlin; participates in First Russian Art Exhibition in Berlin and Amsterdam; meets Moholy-Nagy and Schwitters
1925 Moves back to Moscow; designs horizontal skyscrapers; teaches
1926–30 Exhibition and graphic design for Soviet pavilions in Germany
1927 Marries Sophie Küppers with whom he collaborates on propagandistic Soviet photo magazines
1941 Dies on December 30 in Moscow

LITERATURE
El Lissitzky, 1890–1941: Architect, Painter, Photographer, Typographer, exh. cat. Van Abbe Museum (Eindhoven, 1990).
Arnold J. Band, ed., *Had Gadya: The Only Kid; Facsimile of El Lissitzky's Edition of 1919*, introduction by Nancy Perloff (Los Angeles, 2004).

Photograph of El Lissitzky

1912–19 Synthetic
Cubism move-
ment of Georges
Braque and
Pablo Picasso

1920–21 Alexande
Rodchenko,
Constructions

1919–33 Prohibitio
in the U.S.

1840 1845 1850 1855 1860 1865 1870 1875 1880 1885 1890 1895 1900 1905 1910 1915 1920 1925

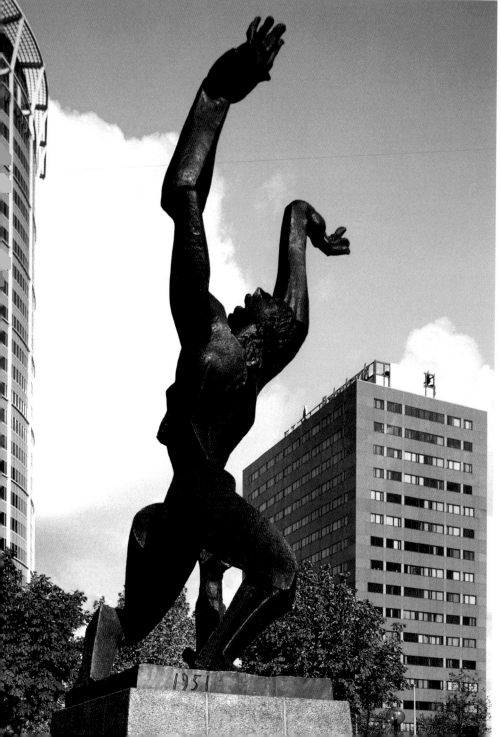

Ossip Zadkine, *The Destroyed City*,
Monument for Rotterdam, 1948–51,
bronze, 650 cm high, Schiedamse Dijk,
Rotterdam

1928 Alexander Fleming
discovers penicillin

1941 Japanese
attack Pearl
Harbor

1943 Michael Curtiz, *Casablanca*

1948 UN Declaration of Human Rights
Declaration of Independence of the
State of Israel, May 14

1955 First Documenta exhibition in Kassel, Germany

1968 Assassination of Martin
Luther King

1973 Yom Kippur War

1930 1935 1940 1945 1950 1955 1960 1965 1970 1975 1980 1985 1990 1995 2000 2005 2010 2015

OSSIP ZADKINE

While his work was initially inspired in Cubism, in the early twenties Ossip Zadkine felt the movement to be indifferent to human beauty. His style became softer, revealing the influence of African art and classical sculpture, and he embraced themes stretching from mythology to biblical figures.

Ossip Zadkine (1890–1967), born in Russian Smolensk, moved to London as a fifteen-year-old boy before settling in Paris in 1909, where he soon became part of the circle around the painter Pablo Picasso, the painter-sculptor Amedeo Modigliani, and the sculptor Alexander Archipenko, a fellow Russian. During World War I, he served as a soldier until suffering gas poisoning. When the Nazis invaded France, he fled to New York, where he taught at the Art Students League. In those years he created work symbolic of the war period such as *Prisoner*, *Warrior*, and *Phoenix*. He returned to Paris in 1945.

War and Destruction
In 1948, he received a commission to commemorate the destruction of Rotterdam, the second largest city in the Netherlands. Having himself experienced the disastrous consequences of war and destruction as a soldier in World War I poisoned by gas, upon arriving to the port city for the first time Zadkine stood face to face with the ruined city and was deeply affected. Rotterdam was destroyed during a German air raid on May 14, 1940; the Netherlands, neutral until invaded on May 10, capitulated a day later. The destruction was truly staggering: the old city was completely wiped out, about 900 people were killed, 25,000 houses burned to the ground, and 78,000 people were left homeless.

The Destroyed City (1948–51), inaugurated on May 15, 1953, is his most important monumental work of the postwar period. Located at the Rotterdam harbor, the sculpture can be looked at from all sides, a decimated pain-ridden giant, its torso disemboweled, its arms stretching to heaven in a desperate gesture of lament. He screams in pain and protest, yet wishes to be healed and restored to his full power. Zadkine combined the best of the two modern artistic movements—Cubism and Expressionism. Initially, the plaque's inscription read just "May 1940," though it was a public secret

the statue was donated by De Bijenkorf, a formerly Jewish-owned department store. Only in 1978 did a new inscription reveal the name of the sponsor, adding that with its donation the store wished to honor its 737 murdered Jewish employees. This sculpture is one of the most powerful modern monuments commemorating the human suffering and material destruction of World War II.

1890 Born Yossel Aronovich Tsadkin on July 14 in Smolensk, Russia (now Belarus)
1905 Sent by his parents to England; studies at London Polytechnic
1909 Meets Chagall in Vitebsk, moves to Paris and has a studio in La Ruche
1911 Studies sculpture with émigré Russian Alexander Archipenko and German Wilhelm Lehmbruck
1912 Meets sculptor Constantin Brancusi, Jacques Lipchitz, and Picasso
1914 Exhibits in Berlin, Amsterdam, and London; becomes friends with Modigliani
1914–19 Serves in World War I; suffers gas poisoning
1933 First retrospective exhibition in Brussels
1941 Emigrates to New York
1945 Returns "poor, unhappy, and impoverished" to Paris
1949 Retrospective exhibition at the Musée d'Art Moderne, Paris
1953 May 15: inauguration of *The Destroyed City*, Rotterdam
1959 Participates in Documenta 2 in Kassel
1967 Dies on November 25 in Paris; his house and studio became a museum

LITERATURE
Sylvain Lecombre, *Ossip Zadkine: L'oeuvre sculpté* (Paris, 1994).

Photograph of Ossip Zadkine

1914 Marcel Duchamp's first
readymade, *Bottle Rack*

| 1840 | 1845 | 1850 | 1855 | 1860 | 1865 | 1870 | 1875 | 1880 | 1885 | 1890 | 1895 | 1900 | 1905 | 1910 | 1915 | 1920 | 1925 |

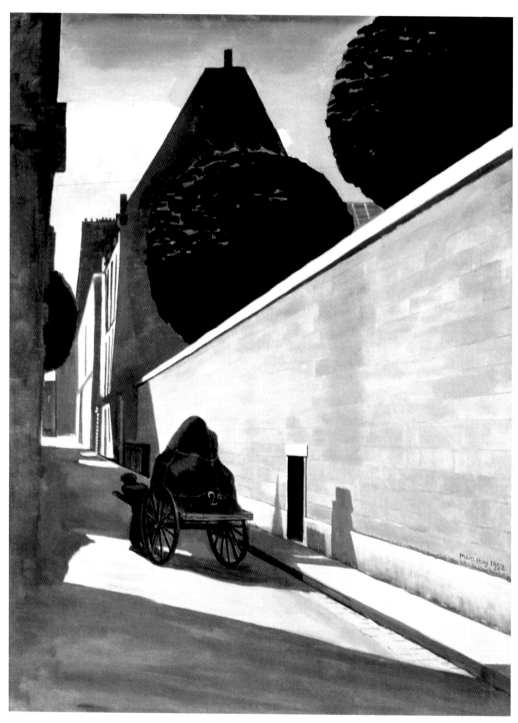

Man Ray, *Rue Férou*, 1952, oil on
canvas, 80 x 60 cm, Man Ray
Trust, Paris

1962 Andy Warhol, *Campbell's Soup Cans*
1990 Reunification of Germany

1939–45 World War II
1959 First happening by Allan Kaprow in New York
1987–93 First Palestinian Intifada

1930 Luis Bunuel, *L'Age d'Or*
1949 Israel becomes a member
of the United Nations
2001 Terrorist attacks on World
Trade Center (9/11)
1965–75 Vietnam War

| 1930 | 1935 | 1940 | 1945 | 1950 | 1955 | 1960 | 1965 | 1970 | 1975 | 1980 | 1985 | 1990 | 1995 | 2000 | 2005 | 2010 | 2015 |

MAN RAY

A name forever linked to modernism, Man Ray was in fact the pseudonym of the son of a Jewish immigrant tailor from Philadelphia. But he left the Old World and his old name behind him as he took a giant leap into the cauldron of twentieth-century art.

Man Ray (1890–1976) was an innovative painter, sculptor, photographer, filmmaker, and object artist. Born in Philadelphia as Emmanuel Radnitzky, he was involved in Dada events and exhibitions in New York between 1916 and 1921 before moving to Paris, where he became part of the Surrealist circle of Tristan Tzara, André Breton, and Francis Picabia. From 1940 until his return to Paris in 1951, he lived and worked in California.

What's in a Name?

What unites Man Ray with Fred Astaire, Kirk Douglas, Al Jolson, Harry Houdini, Yves Montand, Tristan Tzara, and Leon Trotsky? All of them changed their names that may have sounded "too Jewish" to serve their career as a dancer (Friedrich Austerlitz), actor (Issar Demsky), jazz musician (Asa Yoelson), magician (Erich Weisz), singer (Ivo Livi), Dadaist (Samuel Rosenstock), or revolutionary (Lev Bronstein). Emmanuel decided to refashion his ancient Hebrew first name with messianic overtones (it means "God is with us") into Man (human in general), and his foreign-sounding Jewish last name into a neutral Ray.

A Riddle Solved

The Enigma of Isidore Ducasse (1920, 1971) is the enigma of Man Ray himself, who once said, "I am mysterious," and did everything possible to hide his Jewish name and background to avoid being pigeon-holed. The title of this work refers to the legendary Comte de Lautréamont's (alias Isidore Ducasse) saying: "Beautiful as the chance meeting of a sewing machine and an umbrella on a dissecting table." A coarse piece of fabric covers a vaguely anthropomorphic form, firmly tied by a rope (with a warning: "Do Not Disturb").

Man Ray kept his Jewish heritage and social background a closely guarded secret, a fact confirmed by his biographers and friends. His parents were Russian-born Jews; his father worked as a tailor in

a factory and also at home—a house cluttered with scraps of fabric from which young Emmanuel made deliveries by pushcart. The sweatshop experience was common to many Jewish immigrants in America—the families of artist Barnett Newman and architect Louis Kahn included—but Man Ray carefully tied these stories under a blanket. He created this intriguing work in New York, shortly before leaving for Paris in 1921, where he would replace his biological family with a family of avant-garde artists who created their own identities, like fellow Dadaist artist and poet Tristan Tzara. Yet, the clothes irons (with nails), fabrics, and coat hangers—however trivial and witty—are a constant reminder of Man Ray's repressed and (for him) shameful background as the son of Jewish textile workers, and as such the camera with which he photographed high fashion can be seen as an upgrade on the sewing machine of his youth.

Man Ray remained silent about the Holocaust on his return to Paris in 1951 from his native America, to which he fled in 1940. His 1952 painting *Rue Férou*—the Paris street where he lived and worked—depicts a tiny figure pulling a loaded cart in an otherwise deserted street. The heavy load strikingly resembles *The Enigma of Isidore Ducasse*. Man Ray may have once claimed that "Race and class, like styles, then become irrelevant," but he too had to carry the burden of his past and acknowledge (however indirectly) his social background and his Jewishness when he re-entered the world of art and fashion after fleeing Europe: "With my bundle in a black cloth under my arm I felt like a delivery boy"—perhaps like young Emmanuel transporting his father's wares as so many Jewish peddlers did before him. There is more to Jewish identity than just a name.

1890 Born as Emmanuel Radnitzky on August 27 in Philadelphia, child of recent Russian Jewish immigrants
1912 Enrolls in the Ferrer School, New York, after having attended various art classes
1915 Creates first readymades under the influence of his friend Marcel Duchamp; becomes involved with Dada, a radical anti-art movement
1921 Moves to Paris in July and falls in love with famous model Kiki de Montparnasse, who figures in his experimental photos and films
1925 Participates in the first Surrealist exhibition at Galérie Pierre, with Arp, Ernst, Masson, and Picasso
1934 Surrealist artist Meret Oppenheim posed nude for him; together with Lee Miller reinvents "solarization," an experimental photo technique
1940–51 Forced to leave Paris because of World War II; lives in Los Angeles and meets Juliet Browner, a dancer and model of Romanian Jewish decent
1946 Marries Juliet Browner in a double wedding with artists and friends Max Ernst and Dorothea Tanning
1951 Returns to Paris
1976 Dies of a lung infection on November 18 in Paris; he is buried at the Montparnasse cemetery

LITERATURE
Neil Baldwin, *Man Ray: American Artist* (Cambridge, Mass., 2001).
Milly Heyd, "Man Ray/Emmanuel Radnitsky: Who is Behind The Enigma of Isidore Ducasse?," in *Complex Identities: Jewish Consciousness and Modern Art*, ed. Matthew Baigell and Milly Heyd (New Brunswick and London, 2001), pp. 115–41.
Mason Klein, *Alias Man Ray: The Art of Reinvention*, exh. cat. The Jewish Museum (New York, 2009).

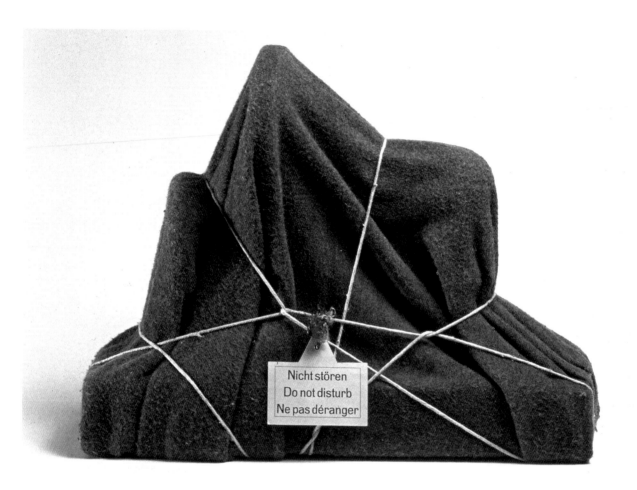

Man Ray, *The Enigma of Isidore Ducasse*,
1920 (Reconstructed 1971), assemblage:
sewing machine, blanket, strings, and
wooden base, 45 x 58 x 23 cm, Museum
Boijmans van Beuningen, Rotterdam

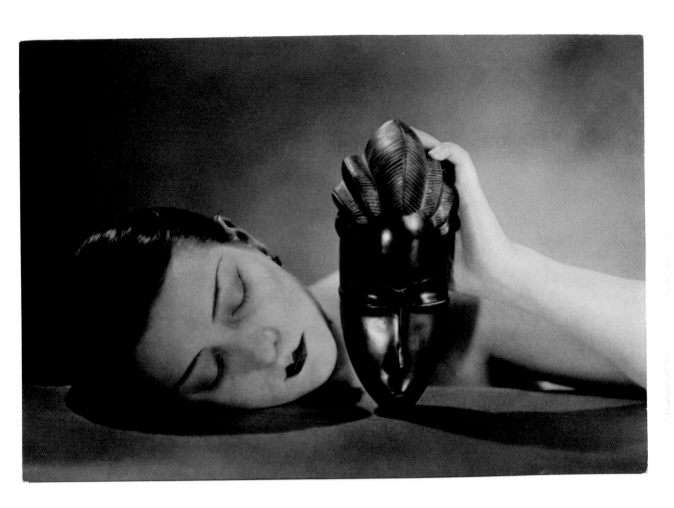

Man Ray, *Noire et Blanche*, 1926

JACQUES LIPCHITZ

AMEDEO MODIGLIANI

PABLO PICASSO

1912–19 Synthetic Cubism
movement of Georges
Braque and Pablo Picasso

1921 Einstein
awarde
Nobel P

1840 1845 1850 1855 1860 1865 1870 1875 1880 1885 1890 1895 1900 1905 1910 1915 1920 1925

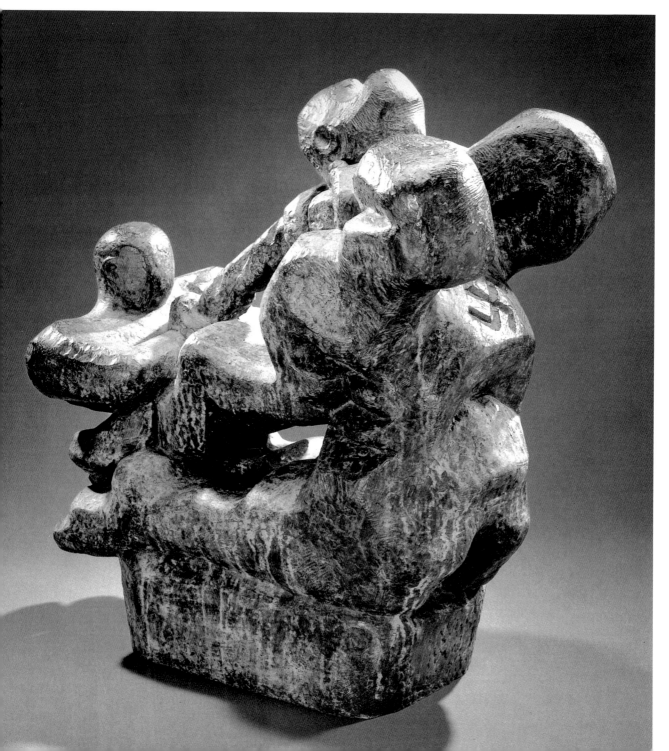

1936 Charlie Chaplin,
Modern Times

1948 UN Declaration of Human Rights

1967 Six-Day War between Israel
and its neighboring states
Egypt, Jordan, and Syria

1995 Israeli prime minister Yitzhak Rabin
and PLO chairman Yasser Arafat
sign peace agreement in Oslo

1940–44 Vichy Regime in France

1945 Beginning of
Cold War

1955 First Documenta exhibition
in Kassel, Germany

1969 Neil Armstrong lands on the moon

1930　1935　1940　1945　1950　1955　1960　1965　1970　1975　1980　1985　1990　1995　2000　2005　2010　2015

JACQUES LIPCHITZ

"I reacted purely instinctively as a Jew on behalf of my dispersed and persecuted brethren. But this monster, which we try to kill, is not only just anti-Semitism, it represents in fact everything which keeps man from advancing." — Jacques Lipchitz

Chaim Jacob "Jacques" Lipchitz (1891–1973), born in Druskininkai, Lithuania (then Russia), moved to Paris in 1909 to study art. There, in Montparnasse, he became acquainted with artists Constantin Brancusi, Chaim Soutine, and Amedeo Modigliani; through Diego Rivera, he met Picasso; and Juan Gris became a close friend. Lipchitz quickly became a celebrated Cubist sculptor whose work was widely admired; as early as 1922, the American collector Albert Barnes bought a number of his sculptures. After the German invasion of France in May 1940, Lipchitz fled first to unoccupied southern France, and from there to New York, where he was to spend the rest of his life. Adjusting to yet another language and culture, difficult for any émigré, was ultimately a propitious turn of events for the sculptor.

Artistic Response to Fascism
Lipchitz's response to Fascism, the impending war, and the Holocaust started with *David and Goliath* in 1933. He continued to address these themes in monumental sculptures with mythological themes such as *Prometheus Strangling the Vulture* (1936), *The Rape of Europe* (1938), and *Theseus Slaying the Minotaur* (1942), in each case representing civilization in battle against barbarism. Works like *Mother and Child* (1941–45) and *Flight* (1940) relate to his own narrow escape from Europe.

This Monster Which We Will Try to Kill
Shortly after Hitler became chancellor on January 30, 1933, Lipchitz began sketching for *David and Goliath*. The biblical David is an extraordinary figure: a warrior and statesman who united the Israelite tribes in establishing Jerusalem as its capital, but also a poet and musician—the author of psalms. Although his life was full of personal contradictions and conflicts, missteps and misbehavior, he remains celebrated in Jewish tradition as the founder of the House of David, expected to rule again in messianic times. David, the small shepherd boy, the unlikely hero, earned his fame with his victory over the Philistine giant Goliath, killing him with a stone from a slingshot and then cutting off his head (1 Samuel 27:49–51). The message of the story struck a chord: a tiny people able to defeat greater adversaries.

This image of the Jew as a hero attracted Lipchitz. The way he depicted David and Goliath in his sculpture is unusual: David is typically seen with his slingshot or cutting off Goliath's head with a sword, but Lipchitz shows him strangling the giant with a rope, actively killing the enemy. He expresses his personal anger with the violence around him, and makes this meaning clear by carving a swastika on Goliath's chest, having little David defeat the Nazi giant, strangling him in an attempt to exorcize impending evil.

Jews and Arabs
In accordance with the Biblical adage to "not wrong a stranger or oppress him, for you were strangers in the land of Egypt" (Exodus 22:20 and elsewhere), Lipchitz responded to Israel's War of Independence in 1948 with the creation of *Hagar* (1948 and 1969). Abraham's first wife and their son Ishmael, considered the ancestor of the Arabs, were sent into the desert, exiled from the land promised to Abraham and Sarah's son Isaac. Lipchitz's lifelong involvement with the fate of the Jews and global injustice culminates in his anguish about those new refugees, the Palestinians; having been a refugee himself, Lipchitz identifies with their cause. And yet, hoping for a peaceful coexistence between two peoples, Lipchitz recognized Israel as his spiritual home, and was ultimately buried there.

1891 Born on August 22 in Druskininkai
1909 After studying engineering, moves to Paris and studies art
1912 Participates in the Salon d'Automne
1920 First solo exhibition at Léonce Rosenberg's Galerie de l'effort moderne
1937 Sculpture for the Paris International Exposition
1941 Flees to the U.S.; settles in 1947 in Hastings, NY
1958 Becomes a U.S. citizen
1959 Participates in Documenta 2 in Kassel
1962 First public sculptures in the U.S. and Israel
1964 Participates in Documenta 3
1973 Dies on May 16 in Capri, Italy, and is buried in Jerusalem

LITERATURE
Alan G. Wilkinson, *The Sculpture of Jacques Lipchitz: A Catalogue Raisonné*, 2 vols. (London, 1996/2000).
Catherine Putz, *Jacques Lipchitz: The First Cubist Sculptor* (London, 2002).

left page
Jacques Lipchitz, *David and Goliath*, 1933, bronze, height: 99.7 cm, estate of Jacques Lipchitz. Courtesy Marlborough Gallery, New York

above
Jacques Lipchitz, 1970

REUVEN RUBIN

HENRI ROUSSEAU

MARC CHAGALL

1929 Riots between Je
and Arabs in Pale

1896 Theodor Herzl writes
The Jewish State

1930 Grant Woo
American G

| 1845 | 1850 | 1855 | 1860 | 1865 | 1870 | 1875 | 1880 | 1885 | 1890 | 1895 | 1900 | 1905 | 1910 | 1915 | 1920 | 1925 | 1930 |

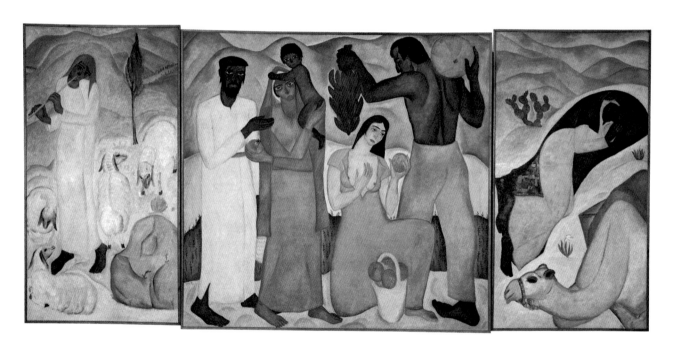

Reuven Rubin, *First Fruits*, 1923, triptych,
from left to right: *The Shepherd, First
Fruits, The Bedouin*; oil on canvas,
188 x 397 cm, collection of the Rubin
Museum Foundation, Tel Aviv

1948 Declaration of Independence of the State of Israel, May 14

1935–44 Walker Evans and Dorothea **1955** *The Family of Man* exhibition at the Museum of Modern Art, New York
Lange document the plight of
poor farmers for the Farm Security **1960** Clement Greenberg, *Modernist Painting*
Administration (FSA) **1962** Cuban missile crisis **1979** Israel-Egypt peace agreement
 1945 Atom bomb dropped on Hiroshima and Nagasaki

'1935 1940 1945 1950 1955 1960 1965 1970 1975 1980 1985 1990 1995 2000 2005 2010 2015 2020

REUVEN RUBIN

Influenced by the large neo-Byzantine murals in his native Romania and the naïve realism of Henri Rousseau and the African art he saw while studying in Paris, Reuven Rubin belonged to an early group of Jewish artists attempting to develop a style reflecting the optimism of living in an old-new Jewish land.

Pioneers in Palestine

Reuven Rubin (1893–1974) was born in Romania the eighth of thirteen children into a poor Jewish Hasidic family. He first went to Palestine in 1912, later studied in Paris, and then immigrated to Palestine for good in 1923.

Rubin's *First Fruits* (1923) may be compared to *The Jewish Family* (1911–12), a work by Russian artist Natalia Goncharova, who like so many of her contemporaries (including Marc Chagall and Wassily Kandinsky) reveals the influence of Russian iconography. *First Fruits* possesses the same expressive iconic style and ritualistic monumentality that transcends the simple narration of a genre scene. The title of this solemn triptych refers to the biblical harvest festival, described in Deuteronomy 26, in which each individual settler in the "land of milk and honey" brings to a specially designated place a basket with the first fruits of the soil. The earliest Zionist settlers in the "Promised Land" revived these ritual observances of the harvest festival. Rubin depicted them in a style resembling social realism. Whether traditionally dressed with their heads and bodies almost fully covered, or modern and secular with naked breast and chest, these Jews celebrate their first fruits—of the land and the womb. They are in unison with the land, celebrating it musically with the animals; or as one with it, relaxed and at home after so many millennia wandering the earth. The desert starts to flourish; a dream is being fulfilled. What in hindsight is tragic irony, Arabs serve as a role model of strength and belonging for these new Israelites.

Zionism

Although rooted in the Hebrew Bible, Jewish tradition, and liturgy, Zionism as a political movement for a national homeland is a product of the Diaspora. "In Basel I founded the Jewish state," said Theodor Herzl (1860–1904), summarizing the first Zionist congress in 1897. This assimilated Austro-Hungarian Jew, a newspaper correspondent in Paris, was as appalled as were his fellow Jews (and many French) by the anti-Semitism that surfaced during the Dreyfus affair in France, in which an assimilated Jewish military officer was unjustly accused and condemned for treason as a result of his being Jewish. Ignoring religious reservations about what many perceived as an irresponsible messianic adventure, Herzl managed to convince Jewish representatives of his dream of a Jewish return to the "Promised Land." In his eyes, European nationalism invited only one response: a Jewish national solution to the endemic problem of anti-Semitism, which plagued backward and absolutist Russia as well as modern and democratic France.

But how do you turn Jewish European traders into Middle Eastern farmers, as their biblical ancestors were? Before it became the independent state of Israel in 1948, Ottoman (and later British) Palestine was colonized, mainly by Eastern European settlers. Supported by philanthropic organizations in the Diaspora, they founded agricultural colonies on uncultivated land, in general either too arid or too swampy. The harsh awakening came after the Arab attacks and riots in 1929. From then on, naïve forms of Zionism needed revision: Palestinian inhabitants also started to develop national thoughts.

1893 Born Reuven Zelicovici on November 13 in Galati, Romania, into a Hasidic family
1912 Leaves for Ottoman-ruled Palestine to study at the Bezalel School of Arts and Crafts (now Academy of Arts and Design) in Jerusalem
1913 Not content with the artistic direction in Jerusalem, he leaves for Paris
1914–18 Forced to return to Romania during World War I
1921 Travels to New York; exhibits his work for the first time
1923 Immigrates to British Palestine
1924 First solo exhibition in Jerusalem
1948–50 Represents Israel as a diplomatic envoy in Romania
1973 Wins the Israel Prize for painting
1974 Dies on October 13 in Tel Aviv
1983 His home on Bialik Street, Tel Aviv, becomes the Rubin Museum

LITERATURE
Milly Heyd, "The Uses of Primitivism: Reuven Rubin in Palestine," in *Art and its Uses: The Visual Image and Modern Jewish Society*, Studies in Contemporary Jewry 6, ed. Ezra Mendelsohn (New York, 1990), pp. 43–70.
Dalia Manor, *Art in Zion: The Genesis of Modern National Art in Jewish Palestine* (London and New York, 2005).
Carmela Rubin, *Dreamland: Reuven Rubin and His Encounter with the Land of Israel in his Paintings of the 1920s and 1930s*, exh. cat. Tel Aviv Museum of Art (Tel Aviv, 2006).

above
Photograph of Reuven Rubin

CHAIM SOUTINE

AMEDEO MODIGLIANI

ERNST LUDWIG KIRCHNER

1845 Richard Wagner, *Tannhäuser*

1866 Civil Rights Act in the U.S.

1851 First World's Fair in London

1881–84 Russian pogroms cause mass
emigration to the United States

1905 German Expressionist group
Die Brücke is founded in Dresden

1916 Dadaist Cabaret Voltaire
founded in Zurich

1928 Alex
Flem
disc
pen

1845 1850 1855 1860 1865 1870 1875 1880 1885 1890 1895 1900 1905 1910 1915 1920 1925 1930

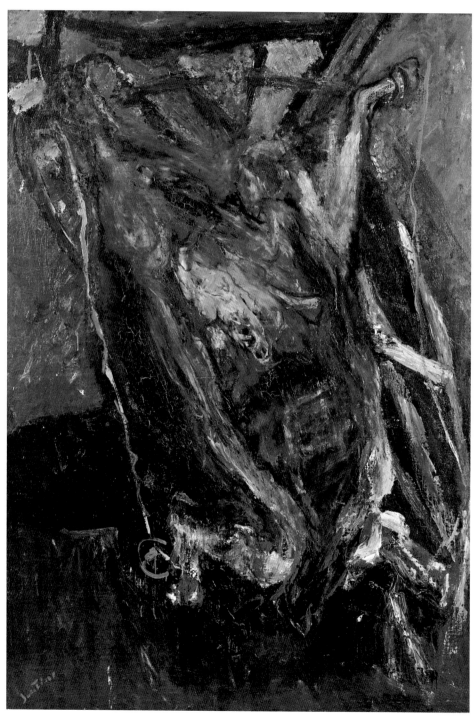

Chaim Soutine, *Carcass of Beef*, ca. 1925,
oil on canvas, 166.1 x 114.9 cm, Stedelijk
Museum, Amsterdam

1940–44 Vichy Regime in France
1939–45 World War II
1949 North Atlantic Treaty Organization
(NATO) is founded

| 1935 | 1940 | 1945 | 1950 | 1955 | 1960 | 1965 | 1970 | 1975 | 1980 | 1985 | 1990 | 1995 | 2000 | 2005 | 2010 | 2015 | 2020 |

CHAIM SOUTINE

At first sight, there is nothing particularly Jewish about the art of Chaim Soutine; in fact, he never painted a Jewish subject. Still, the French Expressionist artist identified himself and was perceived by others as a Jew.

Chaim Soutine (1893–1943) never changed his Hebrew first name and spoke with a Yiddish accent that betrayed his background: he was born near Minsk in the Russian Empire, and studied art in Vilnius. Like Chagall, he married Jewish (in 1925), but unlike him, he never painted his shtetl, Smilovitz, where he was once beaten up for drawing an elderly Jewish man. Among traditional Jews, art is considered a waste of study time, and portraying people is forbidden. Once established in Paris in 1913, he made portraits of himself, a cook, and a communicant, but never of a rabbi as Chagall had. He preferred Chartres Cathedral to synagogues, painted landscapes in southern France, and still lifes of simple provisions. Food was among his favorite subjects, a choice that may originate in his own humble background. He remained modest even after he achieved financial success from acquisitions by French and, especially, American collectors.

His personality and his art have always fascinated his admirers and critics. His work was labeled expressionist and intense, but also primitive and instinctive. It was derogatorily considered as "art based on the Jewish spirit," incapable of incarnating ideas, and hostile to beauty. However much Soutine differed from painters like Chagall and Modigliani, or sculptors like Lipchitz, they and some of their non-Jewish colleagues shared one characteristic: they were foreigners, grouped together under the School of Paris label, excluded from the prestigious French School.

Bloody Business

Soutine became most noted for his paintings of dead animals, about which a critic at the time wrote: "bloody heaps … flesh more flesh than flesh itself." Though perhaps inspired by memories of slaughtered animals in his youth, Rembrandt's *Carcass of Beef (Flayed Ox)* (1655) in the Louvre is a much more obvious influence for his own *Carcass of Beef* (1925). Though an ox chews the cud and has split hooves and is therefore kosher, the majority of animals depicted by Soutine—such as skate, hare, and game—are not. Soutine purchased his carcasses from a nearby slaughterhouse, hung them, and started painting as an assistant fanned away the flies. As soon as the carcass dried, he would get a fresh pail of blood to revive the color of fresh meat. The story goes that when neighbors complained to the authorities about the stench of decaying flesh, Soutine was able to convince the police of the artistic importance of his work.

Fatal Attraction

In Judaism, blood equals life. Its consumption is absolutely forbidden. When an animal is slaughtered for consumption, all blood must be drained. Soutine does the opposite: he replenishes the drained flesh and paints the carcass as if it were dripping blood. Was France, with its abundant street markets and its exquisite cuisine, the counter-image to the poor Russian shtetl of his birth? Do his paintings symbolize the fatal attraction of France, and are his still lifes a reaction to the dietary restrictions and perceived lack of art in Judaism? Is the slaughtered ox a tragic Jewish counter-image to sun-intoxicated France, foreshadowing the future drip paintings of Abstract Expressionism in the United States or the end of all flesh in general, a memento mori like any real still life? Soutine, the outsider inside, exploring borders, died of a perforated ulcer in 1943, before the Nazis could catch him in occupied France and kill him back in Eastern Europe.

1893 Born on January 13 in the Russian shtetl Smilovitz (now Smilavitchi, Belarus) as the tenth of eleven children
1910–13 Studies at the Vilna Academy of Arts
1913 Immigrates to Paris together with his friends Pinchus Kremegne and Michel Kikoine; studies at the École des Beaux-Arts
1914 Art dealer Leopold Zborowski supports him through World War I
1916 Becomes friendly with Amedeo Modigliani
1923 American collector Albert Barnes buys sixty of his works from art dealer Paul Guillaume
1935 First exhibition in Chicago thanks to a French benefactor
1940 Escapes Paris and goes into hiding in southern France
1943 Suffers from ulcer problems and returns to Paris for surgery, which is unsuccessful; he dies on August 9 and is buried at the Montparnasse cemetery

LITERATURE
Maurice Tuchman and Esti Dunow, *Chaim Soutine (1893–1943): Catalogue Raisonné* (Cologne, 1993).
Norman L. Kleeblatt and Kenneth E. Silver, *An Expressionist in Paris: The Paintings of Chaim Soutine*, exh. cat. The Jewish Museum (New York and Munich, 1998).
Sophie Krebs et al., eds., *Soutine and Modernism*, exh. cat. Kunstmuseum Basel (Basel, 2008).

Chaim Soutine in Le Blanc, 1926

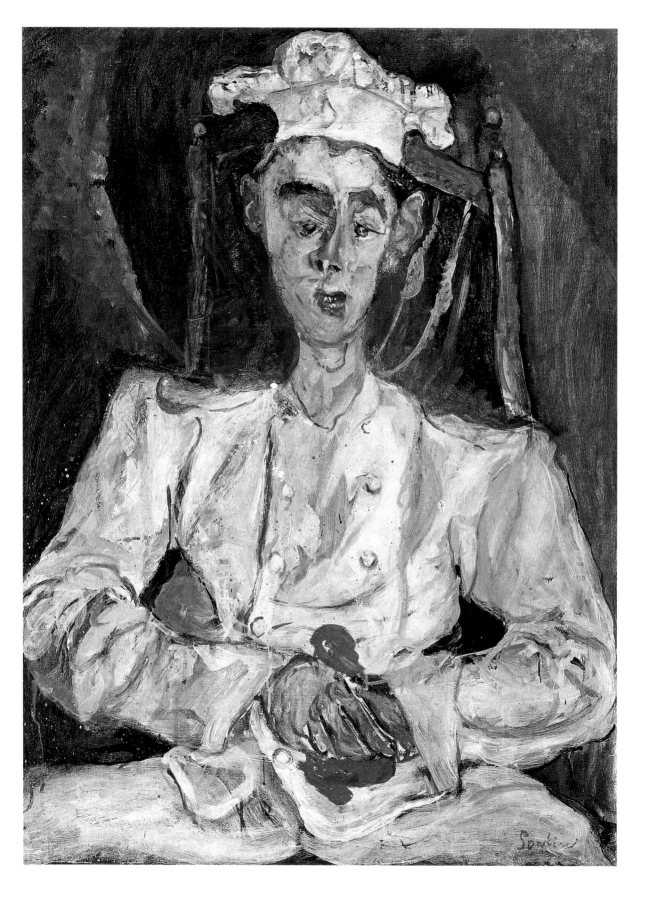

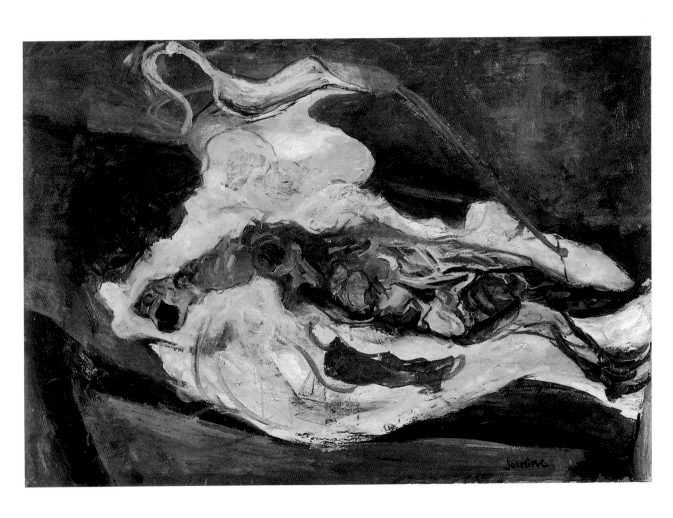

left page
Chaim Soutine, *Pastry Cook with Red Handkerchief*, ca. 1922–23, oil on canvas, 73 x 54 cm, Musée de l'Orangerie, Paris. Collection Jean Walter et Paul Guillaume

above
Chaim Soutine, *Still Life with Pheasant*, ca. 1924, oil on canvas, 64.5 x 92.1 cm, Musée de l'Orangerie, Paris. Collection Jean Walter et Paul Guillaume

1919 The Bauhaus is founded
in Weimar, Germany

1917 Russian Revolution; Jews receive
rights (until Communists take po

1924 André Breton,
Surrealist Man

1845	1850	1855	1860	1865	1870	1875	1880	1885	1890	1895	1900	1905	1910	1915	1920	1925	1930

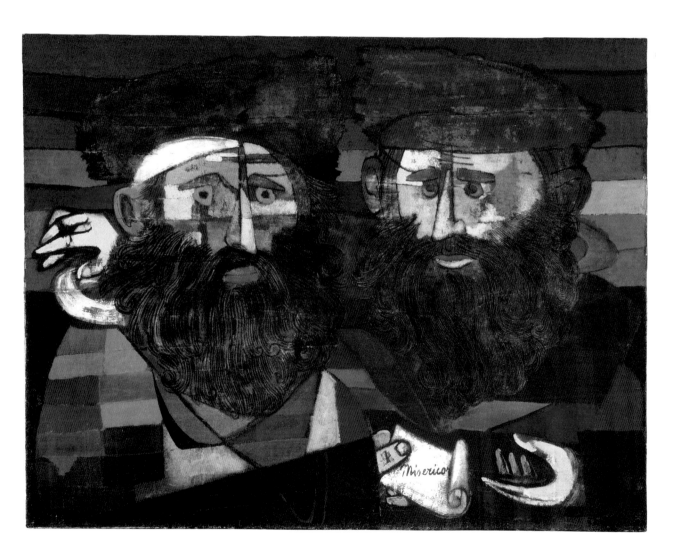

Jankel Adler, *Two Rabbis*, 1942, oil on
canvas, 85.5 x 112 cm, The Museum of
Modern Art, New York. Gift of Sam Salz

1940 German occupation of France

Stock market crash heralds
global economic crisis

1949 Israel becomes a member of the United Nations

1959 First happening by Allan Kaprow
in New York

.932 Aldous Huxley,
Brave New World

1952 Show trials against Jews in Soviet Union

1935 1940 1945 1950 1955 1960 1965 1970 1975 1980 1985 1990 1995 2000 2005 2010 2015 2020

JANKEL ADLER

Polish-born Jankel Adler never abandoned his homeland nor his people as he traveled throughout Europe to develop his art. With one eye always trained on home he successfully rescued Jewish wisdom and human dignity from the inhumanity of World War II.

Jankel Adler (1895–1949) traveled in 1912 from his native Poland to study art in Germany, where, in close contact with Otto Dix and Max Ernst, he became one of the more illustrious innovators in the visual arts. From 1931 until his forced retirement in 1933, he taught at the Art Academy in Düsseldorf where he became friendly with Paul Klee, whose lyrical abstraction and color clearly influenced Adler, as can be seen in the *Two Rabbis* (1942). He fled Germany and wandered about, spending time in Warsaw before going to France in 1937. Shortly after the war broke out in 1939, he joined the Polish army as a volunteer; after his discharge a year later, he settled in the United Kingdom, first in Glasgow and later in Aldbourne near London, where he tried to keep in contact with his native Poland.

A Compelling Appeal

Two bearded rabbis with troubled looks in their eyes stare us pleadingly in the face. They make an appeal by showing us a small scroll on which a single word is written: "Misericordia" (compassion). It is 1942 and they have every right to our compassion: the rough stripes across their heads and the background indicate they are behind the barbed wire of a concentration camp somewhere in Germany or Eastern Europe. They have already been wounded, as the bandage beneath the headgear of the rabbi on the left suggests, the red of their scarves indicating gravely.

In other paintings with Jewish subjects, or in his *Self-Portrait* Adler used Hebrew letters. Why does he use the Latin *Misericordia* and not the Hebrew equivalent *Rahamim*, one of the biblical attributes of God (Exodus 34:6)? The two rabbis are fully aware that according to Jewish tradition God has given man the choice between good and evil and consequently do not blame God. Instead, these rabbis implore us, human beings, to take responsibility and combat evil. They do not pray to God, but appeal to the conscience of men, more specifically to those of the Christian faith.

Classically dressed in their ceremonial headgear, these serious, tight-lipped rabbis with their carefully combed beards—the very antithesis of Nazi propaganda images—are icons of Jewish wisdom and human dignity, even in the most barbaric circumstances of World War II.

1895 Born on July 26 in Tuszyn, a suburb of Lodz, Poland; raised in a Hasidic family
1912 Trains as an engraver with an uncle in Belgrade
1914 Moves to Germany and receives an arts education in Barmen
1918–19 Returns to Lodz and co-founds the avant-garde art group Young Yiddish
1922 In Düsseldorf with Ernst Campendock; member of the Rhineland Secession
1931–33 Teaches at the Art Academy in Düsseldorf; contact with Paul Klee
1933 His art is considered degenerate after the Nazis take power; he travels to Paris and later to other European countries; first solo exhibitions
1937 Meets Picasso in France
1939 With the outbreak of World War II, he joins the Polish army, reconstituted in France, as a volunteer
1941 Dismissed from the army for health reasons; escapes to Great Britain
1949 Dies on April 25 in Aldbourne near London, aware that his nine brothers and sisters were killed in the Holocaust

LITERATURE
Ulrich Krempel, *Jankel Adler, 1895–1949*
(Cologne, 1985).

above
Photograph of Jankel Adler

MORDECAI ARDON ▬▬▬▬▬▬▬▬▬▬▬▬▬▬▬

PAUL KLEE ▬▬▬▬▬▬▬▬▬▬▬▬▬▬▬▬▬▬▬▬▬▬▬▬▬▬▬

LYONEL FEININGER ▬▬▬▬▬▬▬▬▬▬▬▬▬▬▬▬▬▬▬▬▬▬▬▬▬▬▬▬▬▬▬▬

1901 Exhibition of Jewish art during
Fifth Zionist Congress in Basel

1921 Arnold Schoenberg
invents twelve-tone
music

1891 Construction of Trans-Siberian
Railway begins

1909–10 Henri Matisse, *La Danse*

| 1845 | 1850 | 1855 | 1860 | 1865 | 1870 | 1875 | 1880 | 1885 | 1890 | 1895 | 1900 | 1905 | 1910 | 1915 | 1920 | 1925 | 1930 |

Mordecai Ardon, *Train of Numbers*, 1962,
oil on canvas, 74 x 145 cm, Collection of
the Mishkan Le'Omanut, Museum of Art,
Ein Harod, Israel

1935 Nuremberg racial laws deprive
Jews of their civil rights

1945 Liberation of Auschwitz
concentration camp

1962 Andy Warhol, *Campbell's Soup Cans*

1973 Yom Kippur War

1987–93 First Palestinian Intifada

1988 *Freeze*, exhibition of Young
British Artists in London

1935 1940 1945 1950 1955 1960 1965 1970 1975 1980 1985 1990 1995 2000 2005 2010 2015 2020

MORDECAI ARDON

An accomplished storyteller and artist, Mordecai Ardon participated in the birth of a young Israel's art with a modern style, symbolic, often colored by the tribulations of mankind. Capable of transcending any form of nationalism, he is acclaimed throughout the world.

Mordecai Ardon was born Max Bronstein (1896–1992), the son of a Polish Orthodox Jewish watchmaker in Tuchow, in the Carpathian Mountains. He studied at the Bauhaus between 1921 and 1925 and was influenced by such luminaries as Lyonel Feininger, Johannes Itten, Paul Klee, and Wassily Kandinsky, as his later work would testify. He taught and exhibited in Berlin before political events forced him to leave in 1933 for Palestine, where he briefly worked in a kibbutz before he was invited to teach art in Jerusalem, and developed into one of Israel's most celebrated modern artists.

An Israeli Avant-Garde Artist

In his work, the bright light of the land of Israel became imbued by a spirituality reminiscent of his teacher Paul Klee, and darkened by the shadows of the Holocaust. From his only surviving brother he learned in 1945 that his Polish relatives had all perished, and, from this point on, the Holocaust would increasing influence his work.

Returning from a visit to his birthplace Tuchow in 1959, he tells about his anger with the Nazi killers and with a God who remained silent. Art cannot really depict the atrocities, but only allude to it through abstraction and symbolism. The dark lines in *Train of Numbers* (1962) refer to the trains that transported Jews to the destruction camps, riding full speed through a deserted landscape under a blood-red sky. The wheels of the cattle cars already seem to crush the victims, their bodies symbolized by the numbers in the painting—numbers that would be tattooed on those selected for labor at the camps; others were sent directly to the gas chambers. Ardon's seemingly rational and natural landscape grows apocalyptic and is loaded with wheels, colors, signs, childlike scribbles.

In other works there appear Kabbalistic symbols, Hebrew letters, and torn parchment. They all seem to be engaged in a desperate search for meaning, a search which for the artist was far more consequential than for his mentors and role models, such as Klee. In the 1949 translation by Isaiah Tishby of the *Zohar*, the canon of Jewish mysticism, Ardon discovered rare graphic images—seemingly against the anti-iconic image of Judaism—which he gladly incorporated into his work.

Ardon, who oscillated between figurative and abstract styles, remained so engaged with the Bible, Jewish history, and Israeli reality that it prevented him from reaching the complete abstraction of so many of his contemporaries. Instead, this gifted storyteller and talented artist became renowned in the first decades of Israel's existence for his contribution in forging Israeli art—modern, invested with Jewish symbolism, at times haunted by the memory of the Holocaust, but no less by other tragedies that had befallen humanity as a whole. Ardon is internationally acclaimed as an artist who truly transcended the frontiers of narrow nationalism.

1896 Born on July 13 in Tuchow, Galicia, then Austria-Hungary, now Poland
1921–25 Studies at the Bauhaus in Dessau with Klee, Kandinsky, Itten, and Feininger
1926 Studies in Munich
1933 Is forced to emigrate; goes to Palestine
1963 Receives the Israel Prize in painting
1992 Dies in Jerusalem on June 18

LITERATURE
Michele Vishny, *Mordecai Ardon* (New York, 1973).
Arturo Schwarz, *Mordecai Ardon: The Colors of Time*, exh. cat. The Israel Museum (Jerusalem and Tel Aviv), 2003.

Photograph of Mordecai Ardon

ISSACHAR RYBACK ━━━━━━━━━━━━━━━━━━━━━━━━

MARC CHAGALL ━━━━━━━━━━━━━━━━━━━━━━━━━━━━━━━━━━

EL LISSITZKY ━━━━━━━━━━━━━━━━━━━━━━━━━━━━━━━

1916–22 Dada movement

1866 Moorish style New Synagogue
in Berlin opened

1907 Picasso, *Les Demoiselles
d'Avignon*, first work of cubism

1924 Thomas Mann,
The Magic Mountain

1914–19 World War I

| 1845 | 1850 | 1855 | 1860 | 1865 | 1870 | 1875 | 1880 | 1885 | 1890 | 1895 | 1900 | 1905 | 1910 | 1915 | 1920 | 1925 | 1930 |

Issachar Ryback, *The Old Synagogue*,
1917, oil on canvas, 97 x 146 cm,
The Tel Aviv Museum of Art, Tel Aviv

1939–45 World War II
Grant Wood, *American Gothic*
1940 German occupation of France
-31 Empire State Building in
New York by William van Alen

1935 1940 1945 1950 1955 1960 1965 1970 1975 1980 1985 1990 1995 2000 2005 2010 2015 2020

ISSACHAR RYBACK

With a contemporary approach to traditional Jewish life, Issachar Ryback documented the disappearing life in the shtetls in lithographs and illustrated children's books. Along with Chagall and Lissitzky he was responsible for bringing modernism to Jewish art.

The Lost World of the Shtetl

Issachar Ryback (1897–1935) grew up in Elisavetgrad and received his formal education at the Kiev Art Institute. The pogroms in his hometown and other Ukrainian cities would have a profound affect on him. He tirelessly documented the vanishing life in the shtetl and copied scenes from old painted synagogues during an ethnographic expedition in 1917, which he subsequently published. His *Old Synagogue* actually depicts Dobrovna, near Mogilev, one of the shtetls where Jewish religion and culture had flourished for centuries, and a source of inspiration for artists and writers alike. The style of the painting betrays Ryback's contemporary approach to the traditional Jewish life he so cherished. Indeed, together with Marc Chagall and El Lissitzky, he brought modernism to Jewish art—first in Berlin where he moved in 1921, and later in Paris, where he lived from 1926 until his death. In a folio with thirty lithographs, he copied this painting to commemorate the shtetl, which was damaged beyond repair in the aftermath of the Russian Revolution. His illustrated Yiddish children's books and his designs for the Jewish Theater in Moscow earned him renown among a wide audience.

Documenting the Past

Even before their photographic documentation in the 1930s, Russian Jewish artists in search of a style at the beginning of the twentieth century were the first to systematically study these buildings and their decoration. In the wake of their ethnographic expeditions (led by S. Ansky), they even brought to light names of forgotten Jewish decorators such as Israel Lisnicki, who painted the ceilings of the Ukrainian synagogue of Chodorow in 1714 (a reconstruction is preserved in the Diaspora Museum in Tel Aviv); Eliezer Sussmann, who went to Unterlimpurg to paint the synagogue's interior in 1738–39 (now in a museum in Schwäbisch Hall); and Chaim Segal, the legendary ancestor of Marc Chagall

(born Moishe Segal), whose now lost, luxuriously decorated synagogue at Mogilev (1710) Lissitzky had discovered and documented.

Few synagogues in Eastern Europe have survived the vicissitudes of time: the pogroms of the Cossacks in the seventeenth century, countless wars, the systematic destruction by the Nazis, and the forced neglect during the Communist era before and after World War II. This applies to stone synagogues, those imposing fortress-like buildings providing refuge during times of persecution, but more so to wooden synagogues. These distinctive structures with their two- or three-tiered roofs could be found in the small towns and villages of Poland, Ukraine, Lithuania, and even in southern Germany. In contrast to their austere exterior, the interiors were often lavishly decorated with Hebrew texts, signs of the Zodiac, Jewish symbols, and at times entire illustrated biblical stories.

1897 Born in Elisavetgrad, Russia (now Kirovohrad, Ukraine)
1911–16 Studies at the Kiev Art Institute
1917 Member of the Kiev Jewish Kultur Lige
1919 Together with colleague Boris Aronson publishes a key essay about creating a Jewish style of art
1919 Moves to Moscow and teaches at the State Free Art Studios (GSKhM)
1921 Moves to Berlin; participates in avant-garde exhibitions of the November Group and the Secession
1923 Solo exhibition in Berlin; illustrates children's books
1925–26 Back in Russia, develops stage designs for Jewish theaters in Moscow and Kharkov
1926 Settles in Paris, where his work receives recognition
1935 Dies in Paris shortly before a large solo exhibition opens

LITERATURE
Ruth Apter-Gabriel, ed., *Tradition and Revolution: The Jewish Renaissance In Russian Avant-Garde Art, 1912–1928*, exh. cat. The Israel Museum (Jerusalem, 1987).
Susan Tumarkin Goodman, *Russian Jewish Artists in a Century of Change, 1890–1990*, exh. cat. The Jewish Museum (New York and Munich, 1995).

left page
Issachar Ryback, *Old Woman*,
1919/1921–24, oil on canvas,
160 x 105 cm, Bat Yam, Ryback Art
Museum

right
Issachar Ryback, *Berlin Woman*,
1919/1921–24, oil on canvas,
160 x 98 cm, Bat Yam, Ryback Art
Museum

1894 Dreyfus affair: French captain Alfred Dreyfus
wrongly accused of treason

1897 The First Zionist Conference held in Basel

1929–LATE 1930S
Great Depres

1881–84 Russian pogroms cause mass
emigration to the United States

1850 1855 1860 1865 1870 1875 1880 1885 1890 1895 1900 1905 1910 1915 1920 1925 1930 1935

Ben Shahn, *Sound in the Mulberry
Tree*, 1948, tempera on canvas,
mounted on panel, 122 x 91.5 cm,
Smith College Museum of Art,
Northampton, Massachusetts

1948 Declaration of Independence of the State of Israel, May 14

1945 Atom bomb dropped on Hiroshima and Nagasaki

1939–45 World War II **1967** Six-Day War between Israel and its
 neighboring states Egypt, Jordan, and Syria
1940 The Nazis establish ghettos in Eastern Europe

–44 Walker Evans and Dorothea Lange document the plight of
poor farmers for the Farm Security Administration (FSA)

| 1940 | 1945 | 1950 | 1955 | 1960 | 1965 | 1970 | 1975 | 1980 | 1985 | 1990 | 1995 | 2000 | 2005 | 2010 | 2015 | 2020 | 2025 |

BEN SHAHN

A fierce advocate for social justice throughout his life, Lithuanian-born and Brooklyn-bred Ben Shahn is best known as a photographer and muralist who documented the suffering and paid homage to the invaluable struggles of his fellow countrymen.

"A Passion for Justice"

Russian-born Ben Shahn (1898–1969) belongs to a group of Jewish painters and photographers who successfully integrated into the American art scene. Shahn was shaped by the immigrant experience, the labor struggle, and the Great Depression of the thirties and forties, during which he documented its effects on the rural population alongside photographers like Walker Evans and Dorothea Lange. Shahn adopted left-wing politics as his secular religion. His identification with social issues, his defense of minorities and the poor, and his abhorrence of injustice is a running theme throughout his body of social realist work.

Questions of Justice

Brought up Jewish, Shahn was familiar with the Bible and its emphasis on social justice, as well as Jewish history. When painting *The Passion of Sacco and Vanzetti* (1931–32), a work about the much-publicized conviction and execution of two anarchist workers, Shahn perceived parallels with the victimization of Alfred Dreyfus, an assimilated French Jewish army officer. During the thirties and forties, Shahn became increasingly aware of the danger of the United States' isolationism in the face of the emerging threat of anti-Semitism in Nazi Germany. His works testify to his familiarity with both the catastrophic fate of the Jews in the Nazi ghettos and the horrific death of civilians in Hiroshima. Having read the biblical prophets, Shahn was familiar with the tension in Judaism between universal concern for the needs of the world at large and the impulse to work for the particular needs of one's own community. The prophetic call to be "a light amongst the nations" had triggered Jewish involvement in such diverse universal nineteenth-century movements as liberalism, socialism, and communism. For most Jews, both reform and orthodox, and certainly for socialists like Shahn, Jewish nationalism in the form of Zionism was an anomaly. Yet, in the 1940s,

American Jews came to realize the catastrophic impact of the Nazi Holocaust in Europe—for most, their place of origin. The proclamation of the State of Israel in 1948 seemed an appropriate response to the acute need to find a home for the survivors.

Shahn must have felt a renewed sense of Jewish identity when he returned in that same year to the use of Hebrew letters when painting *Sound in the Mulberry Tree* (1948). On the stoop of a New York City tenement sits a boy blowing bubble gum, resembling both the emaciated children in the Warsaw ghetto and the poor children in New York's Greenwich Village that Shahn had photographed in the thirties. Next to the boy stands a girl reading a Hebrew text: "And when you hear the sound of marching in the tops of the mulberry trees, then go into action for the Lord will be going in front of you to attack the Philistine forces" (II Samuel 5:24). The final biblical victory of King David over the Philistines is thus connected to the War of Independence (Arab-Israeli War) of the newly founded Jewish state. Why does Shahn choose this obscure quote? Immediately following is the tale about the seemingly unjust death of Uzza for touching the Ark that David was planning to bring to Jerusalem, and for Shahn this incident serves as an example of inexplicable divine injustice.

Shahn employed the Hebrew alphabet primarily in prints and book illustrations. He never visited Israel however, or wrote about it in his many texts. Yet in his predominantly Jewish hometown of Roosevelt, New Jersey, he must have been aware of the heated debates between religious and socialist Jews about whether or not to support the state, about chauvinism and dual loyalty, and about the need for a homeland for both Jews and Palestinians. For Shahn, questions of justice remained of the utmost importance.

1898 Born on September 12 in Kovno, Russia (now Kaunas, Lithuania)
1906 Moves to New York
1913–17 Trains as a lithographer
1919–22 Studies biology
1922 Studies at the National Academy of Design, New York
1929 Becomes interested in photography after meeting photographer Walker Evans
1931–32 Works on *The Passion of Sacco and Vanzetti*
1932 Assists Diego Rivera paint murals at Rockefeller Center in New York
1954 Participates in the 28th Venice Biennale
1959 Participates in Documenta 2 in Kassel
1960 Retrospective exhibition at the MoMA, New York
1964 Participates in Documenta 3
1969 Dies on March 12 in New York

LITERATURE
Ziva Amishai-Maisels, "Ben Shahn and the Problem of Jewish Identity," *Jewish Art* 12–13 (1986–87), pp. 304–19.
Francis K. Pohl, *Ben Shahn* (San Francisco, 1993).
Deborah Martin Kao et al., *Ben Shahn's New York: The Photography of Modern Times*, exh. cat. Harvard University Art Museums, Cambridge, Mass. et al. (New Haven, 2000).

LOUISE NEVELSON ==============================

DIEGO RIVERA ==============================

PABLO PICASSO ==============================

1931 Whitney
Museum
American
is founde
New York

| | | | | | | | | | | | | | | | | | |
1850 1855 1860 1865 1870 1875 1880 1885 1890 1895 1900 1905 1910 1915 1920 1925 1930 1935

Louise Nevelson, *Homage to 6,000,000*
(I), 1964, black painted wood,
274 x 548.6 x 25.4 cm, present where-
abouts unknown. Courtesy The Pace
Gallery, New York

Meret Oppenheim, *Object*
(Breakfast in Fur)

1950 Jackson Pollock, *Number 32*

1943 Michael Curtiz,
Casablanca

1961 Construction of the Berlin Wall

1959 First happening by Allan Kaprow
in New York

1956 Saul Bellow wins the Nobel Prize for Literature

1977 Walter De Maria, *The Lightning Field*
near Quemada, New Mexico

1979 Israel-Egypt peace
agreement

1992–99 Daniel Libeskind,
Jewish Museum, Berlin

1990 Reunification of Germany

1940 1945 1950 1955 1960 1965 1970 1975 1980 1985 1990 1995 2000 2005 2010 2015 2020 2025

LOUISE NEVELSON

By assembling objects discarded by others, the Abstract Expressionist artist Louise Nevelson imbued found material with a new spiritual existence. Her typically black sculptural creations assumed a formidable presence.

The Realm of Shadows

Louise Nevelson, born Leah Berliawsky (1899–1988), emigrated as a young child with her parents from Pereiaslav near Kiev to Rockland, Maine in the United States, where she grew up. She traveled widely and discovered the arts in all its forms: painting in Munich, where her teacher Hans Hofmann introduced her to abstract art; mural painting in New York working with Diego Rivera; Maya art in Mexico; dance (she was a close friend of Martha Graham); theater; and music. All these elements were to influence her large and dramatic sculptural environments, which beginning in the 1950s brought her increasing international renown.

Material Remembering

Wood would become her primary material: found crates and discarded wood, bits and pieces, profiles and fragments, ornaments—each and every one carrying their own associations and meaning. Painted in a single color—pure white, sacral gold, or mysterious black—they become anonymous, their specific pedigree disappearing in further oblivion. Yet, though frozen, these mixtures of ornament and decay paradoxically seem to somehow come alive, regaining some of their individuality in the ensemble.

Many of her architectonic fantasies, particularly the ones in black, have a commemorative aspect and carry an association with a netherworld, the limbo between life and death. Her large pieces are especially effective in conquering the space in which they stand and manage to create a truly mysterious environment.

Homage to 6,000,000 (I) (1964) is one of her few works with a clear Jewish association. It impressively conveys this association with death and destruction. Without knowledge of its title or subject, the mere dimensions of this enormous room-filling black installation instill it with a magical aura, inviting the viewer into an enchanting yet threatening world. The austere and repetitive size of the crates seem to recall the mechanic massiveness of the destruction; the individual shapes seem to evoke people or parts of their plundered property. In the sculpture's presence, one is immersed in a realm of shadows, forced to reflect on the essence of life and death.

above
Photograph of Louise Nevelson

1899 Born on September 23 in Pereiaslav near Kiev, Russia (now Ukraine) into an Orthodox, Yiddish-speaking family

1905 Moves to Rockland, Maine; her name is anglicized to Louise

1920 Marries Charles Nevelson, of Latvian Jewish descent, a wealthy owner of a New York shipping company (separated in 1931)

1922 Studies at the Art Students League

1931 Studies in Munich with Hans Hofmann

1935 Group exhibition *Young Sculptors* at the Brooklyn Museum

1949–50 Trips to Mexico; becomes familiar with Maya totems

1959 First white environment, *Dawn's Wedding Feast*, included at the MoMA show in New York

1970–71 Wooden wall *The White Flame for the Six Million* at Temple Beth El, Great Neck, New York

1973 Exterior wall sculpture for Temple Israel, Boston

1977 Saint Peter's Lutheran Church in Manhattan commissions her to design the interior of their Chapel for the Good Shepherd

1988 Dies on April 17 in New York

LITERATURE
Brooke Kamin Rapaport, ed., *The Sculpture of Louise Nevelson: Constructing a Legend*, exh. cat. The Jewish Museum (New York and New Haven, 2007).

1939–45
W
W

| 1855 | 1860 | 1865 | 1870 | 1875 | 1880 | 1885 | 1890 | 1895 | 1900 | 1905 | 1910 | 1915 | 1920 | 1925 | 1930 | 1935 | 1940 |

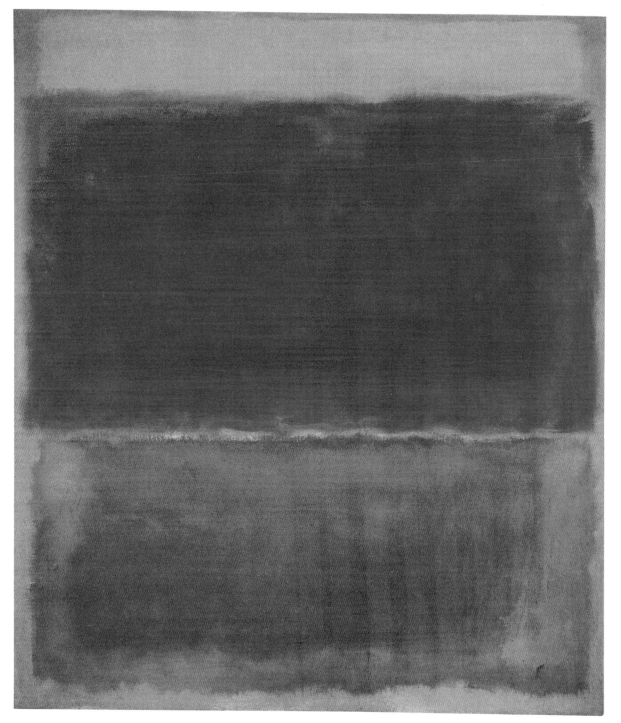

1945 1950 1955 1960 1965 1970 1975 1980 1985 1990 1995 2000 2005 2010 2015 2020 2025 2030

MARK ROTHKO

"The people who weep before my pictures are having the same religious experience I had when I painted them. And if you, as you say, are moved only by their color relationship, then you miss the point."

The Presence of the Divine

In 1948, Marc Rothko (born Marcus Rothkowitz, 1903–1970) began to create what he called "multiforms," works in which he increasingly abandoned themes that related to mythology and figures and gradually turned to the abstraction for which he would become famous. His works would carry only a number and the year of their origin. Rothko himself insisted that he was not an abstractionist, nor a great colorist. His interest was "only in expressing basic human emotions—tragedy, ecstasy, doom, and so on. And the fact that a lot of people break down and cry when confronted with my pictures shows that I can communicate those basic human emotions." For him, color was "merely an instrument."

Sacred Space

His comment on viewers breaking down in tears before his paintings may have convinced the Houston art collectors John and Dominique de Menil to commission Rothko to create what many rightly consider to be his most important artistic statement: several large paintings for the chapel these wealthy benefactors planned to donate to the Institute of Religion and Human Development at St. Thomas University in Houston. The couple had been duly impressed with his Harvard murals (1962) and the paintings intended for the Four Seasons restaurant in New York's Seagram Building (1958, never installed; nine of them are now at the Tate Modern, London).

Following Rothko's proposal, the architects Howard Barnstone and Eugene Aubrey realized an octagonal chapel, similar to Christian baptisteries, so as to completely envelop the visitor with his paintings, fourteen in total—three triptychs and five individual canvasses. As in his studio, the light was to come from above.

Their color is maroon and opaque black, more sumptuous and hermetic than any of his previous

work. Like the curtain separating the Holy of Holiest in the desert Tabernacle or the Jerusalem Temple from the rest of the sacred spaces, these mysteriously dark paintings form a truly "impenetrable fortress of color," creating a sense of awe and hinting to a divine presence, perhaps even to the invisible abstract God of Judaism.

In 1969, the de Menils acquired Barnett Newman's *Broken Obelisk* (1967), to be installed in the reflecting water of the pond in front of the chapel. Their gift was made in commemoration of the recently assassinated civil rights leader Martin Luther King, Jr. Reflecting the new spirit of openness initiated by the Vatican Council in 1965, the chapel, originally conceived as an exclusively Catholic space, was dedicated in truly ecumenical spirit, in the presence of Catholic, Protestant, Jewish, Muslim, Buddhist, and Greek Orthodox clergy. The ceremony took place in February 1971, a year after Rothko's tragic death by suicide and Newman's passing of a heart attack. What remains is one of the most important works of painting, sculpture, and architecture dedicated to religion in modernity— a true *Gesamtkunstwerk*.

1903 Born Marcus Rothkowitz on September 25 in Dvinsk, Russia (now Daugavpils, Latvia)
1913 Immigrates with his mother and sister to the U.S., joining his father and two brothers, who had immigrated in 1910, in Portland, Oregon
1921–23 Studies psychology and philosophy at Yale University, New Haven; leaves for New York
1925 Studies at the Arts Students League under Max Weber
1929 Teaches art to children at Brooklyn Jewish Center; becomes friends with Milton Avery and Barnett Newman
1938 Becomes an American citizen
1940 Changes his name to Mark Rothko
1945 Solo exhibition at Peggy Guggenheim's avant-garde gallery, New York
1958 Co-represents the U.S. at the 24th Venice Biennale
1961 Retrospective exhibition at the MoMA, New York, which later travels to London, Amsterdam, and other European venues
1970 Commits suicide on February 25 in his New York studio

LITERATURE
David Anfam, *Mark Rothko: The Works on Canvas; A Catalogue Raisonné of the Paintings* (New Haven, 1998).
Bonnie Clearwater, *The Rothko Book* (London, 2006).

left page
Mark Rothko, *Untitled*, 1960, oil on canvas, 235.9 x 205.7 cm, Adriana and Robert Mnuchin estate

above
Photograph of Mark Rothko

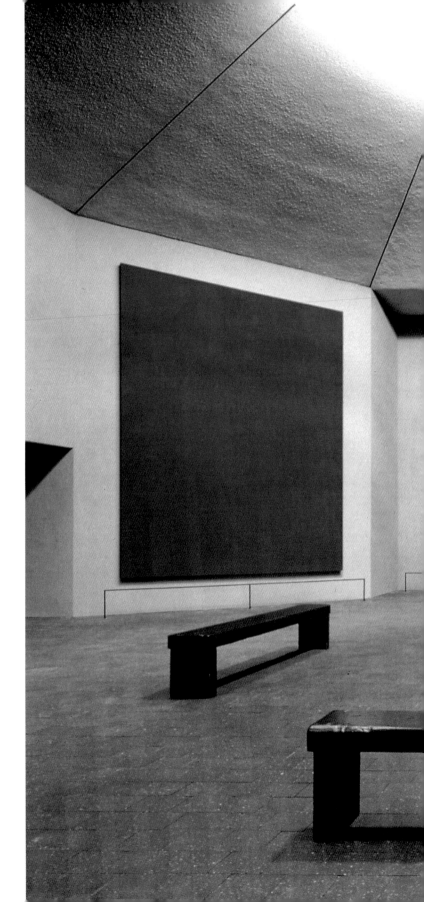

Mark Rothko, Rothko Chapel,
Ecumenical Chapel, Houston,
1965–67, opening 1971

1911 Ernest Rutherford develops
his model of the atom

1927 Charles Lindbergh flies nons
from New York to Paris

1905 Publication of the
anti-Semitic pamphlet
*Protocols of the Elders
of Zion*

1930 Luis Bunuel, *L'Age d'O*

1919 Bauhaus is founded
in Weimar, Germany

1935 Nuremberg
laws depri
of their civ

| 1855 | 1860 | 1865 | 1870 | 1875 | 1880 | 1885 | 1890 | 1895 | 1900 | 1905 | 1910 | 1915 | 1920 | 1925 | 1930 | 1935 | 1940 |

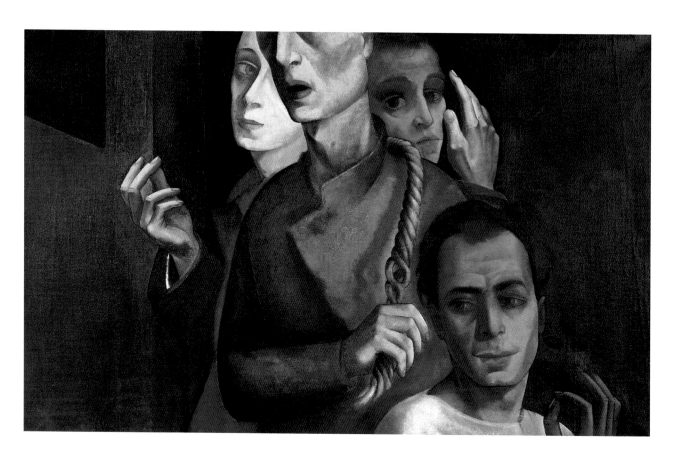

Felix Nussbaum, *Self-Portrait in Death
Shroud (Group Portrait)*, 1942, oil on
canvas, 51 x 80.5 cm, Berlinische Galerie,
Berlin

45 World War II

942–44 Nazis murder six million European
Jews in extermination camps

1945 Liberation of Auschwitz concentration camp

1992–99 Daniel Libeskind,
Jewish Museum, Berlin

| 1945 | 1950 | 1955 | 1960 | 1965 | 1970 | 1975 | 1980 | 1985 | 1990 | 1995 | 2000 | 2005 | 2010 | 2015 | 2020 | 2025 | 2030 |

FELIX NUSSBAUM

With a pictorial language often recalling Giorgio de Chirico and James Ensor, German surrealist painter Felix Nussbaum's melancholic mood and macabre subjects characterize most of his artwork, and not without good reason.

Even before he was killed in Auschwitz, Felix Nussbaum (1904–1944) had looked death in the face. A number of events brought harbingers of a darker future: after he moved to Berlin, anti-Semites vandalized the synagogue and cemetery of his hometown Osnabrück; and in 1932, while in Rome studying at the German Academy, his Berlin studio caught fire. Returning to Germany became impossible after the Nazi's rise to power in 1933: Hitler had been appointed chancellor, Jewish businesses were boycotted (including his family's ironware business), and book burnings staged. Nussbaum and his Polish-born, Jewish partner Felka Platek (they married in 1937), also an artist, decided to go to Belgium: first to Ostend and later to Brussels on renewable visas for resident aliens. Upon the German invasion of Belgium in May 1940, Nussbaum was arrested and deported to St. Cyprien, an internment camp in southern France. He managed to escape and return to Brussels where he and his wife would live in hiding. Tragically, Felix Nussbaum and his wife were betrayed and taken to the Belgian transition camp Mechelen. In the last transport they were deported to Auschwitz and killed upon arrival on August 2, 1944.

Illustrating Despair

Nussbaum's oeuvre is a direct reflection of his personal life and an illustration of the uncertainties of exile and flight, of exclusion and loneliness, and ultimately of death and destruction. Nussbaum often reflected on his fate in self-portraits, in which he expressed a wide range of moods. In his *Self-Portrait in Death Shroud* (1942), Nussbaum, set slightly apart from three more abstracted figures, is looking away despairingly, dressed in a shroud, with a fatal rope behind his head and a broken-off branch of leaves in his hand. The faces and hand gestures behind him reflect, in turn: an introverted, mute acquiescence; a blinded cry of despair before the rope is fitted around the neck; and sadness of the

person raising his hand in accusation. Nussbaum is trapped with his conflicting moods in a reddish-brown room, the only window offering a pitch-black view of an inaccessible world outside.

From then on, all previous intimations of doom paled in comparison with the horrors he was to experience in his final years. Astutely aware of the destructive powers of war and concerned about his own fate and that of his wife and relatives (trapped in German-occupied Holland), fear and anxiety became a palpable reality for Nussbaum, culminating in the creation of apocalyptic works in the months before his arrest in June 1944.

Felix Nussbaum and Felka Platek shared the fate of numerous Jewish artists, both young and old, from all over Nazi-occupied Europe, who were caught in exile or at home, and perished during the Holocaust. Hardly any other painter expressed his prescience of those horrors so strongly and consistently as Nussbaum did in the years preceding his death.

1904 Born on December 11 in Osnabrück, Germany, the son of a Jewish entrepreneur

1923 Moves to Berlin where he takes art lessons

1932 Moves to Rome with his future wife Felka Platek on a grant from the German Academy; later that year, his Berlin studio is set on fire

1933 Unable to return to Germany after the Nazis take power, they travel to Belgium, living in Ostend and later Brussels

1940 Upon the German occupation of Belgium, he is arrested and interned in the St. Cyprien camp in France; escapes back to Brussels; is registered as a Jew

1943 They go into hiding in Brussels

1944 They are deported on July 31 from the transition camp Mechelen to Auschwitz, where Felix and Felka are murdered on August 2

1970s Almost 200 works are restituted to relatives and ultimately acquired by the city of Osnabrück

1998 Opening of the Felix Nussbaum House, a museum designed by architect Daniel Libeskind

LITERATURE
Emily D. Bilski, *Art and Exile: Felix Nussbaum, 1904–1944*, exh. cat. The Jewish Museum (New York, 1985). Karl Georg Kaster, *Felix Nussbaum: Art Defamed, Art in Exile, Art in Resistance*, exh. cat. Kulturgeschichtliches Museum Osnabrück (Bramsche and Woodstock, 1997).

Photograph of Felix Nussbaum

BARNETT NEWMAN ══

MARK ROTHKO ══

WILLEM DE KOONING ═══

1919–33 Prohibition in the U.S.

1941 Japa
atta
Pea
Har

1911 Wassily Kandinsky, *Impression III*

1855	1860	1865	1870	1875	1880	1885	1890	1895	1900	1905	1910	1915	1920	1925	1930	1935	1940		

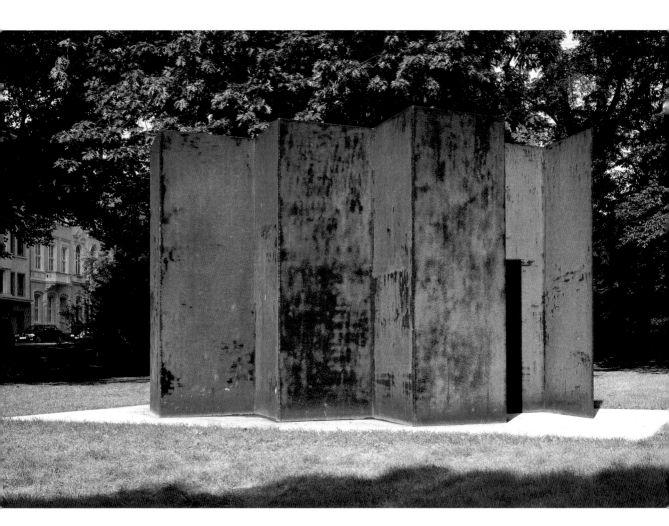

Barnett Newman, *Zim Zum II*, 1985,
Cor-ten steel, 361 x 520 x 250 cm,
Kunstsammlung Nordrhein-Westfalen,
Düsseldorf

1950 Korean War begins
Jackson Pollock, *Number 32*
1965–75 Vietnam War
1968 Stanley Kubrick, *2001: A Space Odyssey*
1947 India gains independence from Britain
1960 Clement Greenberg, *Modernist Painting*
1957 Albert Camus awarded Nobel Prize for Literature
1973 First oil crisis

1945 1950 1955 1960 1965 1970 1975 1980 1985 1990 1995 2000 2005 2010 2015 2020 2025 2030

BARNETT NEWMAN

"What is the raison d'être, what is the explanation of the seemingly insane drive of man to be painter and poet if it is not an act of defiance against man's fall and an assertion that he return to the Adam of the Garden of Eden? For the artists are the first men."—Barnett Newman, 1947

Throughout his career, the now celebrated New York Abstract Expressionist artist Barnett Newman (1905–1970) used titles such as *Onement*, *The Name*, and *Zim Zum*, which all refer to Jewish (mystical) tradition. Newman, though not himself religious, attended Hebrew school and was raised in the Jewish tradition by his parents, immigrants from Russian Poland.

Next to one of the five versions of *Onement* he created between 1948 and 1953, he once wrote "Atonement," a play on words but also a reference to the most solemn day of the Jewish calendar, the Day of Atonement, Yom Kippur, on which each Jew atones for his sins and tries to become at one with himself and with the one God. Atonement/at-onement marks the beginning of a new year, inaugurated and celebrated ten days earlier, and the start of a new creative process for each individual.

The Abstract God
In his painting with the title *The Name I* (1949), Newman may very well mean the four letter Hebrew name of God, "YHWH," which is commonly referred to as *ha-Shem* ("the Name"), and is not pronounced by Jews save once a year, on Yom Kippur, by the high priest in the Jerusalem Temple. When reading the painting from right to left as in Hebrew, the four zips (as Newman called the vertical lines) correspond to the four letters: a pencil-thin zip on the right stands for the tiny letter *yod*; followed by a wider zip, the broad *he*; a narrow zip corresponds to the stick-like form of the *waw*; and the fourth zip on the left is the same as the second, also a *he*. Newman's painting with these four vertical lines is as abstract as the Jewish God.

Jewish monotheism prides itself on being abstract. The abstract nature of God led to a logical and conceptual problem for rabbis: If God is completely abstract, how can he be engaged in creation? To this question, Jewish mysticism gives an answer. According to sixteenth-century Kabbalah, the world

and humanity are not the result of a positive creative act by God as described in the book of Genesis, but a negative step of withdrawal (*zimzum*), in which the infinite God broke his wholeness to make room for a descending order of ten divine spheres. The sixth of them, a male aspect, created the world, whereas the tenth, its female counterpart, accompanies mankind in it and enables man to ascend again to higher levels. This ongoing human creative process is called *tikkun*, literally meaning the completion of an unfinished world and repair (of the original unity of God). Every human being tries to repair and complete the world through his or her creative acts. This concept again became popular in the Jewish world during the last decades.

For Newman, the way an artist works parallels God's creative process, as two sculptures with the title *Zim Zum II* (1985) demonstrate, as well as his *Model for a Synagogue* in which he wrote a Hebrew quotation from Isaiah and the word *zimzum* next to zigzagging windows. Newman was familiar with the Kabbalistic notion of *zimzum* (withdrawal, contraction), which became widely popular through Eastern European Hasidism.

In this context it doesn't come as a surprise that Newman used titles referring to both creation myths and origins from Greek mythology (*Euclid and Prometheus*), the Hebrew Bible (*Day before One*, *Genesis*, *The Word*, *The Command*, *Covenant*, *Adam*, and *Eve*), and the New Testament (*Stations of the Cross*).

1905 Born Barnett "Baruch" Newman on January 29 to parents who emigrated to New York from Lomza, Russian Poland (now Poland); learns Hebrew

1923–27 Studies philosophy and art at City College New York

1931 Shares studio with Adolf Gottlieb; meets Rothko and Milton Avery

1934 Meets his later wife Annalee Greenhouse, born 1909 in Palestine to Russian parents

1945 Learns that most of his relatives in Lomza were killed by the Nazis

1950 First solo exhibition at Betty Parsons Gallery in New York

1959 The Kunstmuseum Basel acquires *Day before One* and New York's MoMA *Abraham*

1963 Contributes a *Model for a Synagogue* to the exhibition *Recent American Synagogue Architecture*, organized by Richard Meier for the Jewish Museum, New York

1966 First solo museum exhibition at the Solomon R. Guggenheim Museum, New York; *The Stations of the Cross: Lema Sabachtani*

1967 Co-signs an advertisement in support of Israel

1970 With Thomas B. Hess, he begins to plan a large retrospective exhibition; publicly solidarity with Soviet Jews

1970 Dies on July 4 in New York

LITERATURE
Richard Shiff et al., *Barnett Newman: A Catalogue Raisonné* (New York, 2004).

Photograph of Barnett Newman

1909 Tel Aviv founded

1929 Wall Street crash in New York

1914–19 World War I

1860 1865 1870 1875 1880 1885 1890 1895 1900 1905 1910 1915 1920 1925 1930 1935 1940 1945

Lee Krasner, *Composition*, 1949, oil
on canvas, 96.5 x 71.1 cm,
Philadelphia Museum of Art,
Philadelphia. Gift of
the Aaron E. Norman Fund

Discovery of the Dead Sea
Scrolls near Qumran

1961 Construction of
the Berlin Wall

1980 Ronald Reagan elected
U.S. President

1952 Elvis Presley rises to fame

1972 Munich massacre (attack on Israeli
team at the Olympic Games)

1994 Yitzhak Rabin, Shimon Peres, and Yasser Arafat
win the Nobel Peace Prize

1960 The Beatles are founded

1950 1955 1960 1965 1970 1975 1980 1985 1990 1995 2000 2005 2010 2015 2020 2025 2030 2035

LEE KRASNER

Lee Krasner was more than simply the wife of the most famous Abstract Expressionist. She was a magnificently gifted painter whose critical eye helped forge one of the twentieth century's most important artistic revolutions.

"I am never free of the past. I believe in continuity. The past is part of the present."

Lee Krasner (1908–1984) was for a long time referred to as Mrs. Pollock. She and Jackson Pollock (1912–1956) formed the most famous artist couple in New York. But this slight illustrates the problem she faced: her work was underappreciated for being that of a woman and, after 1945, the wife of the most famous representative of Abstract Expressionism. Just like Elaine de Kooning (née Fried) and Sophie Taeuber-Arp, Lee Krasner challenged traditional ideas about the role of the female. And she had no problem making reference to her Jewish background.

Lee Krasner, who had studied with the inspiring painter and theorist Hans Hofmann, regularly exhibited in New York as part of a group of painters the critics coined Abstract Expressionists, roughly divided into "action painters" like Pollock and "color field painters" like Clyfford Still. This first genuine American artistic movement ironically consisted of many European immigrants, including Arshile Gorky, Willem De Kooning, Mark Rothko, Barnett Newman, and Lee Krasner. Quite a few of them were also Jewish.

Secret Signs

Between 1946 and 1950 Krasner created her first important abstract paintings, which she herself called hieroglyphs, geometrically patterned works with small scribbles. In *Composition* (1949), she combines her personal, painterly handwriting with allusions to ancient indecipherable sign systems. Language played an important role in her life: she grew up in a household where Russian, Yiddish, and, of course, English were spoken. Krasner, always interested in calligraphy, revealed that she usually started her canvases in the upper right corner, like the Hebrew she learned to write as a child.

The fact that her mysterious signs resemble somehow archaic looking languages, like wedge-shaped cuneiform letters, may not be a coincidence. The discovery of the Ras Shamra tables in 1930—with text very similar to, but predating, the biblical Psalms—created as much enthusiasm as the Dead Sea Scrolls did in 1947, when these biblical texts, one thousand years older than the oldest known manuscript, were unearthed.

After years of American isolationism, interspersed with anti-Jewish sentiments, and the catastrophe of the Holocaust, even unaffiliated Jews like Krasner were deeply impressed by the numerous examples of Jewish continuity: its language, its alphabet, its texts, and the resurrection of its nationhood. She was as moved by Jewish continuity as she was part of American artistic modernity, in which she is finally recognized as being, in her own right, one of the most important representatives of Abstract Expressionism.

1908 Born Lena Krassner on October 27 in Brooklyn, New York, the daughter of Russian Jewish immigrants from the shtetl Shpikov (Szpykiv, now Ukraine)
1921–32 Studies art at Washington Irving High School, the Women's Art School of The Cooper Union, the Art Students League, and the National Academy of Design
1934–43 Employed by the Public Works of Art Project (PWAP)
1936 Meets the painter Jackson Pollock (1912–1956); married in 1945
1937 Studies with Hans Hofmann
1939 Joins the American Abstract Artists (AAA) group, precursor of the New York School of Abstract Expressionist artists, which would include Pollock, Willem de Kooning, Helen Frankenthaler, Newman, Rothko, and Nevelson
1941 Participates in the fifth annual exhibition of the AAA
1955 First solo exhibition at Stable Gallery, New York
1965 First retrospective at Whitechapel Gallery, London
1973 First solo show at Whitney Museum, New York
1984 The Houston Museum of Fine Arts organizes a retrospective, shown at the MoMA after her death on June 19 in New York

LITERATURE
Ellen G. Landau and Jeffrey D. Grove, *Lee Krasner: A Catalogue Raisonné* (New York, 1995).

Lee Krasner, two weeks after Jackson Pollock's death, August 30, 1956

Lee Krasner, *Blue and Black*, 1951–53,
oil on canvas, 146.6 x 209.5 cm,
Museum of Fine Arts, Houston

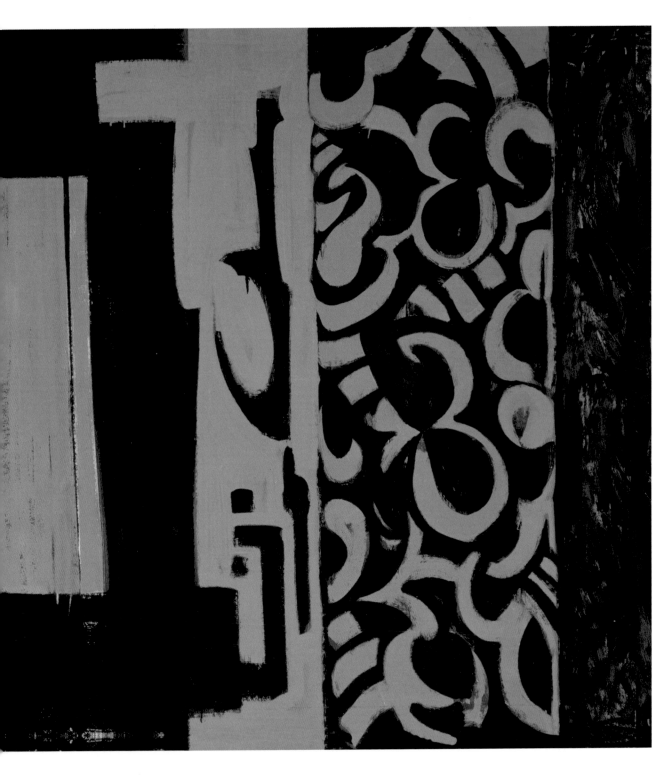

MORRIS LOUIS

MARK ROTHKO

LEE KRASNER

1911 Wassily Kandinsky, *Impression III*

1933 Nazi book burnings

1915 Kazimir Malevich, *From Cubism and Futurism to Suprematism*

1939–45 World War II

1937 Picasso's *Guernica*

1860 1865 1870 1875 1880 1885 1890 1895 1900 1905 1910 1915 1920 1925 1930 1935 1940 1945

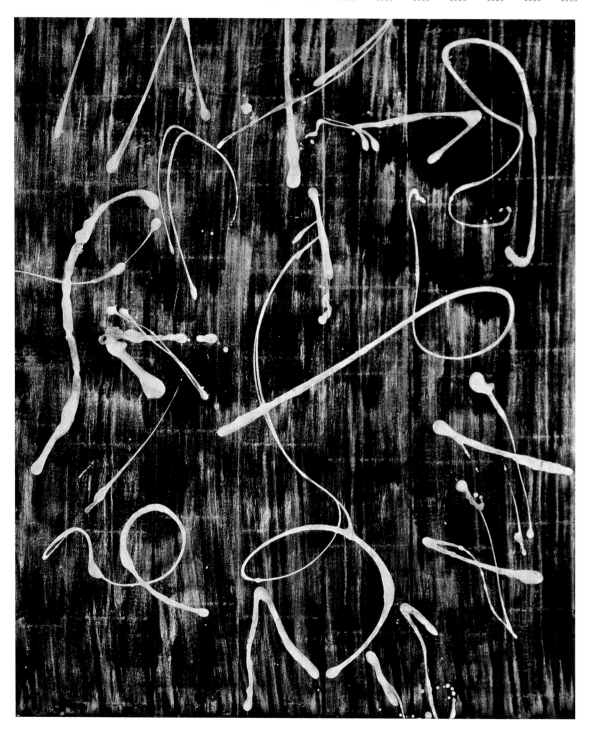

The term "Abstract Expressionism" is
applied to American art by Robert Coates
 1953 Foundation of Yad Vashem, Jerusalem, to commemorate Holocaust victims
 1961 John F. Kennedy becomes U.S. president
1950 Abolition of racial
 segregation in the U.S. **1965–75** Vietnam War

1950 1955 1960 1965 1970 1975 1980 1985 1990 1995 2000 2005 2010 2015 2020 2025 2030 2035

MORRIS LOUIS

Known principally as one of the earlier exponents of color-field painting and his concern for pictorial space and the flatness of the picture plane, Morris Louis had moved away from the realism with which it became increasingly difficult to reflect the horrors of the twentieth century.

Morris Louis (1912–1962) studied at the Maryland Institute of Fine Arts in Baltimore from 1929 to 1933 and lived in New York from 1936 until 1940, when he returned to his birthplace, Baltimore. In New York he became acquainted with Arshile Gorky, and dropped his family name Bernstein. He is primarily associated with the abstract color-field style for which he would become famous. The earlier series of black canvases titled *Charred Journal* (1951), with its white symbols and scribbles vaguely resembling ancient script, strongly contrast with his later, colorful canvases. Though largely ignored in later exhibitions, Louis included this series in his first solo show in Washington in 1953. He explained the absence of color by citing *Guernica* (1937), Picasso's protest to the destruction of the city of that name and whose shock and force lies in the black, gray, and white tones.

Flying Letters

In both the title and in the use of black pigments, in the more abstract work *Charred Journal* Louis evokes the burning of books and ultimately of the Jews in the European crematoria, about which Americans were by then fully informed. In this work as well as in related paintings and drawings of the same period, a six-pointed Star of David and agitated swirls seem to be escaping from the pages of a book or the columns of a Torah scroll.

The series represents a break for Louis from his earlier social realist style in favor of an abstraction deemed the only appropriate medium to express the haunting, unrepresentable reality of the Holocaust. Like many artists of his generation, he felt something completely new had to be created in response to the enormity of war and human destruction. Hardly religious in the common sense, Louis attended High Holy Day services and was proud of his Jewish heritage. As such, he was surely familiar with such liberal and Jewish values as the sanctity of

life and the equality of all human beings created in the divine image.

His *Charred Journal* recalls the legendary story of the martyrdom of Rabbi Hananyah ben Teradyon, commonly read during Yom Kippur service, a scene which is sculpted on the menorah (installed in 1956) in front of the Israeli parliament. As part of a group of pupils of Rabbi Akiva, Hananyah defied the decrees of the Roman emperor Hadrian, and continued to teach Judaism in public. He was arrested and burned at the stake, wrapped in a Torah scroll. Surrounded by flames, he told his pupils what he saw: "I see the parchment burning, but the letters are flying to heaven."

Louis's letters and signs rising from the *Charred Journal* symbolize defiance and the will to survive in even the darkest of times. The barely recognizable yet imperishable Hebrew letters can be read as an allusion to the Phoenix-like rise of the decimated Jewish people in the independent state of Israel. Yet, the mostly unintelligible script largely avoids any such ethnic specificity, in accordance with the optimism of so many people for a new era—artistically and in the world at large.

1912 Born Morris Louis Bernstein on November 28 into a middle-class Jewish family in Baltimore
1929–33 Studies at Maryland Institute of Fine and Applied Arts; leaves before completing the program
1936–40 Lives in New York and works for the Federal Art Project
1938 Officially changes his name by dropping Bernstein
1940 Returns to Baltimore
1947 Marries Marcella Siegel
1951 *Charred Journal* series in which he treats the subject of the Nazi book burnings.
1952 Moves to Washington, D.C.; becomes one of the earliest representatives of color-field painting—a response to Abstract Expressionism/New York School
1953 First solo show at the Workshop Art Center, Washington, D.C.
1955–57 Destroys many of his works
1962 Dies of lung cancer on September 7 in Washington, D.C.
2007–8 Major retrospective exhibition *Morris Louis Now: An American Master Revisited* in San Diego, Atlanta, and Washington, D.C.

LITERATURE
Diane Upright, *Morris Louis: The Complete Paintings* (New York, 1985). Mira Goldfarb Berkowitz, "Sacred Symbols in Morris Louis: The Charred Journal Series, 1951," in *Complex Identities: Jewish Consciousness and Modern Art*, ed. Matthew Baigell and Milly Heyd (New Brunswick and London, 2001), pp. 193–205.

left page
Morris Louis. *Charred Journal: Firewritten A*, 1951, acrylic on canvas, 91.4 x 76.3 cm, Louisiana Museum of Modern Art, Humlebaek, Denmark

above
Photograph of Morris Louis

1917 October Revolution in Russia

1938 Pogrom Night in Germany

1900 Freud publishes *The Interpretation of Dreams*

1933 Hitler and the Nazis come
to power in Germany

1893 Edvard Munch, *The Scream*

1925–26 Walter Gropius, Bauhaus, Dessau

1921 Arnold Schoenberg invents twelve-tone music

1865 1870 1875 1880 1885 1890 1895 1900 1905 1910 1915 1920 1925 1930 1935 1940 1945 1950

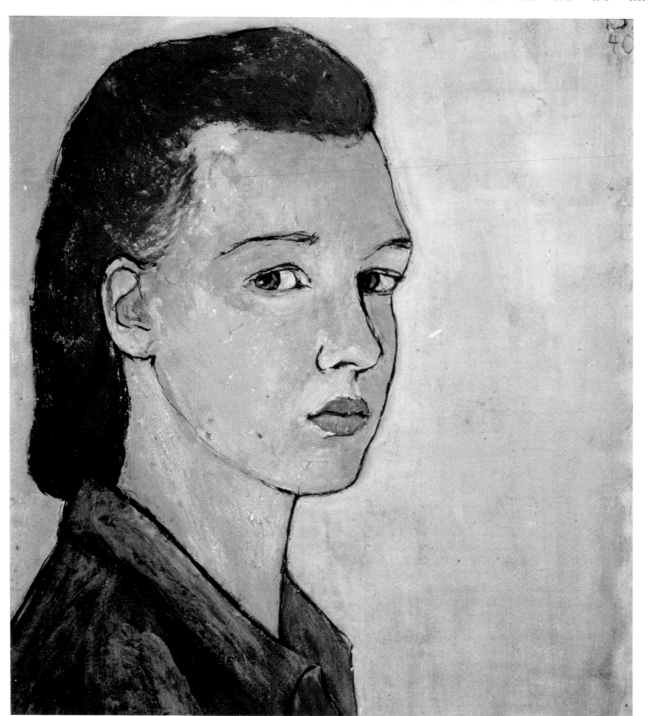

−44 Nazis murder six million European
Jews in extermination camps
49 Israel becomes a member of the United Nations
1952 Show trials against Jews in Soviet Union

1955	1960	1965	1970	1975	1980	1985	1990	1995	2000	2005	2010	2015	2020	2025	2030	2035	2040	

CHARLOTTE SALOMON

Charlotte Salomon produced a truly singular body of work, a story of a life in the middle of twentieth-century Europe that, like so many, would be cut tragically short. In an unparalleled stretch of productivity, she left a testament and a lingering question: "What if?"

"Life? Or Theatre?"

In January 1939, Charlotte Salomon (1917–1943), a not yet twenty-two-year-old woman, left her ancestral home, Berlin, the city she was born and raised in, and her fatherland, Germany. The repercussions of Hitler's rise to power became increasingly evident: the boycott of Jewish stores and professionals (her father Albert was a doctor), the exclusion of Jews from cultural life (her stepmother Paulinka was a lieder singer), and the labeling of art created by Jews as degenerate (Charlotte had to leave the art academy). After the Kristallnacht of November 9–10, 1938, when Jewish property was plundered and synagogues burnt, the family decided to send Charlotte, their only child, to safety in the south of France. All she carried was a small suitcase and a record with Bizet's *Carmen* sung by Paulinka, enough for "a weekend visit" to her maternal grandparents' home, who had fled the country four years earlier. Her father and stepmother accompanied Charlotte to the railway station along with her friend and muse, the music teacher Alfred Wolfsohn (nicknamed "Daberlohn"), to send her off.

Discriminatory laws and later the threat of annihilation in the thirties and early forties would force hundreds of thousands of Jews and non-Jewish artists, intellectuals, and political dissidents in Germany and Nazi-occupied Europe into exile. Success depended, amongst others factors, upon being granted asylum elsewhere and on obtaining an exit visa: most countries kept their borders virtually closed and Germany levied prohibitory taxes and confiscated property.

Creative Despair

With the exception of documentary photographs of the children's transports organized by Jewish relief organizations to save Jewish youth from Nazi Germany, very few if any representations of departure scenes exist in contemporary art. Yet departure is a recurring Jewish experience that began with the divine call to Abraham in Mesopotamia to leave (in an ascending order of difficulty, as the rabbis point out) his country, his place of birth, and his father's house—lines which appear in Hebrew in the painting *Jew in Red* of that other refugee artist, Marc Chagall.

While in France, Charlotte's grandmother, depressed by the outbreak of the war, committed suicide, prompting her grandfather to reveal a family secret: suicide ran in the family and her mother, whom Charlotte had been told died of influenza, also took her own life. Charlotte felt compelled to do "something really extravagantly crazy." In a cathartic outburst of creative energy over a period of eighteen months she painted her life story: *Life? Or Theatre?*, consisting of 1,325 gouaches and transparencies, 769 numbered, and all of the same size. This work, later handed over to her parents who had survived in Holland, is a unique personal testimony in images accompanied by text and music. Its full power and artistic authenticity bring to mind her contemporaries Edvard Munch, Max Beckmann, and Else Lasker-Schüler, and seems to anticipate modern artists such as Markus Lüpertz, Jörg Immendorff, and William Kentridge. We will never know in what direction she would have developed artistically, because Charlotte Salomon—recently married—was betrayed, arrested, and, together with her husband, deported to Auschwitz, where she was murdered in 1943, five months pregnant.

1917 Born on April 16 in Berlin
1930 Her father remarries Paula Lindberg
1933 Charlotte leaves art school and takes private art lessons; her grandparents immigrate to southern France
1939 Charlotte is sent to Villefranche-sur-Mer; her father and stepmother flee to Amsterdam
1940 Interned in Gurs camp with her grandfather, but released; starts working on *Life, or Theatre?*
1943 Her grandfather dies; Charlotte marries Alexander Nagler on June 17 in Nice; a few months later they are betrayed, arrested, and, via the Drancy internment camp, deported on October 7 to Auschwitz, where Charlotte was killed upon arrival
1947 Albert and Paula Salomon, who survived in hiding, travel to Villefranche-sur-Mer and receive *Life, or Theatre?* and her *Self-Portrait*
1970 Albert and Paula Salomon donate Charlotte's work to the Jewish Historical Museum, Amsterdam

LITERATURE
Judith Belinfante et al., *Charlotte Salomon: Life? or Theater?* (Zwolle and Amsterdam, 1998).
Michael P. Steinberg and Monica Bohm-Duchen, eds., *Reading Charlotte Salomon* (Ithaca, NY, 2006).

left page
Charlotte Salomon, *Self-Portrait*, 1940, gouache on cardboard, 39 × 34.4, Charlotte Salomon Foundation, Joods Historisch Museum, Amsterdam

above
Photograph of Charlotte Salomon

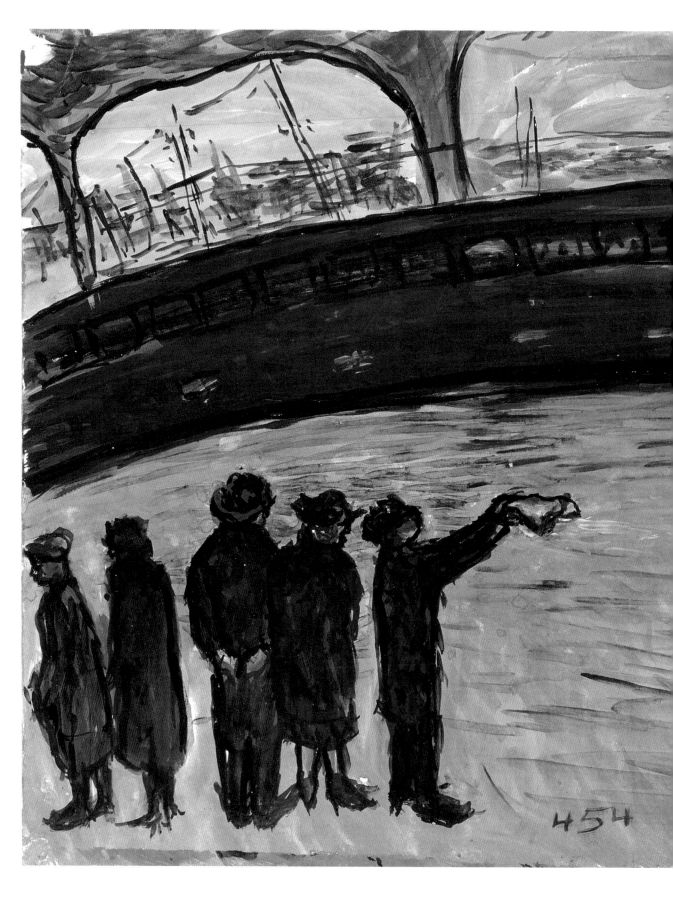

Charlotte Salomon, *Life? Or Theatre?*,
1940–42, gouache on paper, 32.5 x 25 cm,
Charlotte Salomon Foundation, Joods
Historisch Museum, Amsterdam

1914 Marcel Duchamp's first readymade,
Bottle Rack

1945 Beginning of Cold War

1875	1880	1885	1890	1895	1900	1905	1910	1915	1920	1925	1930	1935	1940	1945	1950	1955	1960

Larry Rivers, *History of Matzah:
The Story of the Jews Part II* (detail) 1984,
acrylic on canvas, 295.3 x 457.2 cm,
Yale University Art Gallery. Gift of Jeffrey
H. Loria, B.A. 1962, in memory of Harriet
Loria Popowitz

1968 Student revolts
1980 John Lennon shot
 Ronald Reagan elected U.S. President
2001 Terrorist attacks on World
 Trade Center (9/11)
61 Construction of the Berlin Wall
The Beatles are founded
1962 Andy Warhol, *Campbell's Soup Cans*
1991–92 First Gulf War
1989 Fall of the Berlin Wall

1965 1970 1975 1980 1985 1990 1995 2000 2005 2010 2015 2020 2025 2030 2035 2040 2045 2050

LARRY RIVERS

An artist, musician, and filmmaker, Larry Rivers, one of America's most important postwar artists and considered by many to be the "Godfather of Pop Art," pioneered the pairing of non-narrative art with narrative abstraction.

A Breakable Image of Jewish History

Larry Rivers (1923–2002) was born Yitzroch Loiza (Irving) Grossberg in New York. He began a career as a jazz saxophonist before taking up painting in 1945. Considered the Godfather of Pop Art, he was one of the first artists to focus realistically on everyday objects of American popular culture.

As with previous historical cycles such as *The History of the Russian Revolution* (1965), in *The History of Matzah: The Story of the Jews* (1982–84) Rivers employed a variety of visual quotations in his history of matzah—Egyptian hieroglyphs, Rembrandt's *Moses*, Michelangelo's *David*, Leonardo's *Last Supper*, depictions of rural Polish synagogues, and a painting by Gottlieb all serve to illustrate his three-part visual history of the Jews. *Matzah* uses a chronological story line, and easily accessible historical accounts by Chaim Potok (*Wanderings*), Irving Howe (*World of our Fathers*), and Nathan Ausubel's *Pictorial History of the Jewish People* served as principal sources for the artist.

The triptych is held together by the color and texture of the matzah, symbol of physical and spiritual liberation throughout the ages. The first panel, *Before the Diaspora*, relates the story of the Jews up to the destruction of the Temple and early Christianity. Beginning with a towering Moses (Rivers' cousin) in an Egyptian milieu, through David, the Maccabean victory culminating in the miracle of Chanukah in the second century BCE, and the destruction of Masada in 73 CE, the panel concludes with the last supper of Jesus interpreted as a Passover meal with matzoth. The second panel, *European Jewry*, deals with the European Diaspora beginning with the Assyrian exile in the ninth century BCE and Titus carrying to Rome the seven-branched Temple candelabrum removed from the razed Jerusalem in 70 CE. Granada symbolizes the *convivencia* of Jews, Christians, and Muslims in Spain, while details from manuscripts and yellow badges on dresses illustrate the vicissitudes of

medieval life leading to the expulsion from the Iberian Peninsula in 1492 and the attack on Frankfurt's ghetto in 1614. A representation of Spinoza—expelled from the Dutch Jewish community in 1656 and prefiguring modern individual thought—is juxtaposed with images of pogroms and persecutors; and the panel ends with Theodor Herzl's Zionist solution. The third canvas, *Immigration to America*, covers America, with the Statue of Liberty as a uniting symbol for Russian Jewish immigrants and Jews fleeing Nazi Europe, illustrating the famous lines by American Jewish author Emma Lazarus: "Give me your tired, your poor, / Your huddled masses yearning to breath free."

Matzah, the brittle unleavened bread that accompanied the Jews in their deliverance from Egypt, is the principal symbolic food during the celebration of Passover. Surrounded by stories, songs, and food, the Jews commemorate the constitutive event in biblical history and dedicate time to discuss related episodes in the story of the Jewish people. Children ask, "Why does this night differ from all other nights?" One might say that Passover—in an almost playful manner—develops the Jewish consciousness of history. The bondage in Egypt serves as a trigger for historical and contemporary comparisons and culminates in fundamental discussions about the essence of slavery—physical or spiritual. This celebration of history by association prevailed for thousands of years, as festivals served as the primary vehicles of Jewish memory.

1923 Born Yitzhok Loiza Grossberg on August 17 in Bronx, New York, to Russian Jewish parents; changes his name to Larry Rivers in 1940
1940–45 Works as a jazz saxophonist
1945–46 Studies at the Juilliard School of Music, New York, alongside Miles Davis, with whom he would become friends
1947–48 Studies with Hans Hofmann
EARLY 1960S Lives in the Chelsea Hotel, a famous hotel with artists such as Bob Dylan, Janis Joplin, Leonard Cohen, and the circle around Andy Warhol's Factory.
1965 First comprehensive solo exhibition in five American museums; *The History of the Russian Revolution* was included
1968 Travels to Africa with Pierre Dominique Gaisseau to finish their documentary, *Africa and I*
1970S Works on video projects, including *Tits*; works in neon
1982–84 *The History of Matzah*
2002 Dies on August 14 in New York; major retrospective in Washington, D.C.

LITERATURE
Norman Kleeblatt, with Anita Friedman, *Larry Rivers' History of Matzah: The Story of the Jews*, exh. cat. The Jewish Museum (New York, 1984). Barbara Rose and Jacqueline Days Serwer, *Larry Rivers: Art and the Artist*, exh. cat. Corcoran Gallery of Art (Washington, D.C., 2002).

Larry Rivers, 1978

Larry Rivers, *History of Matzah:*
The Story of the Jews Part I–III, 1984,
acrylic on canvas, 295.3 x 457.2 cm each,
Yale University Art Gallery. Gift of Jeffrey
H. Loria, B.A. 1962, in memory of Harriet
Loria Popowitz

NANCY SPERO

EVA HESSE

PIPILOTTI RIST

1935 Nuremberg racial laws deprive
Jews of their civil rights

1955–68 Civil rig
movement
the U.S.

1920 19th Amendment to the U.S. Constitution prohibits any
U.S. citizen to be denied the right to vote based on sex

1949 Simone de Beauvoir,
The Second Sex

1875 1880 1885 1890 1895 1900 1905 1910 1915 1920 1925 1930 1935 1940 1945 1950 1955 1960

ballade von der „judenhure"
marie sanders

in nürnberg machten sie ein gesetz
darüber weinte manches weib, das
mit dem falschen mann im bett lag

„das fleisch schlägt auf in den vorstädten
die trommeln schlagen mit macht
gott im himmel, wenn sie etwas vorhätten
wäre es heute nacht."

marie sanders, dein geliebter
hat zu schwarzes haar.
besser, du bist heute zu ihm nicht mehr

wie du zu ihm gestern warst.

„das fleisch schlägt auf in den vorstädten
die trommeln schlagen mit macht
gott im himmel, wenn sie etwas vorhätten
wäre es heute nacht."

mutter, gib mir den schlüssel
es ist alles halb so schlimm.
der mond sieht aus wie immer.

„das fleisch schlägt auf in den vorstädten
die trommeln schlagen mit macht
gott im himmel, wenn sie etwas vorhätten
wäre es heute nacht."

eines morgens, früh um neun uhr
fuhr sie durch die stadt
im hemd, um den hals ein schild, das haar
geschoren

blickte kalt.

„das fleisch schlägt auf in den vorstädten
der streicher spricht heute nacht.
grosser gott, wenn wir ein ohr hätten
wüssten wir, was man mit uns macht."

bertolt brecht 1934-36

NANCY SPERO

In a career lasting over fifty years as both an artist and activist, Nancy Spero focused relentlessly on contemporary political and social issues. Eschewing the current of Abstract Expressionism, Spero narrated simple stories to explore universal themes.

"The drumming's now at its height"

The art of Nancy Spero (1926–2009) is political and feminist; her art deals with mythological and martyred women, heroines and victims, sexuality and vulnerability. She has written women into history unlike anyone else. Her concerns are universal, but in her later works she also she took interest in those human victims of the Nazis who were Jewish or had consorted with Jews.

The Ballad of Marie Sanders, the Jew's Whore (Brecht) was, beginning in 1990, the theme of several impressive installations. They were all based on a disturbing 1935 poem by Bertolt Brecht recounting the brutal story of humiliation of a non-Jewish woman who had slept with a Jew—an act forbidden under the Nuremberg racial laws of that year. After earlier installations at Smith College Museum of Art, Northampton, Massachusetts (1990) and the Von der Heydt Museum in Wuppertal, Germany (1991), she created The Ballad of Marie Sanders/Voices: Jewish Women in Time for the Jewish Museum in New York (1993), which included photographs of victimized women in the Warsaw Ghetto, concentration camps, and other Nazi-related atrocities, along with women in positions of power, such as female Israeli soldiers and female Israeli and Palestinian peace activists.

Inhabiting History

In The Ballad of Marie Sanders, the Jew's Whore III (Brecht) (1998) for the Hellerau Festival Hall near Dresden she created a truly impressive site-specific installation. This modernist building of 1911, desolate and deserted, carried the traces of two totalitarian systems: of the Nazis who in 1936 turned it into a police academy, and the Soviets who converted it into a military hospital in 1945. Here, amid frescoes of past heroes, remains of old furniture, peeling plaster, and old wallpaper, Spero's stamped images and the poem of Brecht, quoted in its original German, functioned as an act of recuperation, or, as one of her assistants remarked, "It was as if the

figures and symbols had always been there, as if we had simply uncovered them." The image of a naked and chained woman, which Spero used in previous installations, took on a new and more intense meaning in this particular building. The installation was an outcry against Nazi sexual sadism, a powerful tribute to Marie Sanders surrounded by Spero's favorite heroines: the awe-inspiring Medusa of Greek mythology, and Lilith, her Jewish equivalent; the sea monster Scylla; and female athletes—a memorial to all women humiliated, both past and present.

In other works, Spero commemorated the atrocities against the Jews in Warsaw Ghetto (1997), and paid homage to an unknown seventeen-year-old partisan woman, Masha Bruskina (1993), who under the guise of being a gentile, helped wounded Soviet soldiers escape. She refused to name the other members of her Communist resistance group and was the first woman to be executed by the Nazis in Soviet Russia in 1941; her hanging was meticulously documented by the Nazis. Only many years later was she discovered to have been a Jewish girl from the ghetto of Minsk—a fact still denied by anti-Semites in Belarus.

1926 Born on August 24 in Cleveland, Ohio, to American parents; grows up in Chicago
1945–49 Studies at the School of the Art Institute of Chicago
1949–50 Studies in Paris at the École des Beaux-Arts
1950 Returns to Chicago
1951 Marries the painter Leon Golub (1922–2004)
1956–57 Lives in Italy with her family
1959–64 Lives with her family in Paris, where she has her first solo exhibition at Galerie Breteau
1964 Moves to New York
1966–70 In response to the Vietnam War and the civil rights movement, she becomes a political activist and a feminist, works on her War Series, which includes Victims, Holocaust
1972 Founding member of Artists in Residence (AIR), the first women's cooperative gallery
1978 Traveling retrospective exhibitions in the U.S. and UK
1988 Develops her first large-scale wall installations, often using stamps rather than paint
1997 Participates in Documenta 10 in Kassel
2009 Dies on October 18 in New York

LITERATURE
Jon Bird et al., Nancy Spero (London, 1996).
Dirk Luckow and Ingeborg Kähler, eds., Nancy Spero: A Continuous Present (Düsseldorf, 2002).

left page
Nancy Spero, The Ballad of Marie Sanders, the Jew's Whore III (Brecht), 1998, wall painting installation, Festspielhaus Hellerau, Dresden

above
Nancy Spero in her LaGuardia Place studio, New York, 1999

1939–45 World War II

1938 Pogrom Night in Germany

1960 Clement Greenberg *Modernist Painting*

1880 1885 1890 1895 1900 1905 1910 1915 1920 1925 1930 1935 1940 1945 1950 1955 1960 1965

1990 Reunification of Germany

1983 Discovery of the HIV virus **2003** Human genome decoded

1969 Woodstock festival

1973 Watergate scandal **1986** *Challenger* space shuttle disaster

1988 *Freeze*, exhibition of Young
British Artists in London

1970 1975 1980 1985 1990 1995 2000 2005 2010 2015 2020 2025 2030 2035 2040 2045 2050 2055

SOL LEWITT

A pioneer of both Conceptual and Minimalist Art, Sol LeWitt's geometric forms for spaces ranging from intimate galleries to large public squares might appear simple, but they are imbued with monumental significance. His site-specific sculptures relate meaningfully and profoundly with their surroundings.

Minimal Form and Maximal Meaning

Since the 1960s, Minimalist artists have concentrated on geometric forms and primary colors, more inclined towards an abstract concept and the visual impact of their work than a concrete narrative. Yet, sometimes the rather detached primary structures of Minimal and Conceptual artist Sol LeWitt (1928–2007) are the carriers of a very specific, even political meaning. In a few related projects, LeWitt refers to his Jewish background.

The *White Pyramid* and *Black Form (Dedicated to the Missing Jews)*, commissioned by the Westphalian Museum in Münster for its 1987 Sculpture Projects exhibition was a deliberately political work, both in its title and locale. The *White Pyramid* was situated in the castle garden, forming a visual relation to the *Black Form* located in the castle's court. The *Black Form* was installed at the place where until World War II an equestrian statue in honor of German emperor William I had stood. In both sculptures, LeWitt uses his characteristic geometrical and architectonic shapes and his customary color, white—interestingly LeWitt used black for the first time since 1966. With the additional "Dedicated to the Missing Jews," LeWitt occupied this monumental spot with an explicit reference to the emptiness and silence left behind after the extinction of Münster's Jews during the Shoah; also, as he explained in a letter, to all those unborn and the lack of Jewish life in today's German society. The black sculpture is a clear allusion to death, with its shape reminding one of an enlarged sarcophagus; white is traditionally associated with purity and innocence. The shape of the *White Pyramid* seems a deliberate association with the pharaonic funerary monuments—symbolizing the connection between earth and heaven—that enabled the kings to enter the divine realm, while its specific form, the succession of receding stories, reminds one of the ziggurat, the dwelling place of the ancient Mesopotamian and Persian gods. Thus, the sculptures *White Pyramid*

and *Black Form* symbolize and express both death and elation.

The project was ill-fated. The dedicatory inscription and *Black Form* itself were vandalized so regularly the city saw itself forced to remove the installation after a few months in early 1988; *White Pyramid* ceded way to the University's botanical garden. Yet both survived, in Hamburg and in Chester, respectively. In Hamburg, the *Black Form*, slightly enlarged, stands in front of the town hall of Hamburg-Altona, and now serves as a Memorial to the Missing Jews of Altona, who trace their illustrious history from the seventeenth century until the community's annihilation by the Nazis. The bricked surface no longer refers to a sarcophagus as it did in Münster, but to an inaccessible building, a house in which Jews no longer reside. Dedicated on the fifty-first anniversary of the pogrom night in November 1989, this solid black block, isolated in front of the government building, evades in its abstraction any heroic personification or personified heroism. Yet, without its dedication, it would simply be another Minimalist sculpture.

The shape of the *White Pyramid*, with its more religious associations, Sol LeWitt reuses in his proposal for the Beth Shalom Rodfe Zedek synagogue in Chester, Connecticut (dedicated 2001), which he designed in close collaboration with architect Stephen Lloyd. Its dome with wooden roof beams is architecturally inspired by Eastern European wooden synagogues. LeWitt himself was a member of the congregation.

1928 Born Solomon LeWitt on September 9 in Hartford, Connecticut to a family of Jewish immigrants from Russia
1945–49 Studies at Syracuse University, New York
1950 Travels throughout Europe to study the Old Masters
1953 Moves to New York to study at the Cartoonist and Illustrators School (The School of Visual Arts); sets up a studio on Hester Street on the Lower East Side, in the Jewish area
1955 Works for architect I. M. Pei as a graphic designer; discovers the work of late-19th-century photographer Eadweard Muybridge, who studied sequence and locomotion
1960s Uses modular form of the square in arrangements
1968 Conceives guidelines for his two-dimensional works drawn directly on the wall
1970 First retrospective exhibition, at the Gemeentemuseum, The Hague.
1978 Fifteen-year retrospective at the MoMA, New York
1980 Leaves New York for Spoleto, Italy
1980s Expands his vocabulary with geometric forms
LATE 1980S Returns to New York
2002 Retrospective organized by the San Francisco Museum of Modern Art, travels to New York and Chicago
2007 Dies on April 8 in New York

LITERATURE
Gary Garrels, ed., *Sol LeWitt: A Retrospective*, exh. cat. San Francisco Museum of Modern Art (New Haven and London, 2000).
Susan Cross and Denise Markonish, eds., *Sol LeWitt: 100 Views*, exh. cat. Massachusetts Museum of Contemporary Art (North Adams, Mass. and New Haven, 2009).

Sol LeWitt, *White Pyramid*, Münster, Germany, 1987, white painted concrete block, 510 x 510 x 510 cm, Westfälisches Landesmuseum für Kunst und Kulturgeschichte, Münster

DANI KARAVAN

WALTER BENJAMIN

DANIEL LIBESKIND

1931 Salvador Dalí, *The Persistence of Memory*
1953 Foundation of Yad Vashem, Jerusalem, to commemora Holocaust victims

1935 Walter Benjamin, *Passages*

1940 German occupation of France

1880 1885 1890 1895 1900 1905 1910 1915 1920 1925 1930 1935 1940 1945 1950 1955 1960 1965

1978 Isaac Bashevis Singer wins the Nobel Prize for Literature
1979 Israel-Egypt peace agreement
Six-Day War between Israel and its
neighboring states Egypt, Jordan, and Syria
2005 Peter Eisenman, Memorial to the
Murdered Jews of Europe in Berlin
1973 Yom Kippur War **1982** Lebanon War

1970 1975 1980 1985 1990 1995 2000 2005 2010 2015 2020 2025 2030 2035 2040 2045 2050 2055

DANI KARAVAN

By channeling existing elements, Dani Karavan thoughtfully intervenes in sites already infused with meaning to produce truly monumental works of art. His intervention on the French-Spanish border is a tribute to one of Europe's first truly modern thinkers.

The Israeli sculptor and environmental artist Dani Karavan (b. 1930) is famous for his site-specific environments in which he uses various materials and media, including sand, stone, sound and light, water and wind. He is recognized both in Israel and internationally; twice he has participated in the Documenta in Kassel, and he has twice represented Israel at the Venice Biennale.

Passages

In Portbou, a small village at the steep foothills where the Pyrenees extend into the sea on the French-Spanish border, Karavan created one of Europe's most impressive *lieux de mémoire*. It was here that numerous refugees, escaping Nazi persecution, attempted to cross the border to safety. In a truly dramatic landscape, the artist created a monumental environment in memory of Walter Benjamin (Berlin, 1892), at the place where, on September 27, 1940, this celebrated German Jewish philosopher, critic, and pioneer of new ideas committed suicide out of fear of being handed over to the Gestapo (German secret police). Aware of impending catastrophe, Benjamin had immigrated to Paris in 1933, and after the German occupation of France he tried to escape to the United States via Spain, which reluctantly granted transit visas to Jews. The monument documents his final abortive journey across the mountains from Banyuls sur Mer in France to Portbou in Spain.

Karavan's *Passages—Homage to Walter Benjamin* (1989–94) is a large-scale, site-specific environmental sculpture consisting of several separate parts. The work integrates the sound of the nearby border railway station that indirectly evokes the cattle cars on their way to the concentration camps; the roaring waves of the sea below, the sky above, the old olive tree fighting for life, and the fence of the old cemetery all become loaded with meaning. A square metal platform with a seat overlooks the cemetery where the remains of Benjamin lie

buried, pointing towards the mountains, the sea, the sky, freedom.

The largest section is an underground stairway made out of thick, 2.35-meter-high steel plates cut into the slope. Eighty-seven steps project steeply downward towards the sea; more than two-thirds down, a transparent glass wall prevents further descent. Engraved on the glass is a quotation: "It is more difficult to honor the memory of the nameless than of the renowned. Historical construction is devoted to the memory of the nameless." This leitmotif for the monument comes from *Passages* (1935), the famous but unfinished fragmental text by Benjamin in praise of the Parisian arcades as models for the exuberant and sensuous attractions of modernity. Karavan's installation concentrates on hope and despair, and is as much a discourse with Benjamin as it is part of an ongoing discourse about memory.

The memorial honors all those intellectuals and artists, the famous and anonymous, who because of their birth or politics had to leave Nazi-occupied countries. Many were killed, others took their fate in their own hands or survived in exile often under great privation, but none were ever thanked for upholding the German humanistic tradition, nor were the survivors ever invited back to their homelands. Instead, they were forgotten for decades. Thanks to this memorial in Portbou, these often nameless exiles have at long last received a truly breathtaking monument.

1930 Born on December 7 in Tel Aviv
1945–49 Studies art in Tel Aviv and at the Bezalel Academy of Arts and Design in Jerusalem with Marcel Janco and Mordecai Ardon
1960–73 Designs stage sets in Israel, New York, and Florence
1963–68 Creates the Negev Brigade monument in Beersheba
1965 Wall relief for the assembly hall of the Knesset
1972 Holocaust monument at the Weizmann Institute, Rehovot
1976 Represents Israel at the 37th Venice Biennale
1977 Participates in Documenta 6 in Kassel
1986 *Ma'alot* (Steps), sculpture for Museum Ludwig, Cologne
1987 Participates in Documenta 8
1990–94 *Passages—Homage to Walter Benjamin*, Portbou, Spain
1991 Participates in the first Venice Architecture Biennale
1993 Way of Human Rights, Nuremberg
2000 *Bereshit* (Genesis), Kirishima Art Forest, Japan
2005 *Mizrach*, memorial for the Regensburg synagogue, Germany
2008 Retrospective in Berlin
2010 Retrospective in Tel Aviv

LITERATURE
Ingrid Scheurmann and Konrad Scheurmann, eds., *Dani Karavan: Homage to Walter Benjamin* (Mainz, 1995).
Mordechai Omer, ed., *Dani Karavan: Retrospective*, exh. cat. Tel Aviv Museum of Art (Tel Aviv, 2010).

left page
Dani Karavan, *Passages—Homage to Walter Benjamin*, 1990–94, whirlpool, wind, rocks, stones, cypress tree, olive tree, Cor-ten steel, fence, glass, text, Portbou, Spain

above
Photograph of Dani Karavan

1922 German foreign minister
Walther Rathenau assassinated

1958 Truman Capot
Breakfast at Tif

1939–45 World War II

1880 1885 1890 1895 1900 1905 1910 1915 1920 1925 1930 1935 1940 1945 1950 1955 1960 1965

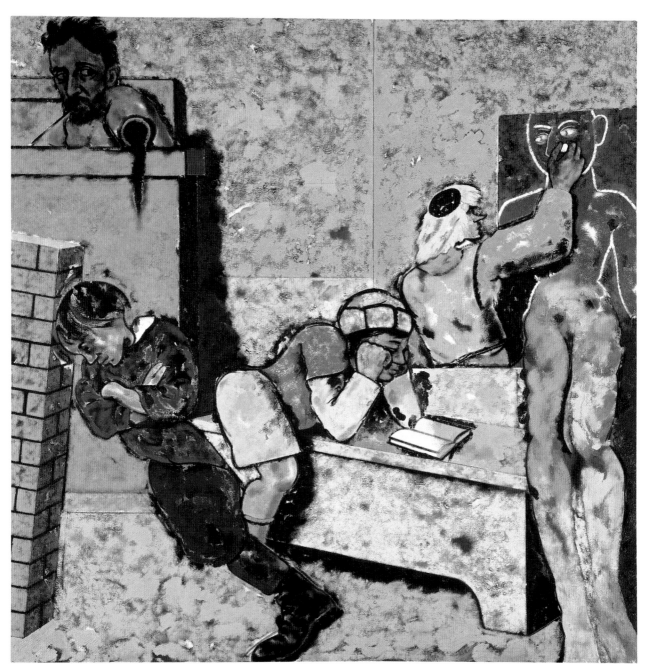

R.B. Kitaj, *The Jewish School (Drawing
a Golem)*, 1980, oil on canvas,
152.4 x 152.4 cm, private collection.
Courtesy Marlborough Fine Art, London

1973 First oil crisis **1982** Michael Jackson, *Thriller*

Beginning of the **1980** Ronald Reagan elected **2004** Tsunami catastrophe in Asia
Vietnam War U.S. President
1969 Woodstock festival **1991–92** First Gulf War

| 1970 | 1975 | 1980 | 1985 | 1990 | 1995 | 2000 | 2005 | 2010 | 2015 | 2020 | 2025 | 2030 | 2035 | 2040 | 2045 | 2050 | 2055 |

R. B. KITAJ

The American-British figurative artist R. B. Kitaj felt connected to "the painters of the great schools of Paris, New York and London, half of whom were not born in their host-countries—a Diaspora of Yiddish and doomed café freedoms which ended in transition camps and the eastern railheads."

Ronald Brooks Kitaj (1932–2007) took the family name of his stepfather Walter Kitaj, a Holocaust refugee from Vienna, whom his mother Jeanne Brooks, of Russian Jewish descent, had married in 1941. After traveling and studying art, primarily in Vienna, he moved to Great Britain in 1957, where he formed, with Francis Bacon and Lucian Freud, part of the London art establishment.

Kitaj is a self-proclaimed Diaspora artist, his Jewishness tied to the image of a European survivor (like his stepfather). Yet, on the other hand, he is a "rooted" American/British Jew, where Jewish means "being different"—both an insider outside and an outsider inside. Kitaj shares the "guilt" of postwar Anglo-Saxon Jews, "surviving" without ever being in danger. He places himself between the nostalgic Russian Jewish world of the "only real Jewish artist" Chagall (and his maternal grandparents) and the acculturated world of his stepfather (a Viennese chemist).

The Jewish School (Drawing a Golem), dated 1980, is far removed from any traditional center of Jewish learning: the teacher has lost all control over the boys as ink spills over one of them. The boy in the middle is in his own world; the boy on the right draws a figure on the blackboard. Yet the scene is not as innocent as it looks: Kitaj gives a particularly Jewish response to European art and provides a commentary on its hostile imagery. As he explains, his composition is based on an nineteenth-century anti-Semitic caricature he found in a 1974 book showing a school classroom in which one of the boys draws a bearded Jew kneeling behind a pig. This so-called Judensau (Jew's sow) was a recurring image in Germany from the Middle Ages. Sculptures and prints depicted Jews suckling a sow's teats, riding upon it, or eating its excrement. As a folk song, "Judensau" was chanted by anti-Semites at Germany's Jewish Foreign Minister Walther Rathenau before he was assassinated in 1922.

The Golem

Kitaj responds to this visual abuse of Jews by having the boy draw a golem instead of the *Judensau*. The golem refers to an ancient legend: the renowned scholar and mystic Rabbi Yehudah Loew created an artificial man out of clay, animated by the divine name, to protect Jews from sixteenth-century Prague falsely accused of using the blood of Christian children for baking matzot (the oft-mentioned "blood libel"). The golem succeeded, but took his orders so literally he became an uncontrollable danger, proving so difficult to "program" Rabbi Loeb had to erase from his forehead the first letter of the Hebrew word *emet* (truth), then reading *met* (death). According to legend, the golem's remains are still hidden in the attic of the Old-New Synagogue in Prague.

The story of an out-of-control monster threatening humans became a recurring theme in modern novels (including Frankenstein) and film. The legend can be understood as a survival myth, a dream of having power for oppressed Jews, at the mercy of whimsical rulers or violent mobs. The creation of an artificial being is the touchstone of human creative power, and it was this theme that attracted Kitaj. His golem is drawn on the blackboard by the "emancipated" child (the artist), but is unfinished and comes too late—blood is already flowing. One child tries to escape by running toward a wall, but the teacher is unable to prevent the ink (blood) from spilling over him. The middle boy represents Jewish learning, which will survive even if the boy does not. Kitaj is aware that no classroom, no image, is innocent after Auschwitz.

1932 Born on October 29 in Cleveland
1957–61 Studies art in Oxford, and at the Royal College of Art, London
1963 First solo exhibition at Marlborough Fine Arts, London
1965 Exhibition at Los Angels County Museum of Art
1976 Finishes *If Not, Not*, in which the concentration camp Buchenwald figures
1985 Finishes *The Jewish Rider*
1989 *First Diasporist Manifesto*
1991 Member of the Royal Academy of Arts, London
1994 Retrospective at the Tate London, later shown at the Metropolitan Museum of Art, NY, and the Los Angeles County Museum
1997 Returns to the United States
2007 Dies on October 21 in Los Angeles

LITERATURE
Emily D. Bilski, *Golem! Danger, Deliverance, and Art*, exh. cat. The Jewish Museum (New York, 1988). Viviane Barsky, "'Home is where the heart is': Jewish Themes in the Art of R.B. Kitaj," in *Art and its Uses: The Visual Image and Modern Jewish Society*, Studies in Contemporary Jewry 6, ed. Ezra Mendelsohn (New York, 1990), pp. 149–85. Richard Morphet, *R. B. Kitaj: A Retrospective*, exh. cat. Tate Gallery (London, 1994).

R. B. Kitaj in his studio

right page
R.B. Kitaj, *Drancy*, 1984–85, charcoal,
crayon, pastel on paper, 100.3 x 78 cm,
Musée d'art et d'histoire du Judaïsme,
Paris

below
R.B. Kitaj, *The Jewish Rider*, 1984–85,
oil on canvas, 152.4 x 152.4 cm, Astrup
Fearnley Collection, Oslo

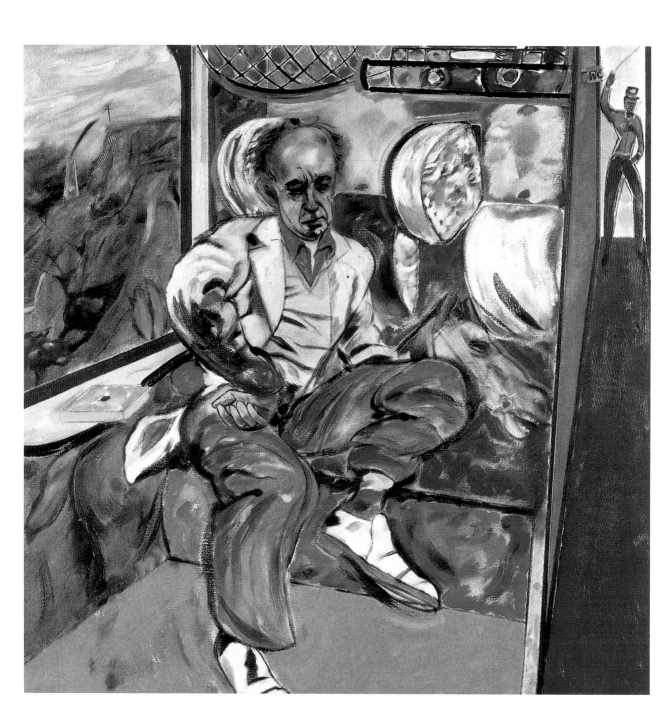

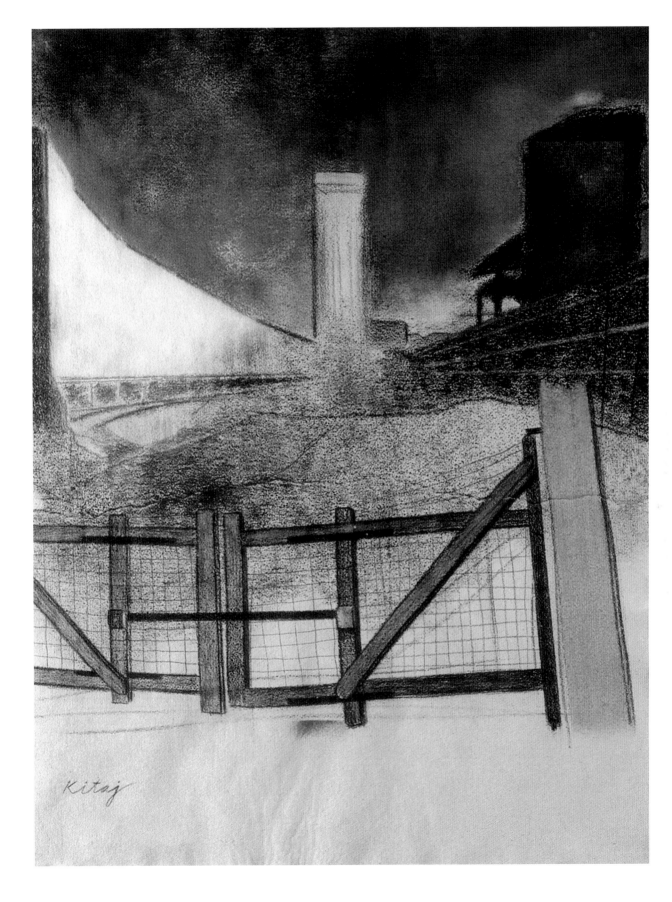

MENASHE KADISHMAN

DANIEL LIBESKIND

RICHARD SERRA

1945 Beginning of Cold War

1932 Aldous Huxley, *Brave New World*

| 1880 | 1885 | 1890 | 1895 | 1900 | 1905 | 1910 | 1915 | 1920 | 1925 | 1930 | 1935 | 1940 | 1945 | 1950 | 1955 | 1960 | 1965 |

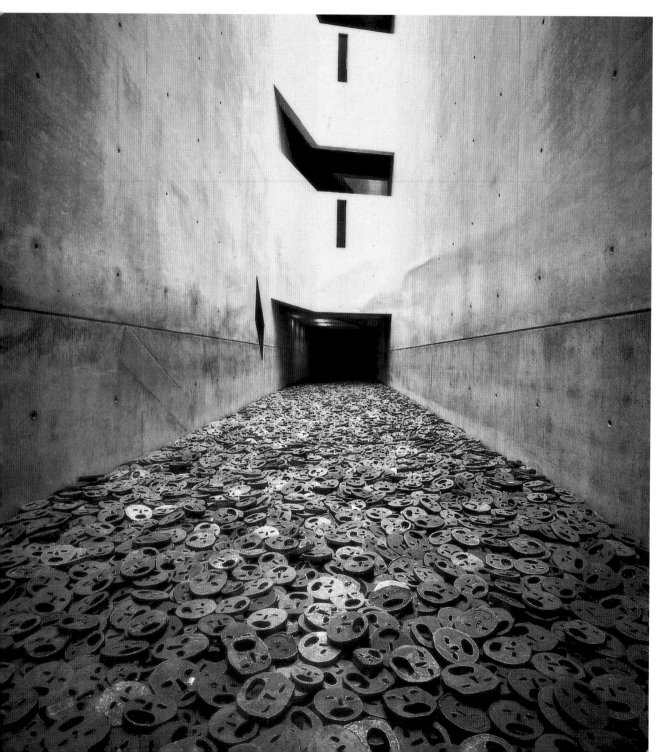

1992–99 Daniel Libeskind, Jewish Museum, Berlin

1975 End of Vietnam War 1995 Christo and Jeanne-Claude wrap the Reichstag, Berlin

1968 Student revolts 1982 Lebanon War 2005 Peter Eisenman, Memorial to the
 Murdered Jews of Europe in Berlin
 1986 Chernobyl disaster 2001 Terrorist attacks on World Trade Center (9/11)

| 1970 | 1975 | 1980 | 1985 | 1990 | 1995 | 2000 | 2005 | 2010 | 2015 | 2020 | 2025 | 2030 | 2035 | 2040 | 2045 | 2050 | 2055 |

MENASHE KADISHMAN

Born and raised in the shadow of twentieth-century history, Menashe Kadishman, Israel's most renowned modern sculptor, combines his life experience with a historical consciousness and knowledge of art to produce works of universal meaning.

Tel Aviv-born sculptor Menashe Kadishman (b. 1932) received his artistic training in his hometown, and lived for a while as a shepherd on a kibbutz, a collective settlement. He studied and lived in London before returning to Israel in 1972 to become its most celebrated modern sculptor, acclaimed both at home and abroad. His work looks more innocent than it is; his recurring themes, painted and sculpted sheep and the sacrifice of Isaac refer to personal experiences: when he was drafted to fight in the 1956 Sinai War as a soldier, as a modern Isaac, and, later, when his own son was drafted into the Lebanon War as a new Abraham. He became aware of sacrifice and victimhood, of the atrocities of war.

Valley of Sadness
It is no surprise he would turn to the horrors of the systematic, technological mass destruction of six million Jews in Europe. No eyewitness report, no photo, no documentary film, no art or poetry can ever do justice in conveying these horrors; at best, one can hope to approximate the atrocity. With this limitation in mind, the inclusion of Kadishman's installation *Fallen Leaves* (1997–99) in one of the voids of Daniel Libeskind's Jewish Museum in Berlin (1989–2001) was an enlightened decision, reinforcing the visitor's nearly visceral, chilling experience of death and destruction in one of the deliberately empty spaces of the building. The space is covered by thousands of intentionally schematic oval head shapes, about half the size of an adult face: nose, staring eyes, and open mouth. Cut from steel, they are heavy and yet look incredibly vulnerable.

Although a sign invites visitors to enter the space and walk over the installation, most hesitate to tread over the faces. When one finally does, the passive observer feels he becomes an active culprit, the squeaking metal transformed into screaming faces. The silence is broken and a dialogue commences between the living and the dead. When passing over the installation, each visitor becomes

a witness to the awful death of a human victim of the Holocaust. With each step the visitor begins to discern what seem to be individual faces, each with a personal voice, whispering or screaming in immeasurable suffering.

However successful it is in transmitting to the visitor the horror of genocide, Kadishman's installation contains a spark of hope—the title *Fallen Leaves* refers to the natural cycle of autumn and winter, followed by the rejuvenated green of spring. The dead belong to the past, as much as they are part of the present, forcing us to become either silent voices from the hereafter or screaming forces for a more humane world.

Commemorating the Holocaust in Germany
Remembering the Holocaust in the land of its perpetrators has been notoriously difficult, and the debates surrounding it have been universally scrutinized. Germany has gradually come to terms with its "unmanaged past," writing, debating, and observing the extermination of its own Jews and those from neighboring countries. This now occupies a central and strategic place in the German conscience—whether, since 1996, Holocaust Memorial Day commemorated on January 27, marking the liberation of Auschwitz by the Soviet army in 1945; or Peter Eisenman's Memorial to the Murdered Jews of Europe (2005), centrally located near Brandenburg Gate in Berlin.

1932 Born on August 21 in Tel Aviv
1947–50 Studies sculpture at the Avni Institute of Art and Design in Tel Aviv
1950–53 Lives as a shepherd on a kibbutz
1959 Lives and studies in London
1965 First solo exhibition in Grosvenor Gallery, London
1972 Returns to Israel
1977 Participates in Documenta 6 in Kassel
1978 Participates in the 38th Venice Biennale
1995 Winner of the Israel Prize for sculpture

LITERATURE
Ulrich Schneider et al., *Menashe Kadishman: Shalechet; Heads and Sacrifices*, exh. cat. Suermondt-Ludwig-Museum, Aachen (Milan, 1999).
Jacob Baal-Teshuva, *Menashe Kadishman* (Munich, 2007).
Marc Scheps, *Menashe Kadishman: Sculptures* (Munich, 2011).

left page
Menashe Kadishman, *Shalechet (Fallen Leaves)*, 1997–99, installation of approx. 10,000 individual sculptures, cut with a mixture of gas and oxygen from sheet steel, thickness: 1.5 to 8 cm, height: 8 to 17 cm, width: 7 to 16 cm, Jewish Museum, Berlin

above
Photograph of Menashe Kadishman

MARCEL BREUER

CHARLES EAMES

1906 Bezalel School of Arts and Crafts
founded in Jerusalem

1945 End of World War II

1919 The Bauhaus is founded
in Weimar, Germany

1933 Hitler and the Nazis come
to power in Germany

1955–68 Civil rights movement
in the U.S.

| 1885 | 1890 | 1895 | 1900 | 1905 | 1910 | 1915 | 1920 | 1925 | 1930 | 1935 | 1940 | 1945 | 1950 | 1955 | 1960 | 1965 | 1970 |

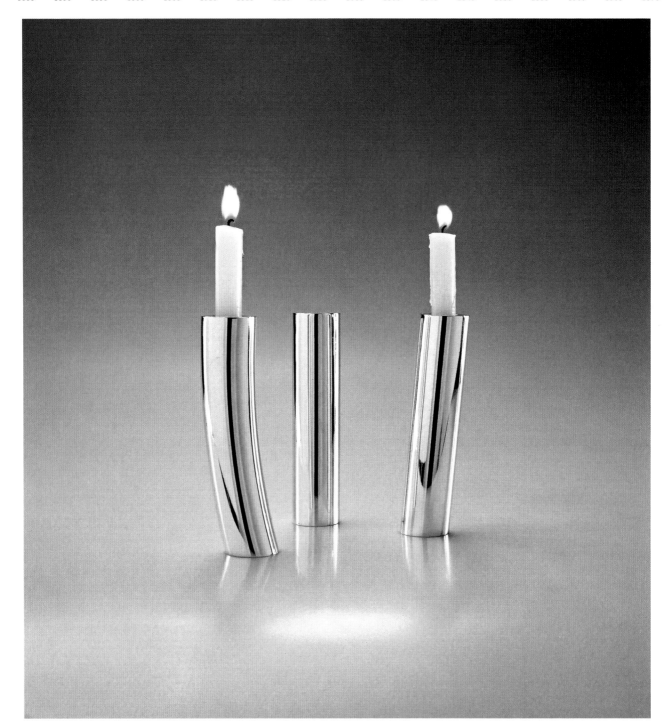

1981 First Columbia shuttle

2000 Herzog & De Meuron, Tate Modern,
Bankside, London

1977 Walter De Maria, *The Lightning Field*
near Quemada, New Mexico

1996 First cloned mammal: Dolly the Sheep

2003 U.S. invasion of Iraq

1975 1980 1985 1990 1995 2000 2005 2010 2015 2020 2025 2030 2035 2040 2045 2050 2055 2060

ZELIG SEGAL

A truly gifted designer of modern Judaica, Zelig Segal, who has also earned renown as a Minimalist sculptor and a painter in an Abstract Expressionist style, is a creator of ceremonial objects of a formal purity and simple materiality that reflect the artist's own ethical and aesthetic beliefs.

After graduating form the Bezalel School of Arts and Crafts (now Academy of Arts and Design) in Jerusalem, Zelig Segal (b. 1933, Jerusalem) became one of Israel's most creative designers of ceremonial objects. Raised with a religious upbringing, his approach is both unconventional and practical; his forms are innovative and free of the familiar language of Jewish ceremonial objects.

Only after the emancipation, when Jews were no longer excluded from the guilds, did Jewish artisans become involved in designing ritual objects to beautify the acts of fulfilling the Commandments. Early Zionists stimulated Jewish craftsmanship when in 1906 they founded a design school in Jerusalem, named after the legendary first Jewish artist, Bezalel, who realized the ceremonial objects for the Tabernacle according to the blueprints Moses received from God, but that he himself could not read.

Let There Be Light
With the *In Memory of the Destruction of the Temple* Sabbath candlesticks, Segal combined the function of the traditional two candlesticks for the Sabbath with a memorial light, alluding to the destruction of the Temple. The two Sabbath candles symbolize the two versions of the Ten Commandments, in which one is ordained to "remember," and also to "ob-serve" the Sabbath day to keep it holy (Exodus 20:8 and Deuteronomy 5:12, respectively). Once destroyed, the Temple—symbol of harmony between the human and the divine—became the symbol of an incomplete world. Still today a small piece in the wall of a synagogue is left unfinished, just as a glass is broken at the height of joy during a wedding ceremony to remind Jews that since the destruction of the Temple the world is incomplete: "If I forget you Jerusalem, let my tongue stick to my palate, if I don't keep Jerusalem in memory even at my happiest hour" (Psalm 137:6). Segal extends this now to the Sabbath, that most joyful weekly festival

which starts with the kindling of lights, and ends when three stars appear in the sky and flames of a braided candle are extinguished to mark the separation (*havdalah*) between sacred and secular, light and darkness.

The association of light with hope and freedom is a universal phenomenon. Light accompanies Jewish ceremonies to impart holiness on special moments, and candles are lit to inaugurate the Sabbath on Friday night and before the start of all festivals. During the eight days of Hanukkah (at the darkest time of year), Jews light candles at sundown; before Passover, remnants of bread are searched for with a light. Both festivals commemorate the Jewish people's struggle for freedom. The eternal light in the synagogue is a reminder of the destroyed Temple lamp; light sanctifies the alliance between man and woman at weddings; and the memorial light serves in remembrance of the departed. Light and darkness are never completely separate.

1933 Born in Jerusalem; receives a religious upbringing
1949–54 Studies at the Bezalel School of Arts and Crafts (now Academy of Arts and Design) in Jerusalem
1964–68 Directs the department of precious metal at the Bezalel Academy
1987 Receives the Jesselson Prize for Contemporary Judaica Design, The Israel Museum, Jerusalem
1992 Retrospective exhibition at the Israel Museum, Jerusalem

LITERATURE
Iris Fishof and Yigal Zalmona, *In a Single Statement: Works by Zelig Segal*, exh. cat. The Israel Museum (Jerusalem, 1992).

left page
Zelig Segal, *In Memory of the Destruction of the Temple*, Sabbath candlesticks, 1988, silver, 17.5 x 3.8 cm, The Israel Museum, Jerusalem. Purchased through the Eric Estoric Fund

above
Photograph of Zelig Segal

1890–92 Paul Cézanne,
The Card Players

1911 Yiddish author Sholem Aleichem
publishes *Tevye the Dairyman*

1952 Elvis Presley hits the headlines

1945 Beginning of Cold War

1963 Assassination of
John F. Kennedy

| 1885 | 1890 | 1895 | 1900 | 1905 | 1910 | 1915 | 1920 | 1925 | 1930 | 1935 | 1940 | 1945 | 1950 | 1955 | 1960 | 1965 | 1970 |

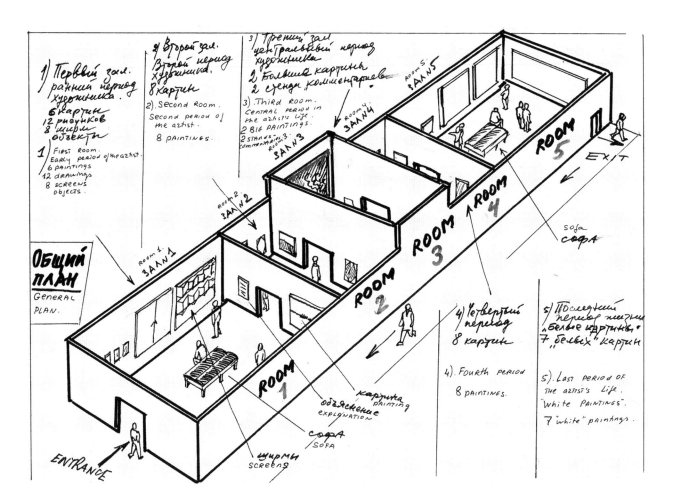

Ilya Kabakov, *Life and Creativity of
Charles Rosenthal*, 1999, perspective
sketch and section of the exhibition
at the Art Tower Mito, felt-pen,
correction fluid, 21 x 29.7 cm

JIM DINE

JOSEPH BEUYS

JOHN CAGE

1959 First happening by Allan
Kaprow in New York

1963 Roy Lichtenstein
Whaam!

1885 1890 1895 1900 1905 1910 1915 1920 1925 1930 1935 1940 1945 1950 1955 1960 1965 1970

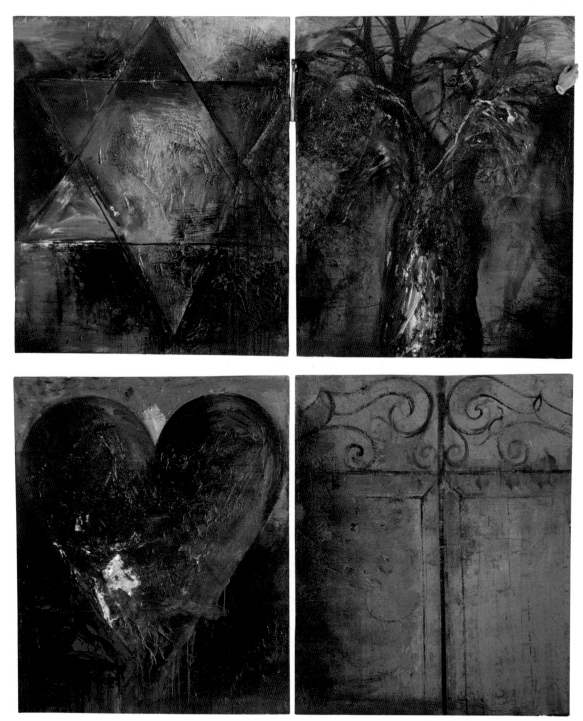

1987–93 First Palestinian Intifada
1989 Fall of the Berlin Wall
1973 Watergate scandal **1994** End of apartheid in South Africa
2005 Hurricane Katrina devastates New Orleans

1975 1980 1985 1990 1995 2000 2005 2010 2015 2020 2025 2030 2035 2040 2045 2050 2055 2060

ILYA KABAKOV

Who is Charles Rosenthal? Who for that matter is Ilya Kabakov? The former is the alter ego of the latter, once a member of the Soviet underground, who combines the best of Russian storytelling with the descriptive language of Jewish tales in order to encapsulate historical, personal, and artistic crises.

Ilya Kabakov (b. 1933) characterizes himself as a stray dog: Ukrainian born, his parents and his wife Emilia are Jewish, his language is Russian, his mentality Soviet. Kabakov was trained in Samarkand and Moscow to be an artist in the service of the state, and was destined to become the painter of the leader, the worker, and the farmer.

Yet, his career took a different turn: he became the most famous artist of the Moscow underground. In his day job he was the officially supported illustrator of children's books; on his own time, his Moscow attic filled with unofficial work dealing with the boring, frightening, and banal aspects of everyday life in Soviet Russia. Beginning in the midsixties, his works and installations were occasionally exhibited in the West. His underground existence ended in the late eighties when the Soviet Union collapsed. After residing in various European cities, Kabakov moved to New York in 1992.

In exile, Kabakov became the chronicler and ethnologist of the lost society that was the Soviet Union, with junk-laden, dust-collecting spaces exhibited all over the world. Has the unofficial Kabakov now become official? Not when we get to know him through an installation like *Life and Creativity of Charles Rosenthal* (1999).

Who is Charles Rosenthal?

Who is this Charles Rosenthal, this alter ego of the painter Kabakov? As one might expect, the fictitious Rosenthal is a fellow Ukrainian, born in 1898 in Kherson, then one of the most important Jewish cities of Eastern Europe. Charles is not his real name, but Sholom, which, not coincidentally, is that of the great Yiddish storyteller Sholem Aleichem, whose novel *Wandering Stars* Kabakov illustrated in 1957 as his academy diploma work. Rosenthal's fictitious biography bears all the clichés about Jewish artists of his generation who moved from provincial Russian towns to the big city and then emigrated abroad—some to find success like

Chagall, and others, like Rosenthal, to be forgotten until "rediscovered" (by Kabakov). Rosenthal studied in St. Petersburg at "Shtiglitz Academy" (reminiscent of American Jewish modernist photographer Alfred Stieglitz), and became acquainted with modernists like Paul Cézanne, the hero of so many Russian painters. Of course Rosenthal studied in Vitebsk with the magical storyteller Marc Chagall, and became fascinated by Kazimir Malevich's abstract art. And naturally, he immigrated in 1922 to Paris, the mecca for so many Jewish painters. He died in a car accident in 1933, the year Kabakov was born.

Like Rosenthal, Kabakov can be found at the centers of modern art; like Rosenthal, he perceives himself an outsider. Like Chagall, he is a dissenter with regard to modernism. Rosenthal/Kabakov oscillates between abstraction and realism, unable to escape the seductions of the absolute white of a Malevich—the great dictator of the Russian avant-garde with whom all Russian artists have a complex relationship—and yearning for the apolitical naturalism of the nineteenth century, which became tainted and misused by Socialist Realism. The installation plays on these encounters with art history.

Kabakov offers his perspective as an outsider and émigré on another outsider and émigré, a forgotten Jewish artist. Through Rosenthal, Kabakov the artist sheds new light on Russian art and the fate of individual creators. At the same time, Kabakov the curator installs works in museum spaces, and orchestrates a sense of disorientation and confusion, forcing the viewer to ask questions about the role of the (Jewish) artist in society.

1933 Born on September 30 in Dnepropetrovsk, in the Soviet Union (now Ukraine)
1945–51 Studies art in Moscow
1950s Begins making his first unofficial works; becomes acquainted with and influenced by Robert Falk (1881–1958), who worked in the style of Cézanne and was permitted to exhibit in the Soviet Union
1957 Graduates from V.I. Surikov State Art Institute, Moscow, specializing in graphic design and children's book illustration
1965 Full member of the Union of Soviet Artists
1985 First solo exhibition at Dina Vierny Gallery, Paris
1987 Leaves the Soviet Union
1988 Starts working with Emilia Kanevsky; from this point on their work is collaborative
1988–92 Lives and works in various countries, becoming successful
1988–89 Exhibits in New York, Bern, Venice, and Paris
1992 Moves to New York and marries Emilia Kanevsky
1993 The Kabakovs represent Russia at the 45th Venice Biennale with their installation *The Red Pavilion*
2004 Kabakov is the first living Russian artist with an exhibition at the Hermitage Museum

LITERATURE
Emilia Kabakov, ed., *Ilya Kabakov: Paintings/Gemälde, 1957–2008*; *Catalogue Raisonné* (Bielefeld, 2008).

Ilya and Emilia Kabakov during the Sharjah Biennale, 2011

2000–5 Second Palestinian Intifada
1980 Ronald Reagan elected U.S. President **2004** Tsunami catastrophe in Asia
1973 First oil crisis **1991–92** First Gulf War
1982 Michael Jackson, *Thriller* **2007–10** Global financial crisis

| 1975 | 1980 | 1985 | 1990 | 1995 | 2000 | 2005 | 2010 | 2015 | 2020 | 2025 | 2030 | 2035 | 2040 | 2045 | 2050 | 2055 | 2060 |

JIM DINE

Primarily associated with happenings and the Pop Art of the 1960s in New York, Jim Dine's often autobiographical work has waded through many of the twentieth century's artistic currents. Having used everything from a bathroom to a kitchen sink, Dine has canvassed the world of objects in the service of beauty.

Jim Dine (b. 1935) described his *Painting (Cruising) (La Chasse)* of 1981 as "cruising my themes and cruising as a painter … taking chances with unknown things and literally, physically, taking chances in the painting. This was a sort of random search for that sensation." Four poetically painted yet potent symbols are the result of his intuitive search: a six-pointed star, a tree, a heart, and a gate. Of these four, the inclusion of the Star of David, a specifically Jewish symbol, is most surprising—a rare allusion to Dine's Jewish background. And yet the Star of David, now universally recognized as a Jewish symbol or a symbol of Judaism, wasn't always known as such. This ancient decorative motif was to be found among many peoples from Oriental Antiquity to Christianity and Islam as a symbol without meaning.

Despite its association with King David, the hexagram, two interlocking equilateral triangles, plays no role in either the Bible or rabbinic literature. As Gershom Scholem, the famous scholar of Jewish mysticism has pointed out, originally no Jew thought of detecting any, even secret, Jewish meaning in it. Six- (and five-) pointed stars do occasionally appear on ancient Jewish monuments, but compared to the menorah (seven-branched candelabrum) or the two lions flanking a Tree of Life or a Torah niche, the Shield of David (Hebrew: *Magen David*) was a "foreign shoot in the vineyard of Israel." Beginning around 1500, Jews used the six-pointed star as a printer's mark, especially in Prague, which is most likely the origin of the Jewish connection. From there, it spread to other Jewish communities in Bohemia and Moravia, to Austria and Amsterdam, and ultimately to the rest of Europe.

Imbuing a Symbol with Meaning
With the emancipation of the Jews around the middle of the nineteenth century, and in its wake the possibility of building new and more flamboyant synagogues outside the former ghetto, the need arose for a striking and simple visual symbol as a counterpart to the Christian cross. The choice for the Star of David was obvious: it was already fairly familiar, and for the pious it did not have religious connotations. For the same reason, the Zionists, primarily secular in orientation, subsequently chose it as their official insignia at the Basel congress in 1897, the founding year of the movement. By that time, the sign was already widely used as a popular Jewish symbol on every new synagogue, and for every Jewish organization.

During the Holocaust, the Germans intentionally imposed the yellow six-pointed star on Jews as a sign of degradation and humiliation, marking the Jews for extermination—yellow is traditionally the color of shame. Yet, the symbol survived in the dark blue color the Zionists had chosen for the Israeli flag. The color is an allusion to the traditional color dye used to make the tassels of the striped Jewish prayer shawl: the blue star and stripes are prominent on the Israeli flag.

Although the Star of David was originally not a specifically Jewish symbol, Dine's choice of this symbol and the color blue are appropriate. It just may cruise the mind of the viewer that perhaps the red stains on the canvas refer to a more painful recent past, nicely outweighed by the tree of life, the heart, and the gate. The Shield of David does after all have a strong and protecting connotation: a royal insignia, a sign of pride.

1935 Born on June 16 in Cincinnati, Ohio to second-generation Jewish immigrants from Eastern Europe
1951–57 Studies at the Cincinnati Arts Academy, Boston Museum School, and Ohio University, Athens
1958 Moves to New York
1960 First solo show at Reuben Gallery, New York
1960s Participates in happenings with Claes Oldenburg, Allan Kaprow, and John Cage
1962 His work is included in what is considered the first Pop Art exhibition in the Norton Simon Museum, along with Roy Lichtenstein, Andy Warhol, and others
1964 Participates in the 32nd Venice Biennale
1967–71 Lives with his family in London
1968 Participates in Documenta 4 in Kassel
1970 Major retrospective at The Whitney Museum of American Art, New York
1977 Participates in Documenta 6
2004 *Drawings of Jim Dine* shown at the National Gallery of Art, Washington, D.C.

LITERATURE
Gershom Scholem, "The Star of David: History of a Symbol," in *The Messianic Idea in Judaism* (New York, 1971). Marco Livingstone, *Jim Dine: The Alchemy of Images* (New York, 1998). Judith Brodie, *Drawings of Jim Dine*, exh. cat. National Gallery of Art, Washington, D.C. (Göttingen, 2004).

Jim Dine, *Painting (Cruising) (La Chasse)*, 1981, acrylic on canvas with objects, four panels, 182.9 x 619.1 cm, Private collection. Courtesy of Pace Wildenstein, New York

1916 Dadaist Cabaret Voltaire
founded in Zurich

1920–21 Alexander Rodchenko,
Spatial Constructions

1940 Germans invades
the Netherlands

1941 Bruce Nauman is born

1952 Samuel Beckett,
Waiting for Godot

1950 Korean War
begins

1959 First happening by Allan
Kaprow in New York

1962–68 Ludwig Mies
der Rohe, Neue
Nationalgalerie

1885 1890 1895 1900 1905 1910 1915 1920 1925 1930 1935 1940 1945 1950 1955 1960 1965 1970

Eva Hesse, *No title*, 1970, latex, rope,
string, wire, 244 x 549 x 92 cm,
installation view at 435 West Broadway,
New York, 1970, Whitney Museum of
American Art, New York. Purchased with
funds from Eli and Edythe L. Broad,
the MRs. Percy Uris Purchase Fund, and
the Painting and Sculpture Committee,
April 1998

1975 1980 1985 1990 1995 2000 2005 2010 2015 2020 2025 2030 2035 2040 2045 2050 2055 2060

EVA HESSE

The art of Eva Hesse can quite easily be read through the prism of her tragedy filled and painful life. As a seeming response to the difficulty of her own material world, she moved increasingly towards immateriality, employing cheap materials and industrial refuse to reflect on her existence and the world around her.

Eva Hesse (1936–1970) was born in Hamburg into an observant middle-class Jewish family. In 1938, she and her older sister Helen were taken on a children's transport to Holland to escape the Nazis. The next year their parents took them to England and, thereafter, to New York. In what was supposed to be a safe environment, the next tragedy occurred. Shortly after her parents divorced—Eva was ten years old—her mother, who suffered from serious depression, committed suicide. The death of her mother contributed to the insecurity caused by her forced exile. The diaries she kept beginning in 1954 helped her search for stability and self-assurance as a woman and, increasingly, as an artist. After art studies in New York and at Yale she created works influenced by Dada and the objects of Marcel Duchamp.

In 1964–65, Eva Hesse spent an extended period of time in Germany on a stipend. Her German stay marked a turning point in her life and in her work; it represented her transition from two-dimensional Abstract Expressionist drawings to three-dimensional works in soft, fragile, highly unorthodox materials, her colors gradually receding toward monochromatic white, gray, and black. Apart from visiting exhibitions, meeting artists, and reading, in Germany she had tried to retrace her own past; as she wrote, "It's a weird experience. Like a secretive mission, a new generation seeking the past. I knew next to nothing of my family or my grandparents…. Never knowing them, their lives, they never knowing me or mine. I never had the grandpa, the grandma … the encouragements, proudnesses, my mother, where she was from and grew, even then distortedly grew."

Gravity's Levity
In 1967 she started to experiment with gravity—hanging and balancing her sensual, corporal, individual, funny, and somewhat disturbing pieces—and using ephemeral materials, such as

latex, fiberglass, and polyester in her works, which she knew would deteriorate with time.

Well before Eva Hesse died prematurely of a brain tumor in 1970, her work earned increasing attention from the New York art world. *Untitled (Rope Piece)* was created in 1970 shortly before she succumbed to a long illness. The network of chaotic ropes and strings are her handwriting, searching to securely tie knots and to untie remaining riddles, to find a thread to the past that playfully hangs in suspense—evading answers and evoking ever more questions. Today her personality and her work continue to fascinate. The work of this woman, who fought to be recognized in the male-dominated world of art, is now much sought after, and regularly features in major exhibitions.

Eva Hesse, 1960

1936 Born on January 11 in Hamburg
1938 Together with her sister Helen she is sent on a children's transport to Amsterdam
1939 The family emigrates to New York, settling in Washington Heights; mother Ruth suffers from depression
1945 Her parents divorce; her father remarries and takes the two daughters; a year later her mother commits suicide
1952–59 Studies at the Art Student League and Cooper Union in New York, and at the Yale School of Art
1959 Returns to New York and starts to work as a textile designer, making her first abstract works
1962 Participates in a happening of Allan Kaprow in Woodstock
1964–65 Visits Germany on an artist's stipend; exhibits in Düsseldorf
1966 Through Sol LeWitt, whom she knows since 1960, she meets Donald Judd and Dan Flavin
1967 Participates in a symposium with Louise Bourgeois on erotic symbolism
1968 Exhibits at the famous New York gallery of Leo Castelli with Robert Morris, Richard Serra, and others; solo exhibition *Chain Polymers* at Fischbach Gallery in New York
1970 Dies of a brain tumor on May 29

LITERATURE
Elisabeth Sussmann et al., *Eva Hesse: Sculpture*, exh. cat. The Jewish Museum (New York, 2006).

MORRIS LOUIS

CY TWOMBLY

MOSHE GERSHUNI

1906 Bezalel School of Arts and Crafts
founded in Jerusalem

1909 Tel Aviv founded

1942–44 Nazis murder six million European
Jews in extermination camps

1960–61 Adolf Eichmann
sentenced to death
in Jerusalem

| 1885 | 1890 | 1895 | 1900 | 1905 | 1910 | 1915 | 1920 | 1925 | 1930 | 1935 | 1940 | 1945 | 1950 | 1955 | 1960 | 1965 | 1970 |

Moshe Gershuni, *Isaac! Isaac!*, 1982,
mixed media on paper, 140 x 200 cm,
The Tel Aviv Museum of Art, Israel

1973 Picasso dies

Six-Day War between Israel and its
neighboring states Egypt, Jordan, and Syria

2003 Human genome decoded

1996 First cloned mammal: Dolly the Sheep

1990 Reunification of Germany

2009 Barack Obama awarded
Nobel Peace Prize

1975　1980　1985　1990　1995　2000　2005　2010　2015　2020　2025　2030　2035　2040　2045　2050　2055　2060

MOSHE GERSHUNI

*From his beginnings as a conceptual artist, to his expressionist evolution in the eighties, to his sculpted objects of today,
Israeli artist Moshe Gershuni synthesizes the sacred and profane, the public and the private to reflect profoundly upon
the ambivalent nature of his homeland.*

"Little Isaac, where are you going?"
Born to Polish parents in Tel Aviv, Moshe Gershuni
(b. 1936) frequently uses Hebrew as well as Yiddish
religious writing in his expressionistic artwork. The
use of his texts are provocative: secular Israelis
disdainfully associated Hebrew religious texts with
backward religiosity, whereas Yiddish was despised
as the "jargon" of the "cowardly" Diaspora Jews.
His quotations and wordplay serve to comment
bitterly and ironically upon the euphoria of Israeli
military victories and accentuate the dark fears of
the soldiers; to express anger about the Shoah; to
vent his fury about an absent God; and, recently, to
identify with the fate of Palestinians.

In *Isaac! Isaac!* (1982) Gershuni deals with the
famous biblical story in the book of Genesis (chapter
22). Abraham was prepared to sacrifice his only,
beloved son Isaac, bending—both father and son—
to God's will. Thanks to God's last-minute interven-
tion—seeing their commitment and accepting
as a whole-burnt offering (*holocaust* in the Greek
translation) a lamb in the child's place—He spares
the life of Isaac.

From Weakness to Strength
In the 1960s, the biblical story of the binding of
Isaac became a dominant theme in Israeli culture,
replacing the naïve pastoral Orientalism of the early
pioneers, and the imagery of the "sabra"—the
blond, blue-eyed, virile, and native-born Israeli—
the hero during the first decades of the Jewish
state's existence. Holocaust survivors, scarred and
traumatized, felt displaced in an ideological climate
that blamed them for being "brought like lambs to
the slaughter," passive victims. The Diaspora was
bracketed out of the Zionist concept of history that
ended with the destruction of the Second Temple in
70 CE (and subsequent exile), only to resume again
in 1948. The survivor's voice wasn't heard until the
nationally broadcast trial of Adolph Eichmann in
1960–62, when an Israeli court prosecuted, on behalf

of the victims and the survivors, the architect of the
system of mass extermination of European Jewry,
and through him Nazi Germany in general. The
impact was tremendous: the Holocaust moved to
the center of Israeli cultural and political conscious-
ness. Modern Israeli literature and art began to
take up the medieval Jewish tradition, expressed in
haunting liturgical poetry, in which Isaac was
actually sacrificed. Isaac is no longer the surviving
son, but a prey bound for slaughter conjuring up
the victims of the medieval Crusades, the pogroms,
and the Holocaust, in which not just the lamb but
also the son and the father are killed—together.
The Arab-Israeli Six-Day War of 1967, and sub-
sequent wars, made the story an obvious subject
for artists who were conscripted in the army just
like their sons.

The predominant colors in Gershuni's palette
are yellow, related to the Nazi yellow star; black,
associated with death; and red, a reference to the
blood of the victims of both the Holocaust and the
Israeli wars and an allusion to Gershuni's wish to
downplay the differences between Israel and the
Diaspora—an acknowledgement of the continued
presence of those anxieties that Israelis believed
they had left behind in the Diaspora. Gershuni's
often radical work—containing allusions to the
Bible, Jewish liturgy, and modern Hebrew and
Yiddish poetry—is a crude awakening from the
Zionist dream of a peaceful, normalized existence.

1936 Born on September 11 in Tel Aviv;
his parents, Yona and Zvi Kutner,
had immigrated from Poland in
the 1920s
1960–64 Studies at the Avni Institute
of Art and Design, Tel Aviv
1972–77 Teaches at the Bezalel
Academy of Arts and Design,
Jerusalem
1988 *Thirteen Etchings for Poems by
C. N. Bailik*, Tel Aviv Museum of
Art
1990 Exhibits at Tel Aviv Museum of
Art
1997 First exhibition at Jerusalem Print
Workshop
2003 Winner of the Israel Prize
2010 Major retrospective at Tel Aviv
Museum of Art

LITERATURE
Itamar Levy, *Moshe Gershuni: Works,
1987–1990*, exh. cat. Tel Aviv Museum
of Art (Tel Aviv, 1990).
Sarah Breitberg-Semel, *Moshe Gershuni*,
exh. cat. Tel Aviv Museum of Art
(Tel Aviv, 2010).

Photograph of Moshe Gershuni

1945 Beginning of Cold War

1968 Student revolts

1950 Josef Albers, first painting of
the series *Homage to the Square*

1890 1895 1900 1905 1910 1915 1920 1925 1930 1935 1940 1945 1950 1955 1960 1965 1970 1975

Richard Serra, *The Drowned
and the Saved*, 1991–92,
wrought steel, two pieces,
143 x 155 x 35 cm each.
Designed and realized for
the Synagogue Stommeln,
Germany; present location:
Diözesanmuseum, Cologne

RICHARD SERRA

With his powerful site-specific work, Minimalist sculptor Richard Serra ranks among the world's most innovative contemporary artists. He employs untraditional materials like rubber, neon, and lead, and his celebrated large-scale works in Cor-ten steel adorn and dignify some of the globe's most emblematic locations.

As with most of his sculptures, American artist Richard Serra (b. 1939) created *The Drowned and the Saved* (1992) for a specific location, in this case the former synagogue of Stommeln (Germany), which regularly features artistic installations. The building survived the Pogrom Night in November 1938 only because its Jewish community had already been forced into exile. The former sanctuary, meticulously restored but totally empty, attests to the devastation—the title, size, and abstract nature of this specific installation invite the viewer to reflect upon its meaning. The sculpture's stark presence prevents the visitor from comfortably walking around or drawing too near: the sculpture seems to point to the building's lost sanctity as much as make reference to those who once inhabited it.

Bearing Witness

The title of this work refers to two texts by the Italian Jewish author Primo Levi (1919–1987): a chapter in his book *Survival in Auschwitz* (1965), and a book entitled *The Drowned and the Saved* (1988), published shortly before he committed suicide. Arrested as a member of a resistance group, Levi had been deported to Auschwitz in 1944. He survived, but remained haunted by what he had witnessed. In his early description of the inmates in Auschwitz, Levi makes a harsh distinction between two categories of prisoners: those who have given up everything and can only follow orders, and others who battle at all costs for their own survival. Two worlds clash here. In 1988, Levi nuanced his views about the survivors. He expresses his feeling of shame of belonging himself to this minority, "I might be alive in the place of another, at the expense of another." He observes, "We, the survivors are those who by their prevarications or abilities or good luck did not touch bottom. Those who did so, those who saw the Gorgon, have not returned to tell about it, or have returned mute.... They are the rule, we are the exception." He no

longer claims a contrast between the drowned and the saved as he did earlier, but admits they are inextricably linked to one another.

In his sculpture *The Drowned and the Saved* (1992), Serra does precisely this: he makes the two angled, mirroring shapes subtly support or rather "clash" with each other in the middle. Separately, each element would collapse. Neither the drowned nor the saved can stand on their own—the living cannot exist without the dead; they need each other.

The work evokes the very questions Serra, at the time of creating this sculpture, remembers asking his Jewish mother, Gladys Feinberg, at age five: "What are we, who are we, where are we from? One day she answered me: if I tell you, you must promise never to tell anyone, never. We are Jewish. Jewish people are burned alive for being Jewish. I was raised in fear, in deceit, in embarrassment, in denial. I was told not to admit who I was, not to admit what I was." His mother, born in Los Angeles into a Russian Jewish family originally from Odessa and familiar with prejudice and persecution, raised Serra, like so many of his generation, in silence and denial, believing that in this way she could protect him. Serra's work expresses this awareness in the choice of heavy lead for many of his sculptures. As Serra said about *Gravity* (1993), the sculpture he created for the U.S. Holocaust Museum in Washington, "we face the fear of unbearable weight ... the weight of history."

1939 Born on November 2 in San Francisco to a Spanish-born father and Jewish mother, Gladys Feinberg
1961–64 Studies painting at Yale University; contact with Josef Albers
1966 Visits Florence; first sculptures of fiberglass, neon tubing, and rubber; first solo exhibition in Galleria La Salita, Rome; moves to New York.
1968 Produces his first short films
1972 Participates in Documenta 5 in Kassel
1977 Death of his mother; creates the sculptures *Terminal* and *Tot (dead)* for the city of Bochum, Germany
1981 Marries German art historian Clara Weyergraf; *Tilted Arch* installed in New York (dismantled)
1982 Participates in Documenta 7
1987 *Berlin Junction*, memorial to the Nazi euthanasia program, in front of Berliner Philharmonie; participates in Documenta 8
1992 Makes *The Drowned and the Saved*
1993 Creates *Gravity* for the U.S. Holocaust Memorial Museum
2007 Major retrospective at the MoMA, New York

LITERATURE
Kynaston McShine and Lynne Cooke, *Richard Serra Sculpture: Forty Years*, exh. cat. The Museum of Modern Art (New York, 2007).

Dieter Schwerdtle, Richard Serra in Kassel, 1982, Turin, private collection

MICHA ULLMAN ══════════════════════════════════

MENASHE KADISHMAN ════════════════════════════════════

RICHARD SERRA ══════════════════════════════════════

1961 Construction of the Berlin Wall

1951 Morris Louis, *Charred Journal*

1933 Nazi book burnings

1955 First Documenta exhibition
in Kassel, Germany

| 1890 | 1895 | 1900 | 1905 | 1910 | 1915 | 1920 | 1925 | 1930 | 1935 | 1940 | 1945 | 1950 | 1955 | 1960 | 1965 | 1970 | 1975 |

Micha Ullman, *Library*, 1993–94,
subterranean space: 7.06 x 7.06 x 5.29 m,
glass viewing cover: 1.20 x 1.20 m,
Bebelplatz, Berlin

1993 The United States Holocaust Memorial
Museum opens in Washington

1978 Isaac Bashevis Singer wins **1994** First "Stumbling Stone" in Cologne by German artist Gunter Demning
the Nobel Prize for Literature **2000–5** Second Palestinian Intifada

1989 Fall of the Berlin Wall **2005** Peter Eisenman, Memorial to the Murdered Jews of Europe in Berlin

1980 1985 1990 1995 2000 2005 2010 2015 2020 2025 2030 2035 2040 2045 2050 2055 2060 2065

MICHA ULLMAN

Sculptor Micha Ullman employs empty space as one would material, molding it to give form and meaning. His subterranean works are reflections on absence, emptiness, and the very earth out of which he excavates his sculptures.

A Holocaust of Books

Even though modern Berlin is reunited, rebuilt, and restored, its ghosts remain ubiquitous: memories of the topography of the Nazi terror and the destruction of the Jews surface everywhere. Government offices are housed in Nazi buildings, the former concentration camp Sachsenhausen is just a stone's throw away from the center, as is the villa on the idyllic Wannsee lake where the annihilation of the Jews was planned. In spite of the forward-looking, modern glass cupola that crowns it, the German Reichstag preserves the traces of arson and attack and can be as little ignored as the hundreds of steles next to Brandenburg Gate that symbolize the mass murder of European Jews, initiated and carried out from Berlin. More numerous in the city are those "stumbling stones" with the name of an individual victim in the sidewalk, near railroad tracks, on street signs, as plaques on a wall, or at empty spots between houses that bear witness to personal tragedies, mainly of Jews, but also of artists and intellectuals whose views and lives were despised by the Nazis.

Where They Burn Books …

To the category of less monumental—but no less impressive—memorials belongs the work of the Israeli sculptor and object artist Micha Ullman. Born in Tel Aviv in 1939 to parents who fled Nazi Germany in 1933, he became famous for his site-specific works, the most well known of which can be found in Berlin. It is one of Germany's most inconspicuous and impressive monuments to the victims of the Holocaust. Ullman's *Library* (1993–94) commemorates the book burnings in Berlin and seventeen other German university towns on May 10, 1933. The action, organized by the German Student Association and attended in Berlin by some 5,000 students and a crowd of 80,000 spectators, resulted in the burning of approximately 25,000 books, the majority works by Jewish authors and scholars.

The square is empty: no statue, no fountain, not even a bench. Barely visible in the middle of the Bebelplatz lies Ullman's *Library*. It is a subterranean installation, surrounded by the ponderous symbols of German cultural, religious, and intellectual life: the State Opera house, St. Hedwig's Cathedral, the former Royal Library, and, on the other side of Unter den Linden, Humboldt University. Securely locked off by thick glass, a rectangular white room with white shelves theoretically offers space for some twenty thousand books. It is difficult to get a grip on its layout and structure; one must search hard for a position from which to look inside, bending down or kneeling, only to struggle with the reflection of the clouds, or the dizzying abyss of the infinite sky. Inserted in the pavement, the installation is best seen at night. Lit solely from within, the illuminated work appears as an eternal memorial light on an ominously dark square.

On a bronze plaque nearby one reads: "That was but a prelude; where they burn books, they will ultimately burn people also." These words that Heinrich Heine had written over a century before the Holocaust (*Almansor*, 1823, verses 243 and 244) actually refer to the burning of a Koran by the Spanish inquisition in Granada around 1500—and it was with the Muslims that the young Heine sympathized in his play. Muslims call the Jews "the people of the book." In 1933, a holocaust of books took place. Although nobody died at the time, the modern-day visitor clearly senses what we know in hindsight, namely what Heine predicted. Trying to look into the empty library, we realize how hard it still is to fill the inaccessible void with new life and wisdom.

1939 Born in Tel Aviv to German parents who had escaped Nazi Germany in 1933
1960–64 Studies at the Bezalel School of Arts and Crafts (now Academy of Arts and Design) in Jerusalem
1965 Studies at the Central School for Arts and Design in London
1970–78 Teaches at the Bezalel Academy
1987 Participates in Documenta 8 in Kassel
1991–2005 Teaches sculpture at the State Academy of Fine Arts in Stuttgart
1992 Participates in Documenta 9
1997 Memorial for the former Lindenstrasse Liberal Synagogue in Berlin-Kreuzberg, in collaboration with Zvi Hecker and Eyal Weizmann
2009 Receives the Israel Prize for sculpture
2011 Major solo exhibition in the Israel Museum, Jerusalem

LITERATURE
Friedrich Meschede, *Micha Ullman: Bibliothek* (Amsterdam and Dresden, 1999).
Micha Ullman, exh. cat. Museum Wiesbaden (Wiesbaden, 2003).

Photograph of Micha Ullman

SOL LEWITT

STEPHAN BALKENHOL

1969 Georg Baselit
Forest Upside
first upside-d
painting

1955–68 Civil rights
movement in the U.S.

1942 Edward Hopper, *Nighthawks*

1967 Six-Day War between Israel and its n
boring states Egypt, Jordan, and Syri

| 1890 | 1895 | 1900 | 1905 | 1910 | 1915 | 1920 | 1925 | 1930 | 1935 | 1940 | 1945 | 1950 | 1955 | 1960 | 1965 | 1970 | 1975 |

Jonathan Borofsky, *Berlin Dream*, 1982,
acrylic on two canvases split,
left: 361 x 227 cm, right: 288 x 178 cm,
overall: 361 x 405 x 117 cm, Paula Cooper
Gallery, New York

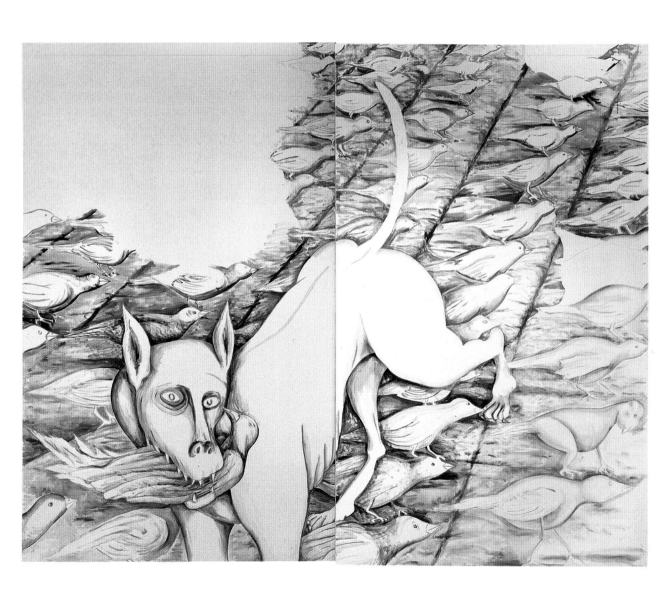

2003 Human genome decoded

1990 Reunification of Germany **2009** Barack Obama awarded
 Nobel Peace Prize
Picasso dies **1996** First cloned mammal:
 Dolly the Sheep **2010** "Arab Spring" begins with protests in Tunisia

1980 1985 1990 1995 2000 2005 2010 2015 2020 2025 2030 2035 2040 2045 2050 2055 2060 2065

JONATHAN BOROFSKY

One of the most influential artists of his generation, Jonathan Borofsky's gallery and museum exhibits in the eighties revolutionized the experience of art. And with public art installations in cities all over the world, his conceptual, figurative, and oftentimes monumental sculptures celebrate universal themes that are both simple and of great emotional depth.

Jonathan Borofsky (b. 1942) grew up in the large Jewish community of Boston and absorbed his first impressions of the Holocaust as a child. After studying art in the United States and France, he settled in New York in 1966, turning to Conceptual Art. Beginning in about 1969, Borofsky frequently used numbers in works such as his *Self-Portrait* of 1979, in a modern grappling with the Nazi practice of tattooing concentration camp inmates. In addition, he created a whole series of works with numbers starting with 1,933,000, undoubtedly a reference to the year Hitler was elected chancellor of Germany.

Running Away?
In 1976, he visited Germany for the first time, and started to make his first open references to the Holocaust in *Hitler Dream*: "I dreamt that some Hitler-type person was not allowing everyone to roller-skate in public places. I decided to assassinate him, but I was informed by my friend that Hitler was dead a long time." Borofsky told how he was like the running man himself, "looking over my shoulder to see who's chasing me—a person, my past, Hitler, whatever." Borofsky related how he was born in the year Hitler was in his prime, and already as a child became fascinated by, angry with, and afraid of the ultimate "evil-doer" of the twentieth century. In 1982, he clandestinely painted a *Running Man* on the Berlin Wall and worked on his installation for the exhibition *Zeitgeist*. The figure of the running man is a central theme in Borofsky's work.

In *Berlin Dream* (1982), he dreamt of "a dog that got into a garden of birds—the fence was broken." This visceral image can be alternatively interpreted as the Jews, represented by the vulnerable birds and attacked by the ferocious Nazi dogs in the concentration camps, as the East Germans trapped behind the Berlin Wall, or even as the West Berliners living in a walled-in enclave in a Communist country. The context of this installation (shown subsequently in New York, the Israel Museum in Jerusalem, and elsewhere) is the violent world of terror, and the fear of defenselessness.

As for so many Jews, it was difficult for Borofsky to work and exhibit in Germany, particularly in Berlin, where the ghosts of the past are still so much alive. Berlin had been the capital of militaristic Prussia and of Hitler's Third Reich, and here, during the Cold War, the East and West played their dangerous game of cat and mouse. Zeitgeist was held in the Martin-Gropius-Bau, a pompous building located between the Berlin Wall and the former Gestapo torture cellars that had been recently excavated, an area haunted by a terrible history and, at the time, a threatening present certainly capable of inducing the nightmares Borofsky had had.

The generation that was victimized is dying out; the successive generations must now deal with the fear and anxiety created by such a horrific legacy. For Jews born after World War II, the Holocaust remains an issue of vital importance—though not victimized personally, a great many were raised by survivors of the Nazi terror. Whether the tragic family history was concealed or in turn formed an integral part of their upbringing, the (grand)children of the survivors seek to confront the topic themselves, breaking a conspiracy of silence. The descendents go off to find "their roots," and visit the sites of destruction. They look to identify with the fate of their (grand)parents and allow themselves to express their own feelings of pain and anxiety while admitting that nothing could ever compare to the pain of what their ancestors had experienced.

1942 Born on March 2 in Boston
1960–64 Studies for a BFA at Carnegie Mellon University
1964–66 Enrolls in the MA program of Fine Arts, Yale University
1969–77 Teaches at the School of Visual Arts in New York
1977–80 Teaches at California Institute of Arts in Los Angeles
1982 Participates in Documenta 7 in Kassel
1990 The first *Hammering Man* is commissioned by the city of Frankfurt for its Trade Fair; other versions would be placed in Seattle, Seoul, New York, Basel, et al.
1992 Participates in Documenta 9
2004 Exhibition at Rockefeller Center, New York.
2006 His *Walking to the Sky* is installed permanently on the campus of Carnegie Mellon University

LITERATURE
Jonathan Borofsky, exh. cat. The Israel Museum (Jerusalem, 1984).
Mark Rosenthal, ed., *Jonathan Borofsky*, exh. cat. The Whitney Museum of American Art/Philadelphia Museum of Art (New York, 1984).

following double page
Jonathan Borofsky, *Self-Portrait*, 1979

above
Photograph of Jonathan Borofsky

DIEGO RIVERA

EL LISSITZKY

1972 Munich massacr
(attack on Israel
at the Olympic C

1952 Show trials against Jews
in Soviet Union

1967 Six-Day War between Israel
its neighboring states Egyp
Jordan, and Syria

| 1895 | 1900 | 1905 | 1910 | 1915 | 1920 | 1925 | 1930 | 1935 | 1940 | 1945 | 1950 | 1955 | 1960 | 1965 | 1970 | 1975 | 1980 |

Grisha Bruskin, *Alefbet
Lexicon no. 1 and no. 2,*
1987, oil on canvas,
116 x 88 cm each, Museum
Ludwig, Cologne, Germany.
Donation Ludwig

Grisha Bruskin, *Alefbet
Lexicon no. 3 and no. 4,*
1988, oil on canvas,
116 x 88 cm each, Collection
Henri Nannen, Kunsthalle
Emden, Germany

1995 Christo and Jeanne-Claude
wrap the Reichstag, Berlin
1 *Columbia* space shuttle
1989 Fall of the Berlin Wall 2005 Hurricane Katrina devastates New Orleans
1991 Soviet coup d'etat attempt
1985 Marc Chagall dies

| 1985 | 1990 | 1995 | 2000 | 2005 | 2010 | 2015 | 2020 | 2025 | 2030 | 2035 | 2040 | 2045 | 2050 | 2055 | 2060 | 2065 | 2070 |

GRISHA BRUSKIN

Artist and writer Grisha Bruskin was a vital figure in the nonconformist movement. His largely symbol-based work explores the private life of the individual, the collective of the Soviet, and the national reality of Judaism.

Grisha Bruskin (b. 1945) grew up in Moscow at a time when Jews gradually shed the mark of Cain—a source of shame and embarrassment—and projected a sense of pride and affirmation. In the wake of the Six-Day War (1967), Jews emerged from the shadows. When Chagall inaugurated a small show of lithographs in Moscow's Tretyakov Gallery in 1973, Bruskin became aware of the vanished world of the shtetl he knew only from books, and began to dream of exhibiting his own Jewish-themed work. His first solo exhibitions a few years later in Moscow (1976) and Vilna (1983), however, were denounced and forced to close for "promoting Zionism." With the ultimate success of his work—celebrated as "Glasnost Art" by Western critics—in a Sotheby's Russian art auction in Moscow in 1988 (in which his pieces brought record prices), Bruskin relocated to New York City.

Encyclopedia of a Vanished World
From 1983 on, he worked on two series of paintings: the *Fundamental Lexicon*, reflecting the world of monumental social realist art, and the *Alefbet Lexicon* (1987–88, from the Hebrew word for alphabet), which explores archetypical Jewish figures. Against a background of cursive Hebrew script, the *Alefbet Lexicon* consists of patriarchal figures in traditional garb (prayer shawls, phylacteries, and skullcaps) depicted in positions proclaiming—almost provocatively—their Jewish faith. He paints mysteriously dressed, gesticulating Jews carrying symbols like matzot (unleavened bread was hardly available in the Soviet Union), candlesticks, and other ritual objects rare at the time (Torah scrolls, prayer books, and fruits and plants featured during Jewish festivals), as well as winged angels, pious mystics, and possessed souls.

Dissected and isolated like saints on Russian icons (similar to the way Bruskin depicts the pseudo-religious heroes of the former Soviet system), the Jewish figures in *Alefbet Lexicon* seem to reflect the

contemporary nostalgia in both East and West for a religious world that no longer exists. Painted against backgrounds of Hebrew script that look like the pages of a book, the figures do not appear to interact with each other, but rather seem to wait endlessly to be continued into an ever expanding greater whole in which each person, each attribute, is calling for more questions and reactions from the reader of this illustrated lexicon. From it, a larger structure, a whole system could emerge—a new Jewish "text," an encyclopedia of images and ideas. In this sense Bruskin is truly one of the "People of the Book" for whom a seemingly endless list of commandments (613 in total) attempt to structure life and determine ideology. Bruskin's figures appear to be pleading to come alive, just as the separate blocks of commentary surrounding classic Jewish text are waiting to be revived through debate with the modern reader.

1945 Born Grigoriy Davidovich "Grisha" Bruskin on October 21 in Moscow
1963-68 Studies in the Department of Applied Arts at the Moscow Textile Institute
1969 Member of the Artists' Association of the USSR
1980s Contacts with intellectuals and artists promoting alternative ideas
1982 His *In the Red Space* attracts undesirable attention from the authorities for depicting a golem—wearing a Soviet uniform—carrying a synagogue from which people are falling
1976-84 Various exhibitions in Vilnius and Moscow are closed by the authorities
1983 Starts working on *Alefbet* and *Fundamental Lexicon* series
1989 Emigrates to New York; begins to regularly exhibit internationally
2005/7 Participates in the 1st and 2nd Moscow Biennale of Contemporary Art

Literature
Grisha Bruskin: Life is Everywhere, exh. cat. Pushkin Museum (Moscow, 2001).
Grisha Bruskin: Modern Archaeology, exh. cat. Marlborough Gallery (New York, 2004).
Grisha Bruskin: Tapestry Project, exh. cat. Musée d'art et d'histoire du Judaïsme (Paris, 2010).

Grisha Bruskin at the exhibition *Fragments of an Endless Collection*, Museum Judengasse, Frankfurt 2003. Photo by Barbara Klemm

1951 Morris Louis, *Charred Journal* **1973** Yom Kippur War

1955–68 Civil rights movement in the U.S. **1983** Disc

1960–61 Adolf Eichmann sentenced of th
to death in Jerusalem viru

1900 1905 1910 1915 1920 1925 1930 1935 1940 1945 1950 1955 1960 1965 1970 1975 1980 1985

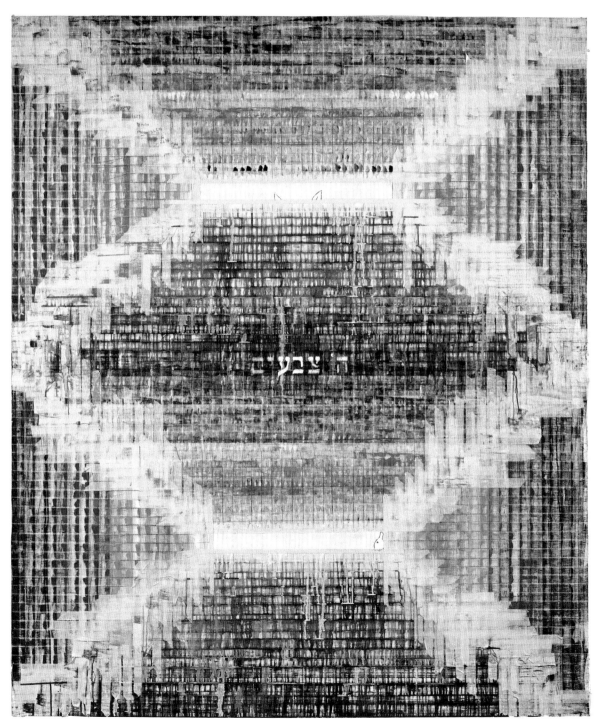

1995 Israeli Prime Minister Yitzhak Rabin and PLO chairman
Yasser Arafat sign peace agreement in Oslo

1989 Massacre in Tiananmen
Square in China **2003** Human genome decoded

1990 Reunification of Germany **2010** "Arab Spring" begins with protests in Tunisia

| 1990 | 1995 | 2000 | 2005 | 2010 | 2015 | 2020 | 2025 | 2030 | 2035 | 2040 | 2045 | 2050 | 2055 | 2060 | 2065 | 2070 | 2075 |

MICHAL NAAMAN

*The kibbutz-born contemporary artist Michal Naaman is fundamentally modern yet firmly rooted in traditional Judaism.
She is a perfect example of an artist of Israeli society, primarily secular but producing art that plays with, challenges, and
provokes the traditions of a culture thousands of years old.*

In her *Lord of Colors (in White)* (1998) Michal Naaman
(b. 1951) deals with the tension between religion
and modernity. The words "Hashem tzva'im"
(Lord of Colors) are written in white Hebrew letters
over an abstract colored background. The title is a
pun on "Hashem tsva'ot" (Lord of Hosts), a biblical
title for God used in connection to his bellicose
activities. In her painting she turns the male
military God into a female life-sustaining God
who created the colorful rainbow to conclude the
covenant with all living creatures on earth, which
would never be destroyed by a massive flood again
(Genesis 9:12–17). The title and content of this work
refers subtly to another gender-related irony: in
Hebrew, *tzva'im* (colors) has a masculine form,
whereas *tzva'ot* (hosts) has a feminine plural ending.
She plays with the attributes of God's name, but
at the same time abbreviates the name itself
respectfully with one letter, in conformance with
the tradition of not spelling out God's four-letter
Hebrew name.

A Colorful God

God of colors? The *Zohar*, the bible of Jewish
mysticism that originated in thirteenth-century
Spain, asks what it means when the text says that
God "appeared" to the patriarchs instead of
speaking to them (Exodus 6:3), and explains that he
reveals his true nature not in an anthropomorphic
form, but in colors—each letter having a different
color. The Lord of Hosts is transformed into a
mystical God of colors when Naaman connects
God's creative powers with her own impulse to make
a colorful painting as an expression of the human
impulse to create art. She is aware of the power of
the word as one of the secrets and charms of
Hebrew, which she now extends to secular art, no
longer limiting it to the male rabbis or the exclusive
circle of the mystics of old. She is seizing control of a
power that had previously been denied to her as a
woman and as a secular person.

Hebrew, the mother tongue of modern secular
Israelis, is the sacred language of the Bible, spoken
three thousand years ago in ancient Israel, and,
after the loss of statehood from the destruction of
Jerusalem in 70 CE, was used mainly passively for
religious purposes. The square script Naaman uses
is the same male scribes used for two thousand
years to copy the text of the Bible on parchment
scrolls, its shape being the basis of modern Hebrew
printed texts. Thanks to the efforts of Eliezer Ben-
Yehuda (1858–1922), Hebrew was revived as a
spoken language when Jewish immigrants went to
Palestine in the late nineteenth century. Only Ultra-
Orthodox Jews still prefer to speak Yiddish rather
than use the holy tongue for secular use.

In the cycle to which this painting belongs,
Naaman plays with biblical words and images,
making Hebrew puns, referring to the male and
female aspects of the abstract God of Jewish
mysticism. She literally explores its specter, without
any fear of exploring its limits and tensions within
the time-honored traditions of the Jewish religion
and the holy language.

1951 Born in Kvutzat Kineret, Israel
1974 Earns her BA in History of Art and
Comparative Literature, Tel Aviv
University
1972 Graduates from the Art Teachers
Training College, Ramat
HaSharon
1975 First solo exhibition at Yodfat
Gallery, Tel Aviv
1978–80 Studies at the School of
Visual Arts, New York
1982 Participates in the 40th Venice
Biennale
1999 Retrospective at the Tel Aviv
Museum of Art
2002 Receives the Sandberg Prize for
Israeli Art, The Israel Museum,
Jerusalem

LITERATURE
Arturo Schwarz, *Love at First Sight:
The Vera, Silvia, and Arturo Schwarz
Collection of Israeli Art*, exh. cat.
The Israel Museum (Jerusalem, 2001).

left page
Michal Naaman, *Lord of Colors (in White)*,
1998, oil paint and masking tape,
200 x 170 cm, Tel Aviv Museum of Art

above
Photograph of Michal Naaman

1954–62 Algerian War

1955 Beginning of Pop Art

1947 India gains independence
from the United Kingdom

1973 Chilean coup d'état, electe
president Salvador Allende

1976 Apple is founded

1982 Michael Jac
Thriller

| 1900 | 1905 | 1910 | 1915 | 1920 | 1925 | 1930 | 1935 | 1940 | 1945 | 1950 | 1955 | 1960 | 1965 | 1970 | 1975 | 1980 | 1985 |

ANISH KAPOOR

One of the most influential sculptors of his generation, Anish Kapoor employs abstract, geometric forms to magnificent effect in oftentimes richly colored site-specific works. Present in the world's most important collections, Kapoor's artwork straddles the line between the sculptural and the architectural.

A Whisper of Angels

The world-famous British artist Anish Kapoor (b. 1954) was born and raised in India to a Jewish Iraqi mother and an Indian father. His mother originated from Baghdad: "My mother was then only a few months old. She had an Indian Jewish upbringing. Her father, my grandfather, was the cantor in the synagogue in Pune. At the time, the Jewish community in Mumbai was quite large, mostly consisting of Baghdadi Jews." Kapoor spent his early years in Bombay (Mumbai) and Dehra Dun. In 1971 he went to Israel, first staying at a kibbutz, and then studying electrical engineering. In 1973 he went to study art in London, where he still lives.

Much of Kapoor's early sculpture is characterized by geometric forms, usually monochromatic and brightly red or blue colored, with powder pigment often covering the works and the floor around them. Later works are made of solid, quarried stone, some of which have mysterious openings. Recently he has experimented with curved mirroring surfaces, some of them gigantic in size, reflecting and at the same time distorting both the viewer and the surroundings. His stainless steel mirrored work *Turning the World Upside Down*, installed at the Israel Museum, Jerusalem in 2010, seems to reverse earth and sky, and to reflect on the sacred and profane aspects of the holy city—dualities which often play a role in the work of Kapoor.

Mysteries

In an exhibition at Le Magasin in 1990, Kapoor installed the work *It Is Man* (1989) alongside the work *Angel* (1990). The juxtaposition of these two works affirms the dualism between dark and light; male and female are united, and we are immersed in a mysterious world of darkness and light, form and formlessness. In *Angel*, slabs of slate are covered in blue pigment, scattered over the floor: the stones seem to flow in space.

The rough stone of *It Is Man* draws us into a smooth, seemingly endless dark blue womb-like depth, a birth channel, hiding the mythical powers of the androgynous creation of man—"male and female He created them" (Genesis 1:27). Darkness is one of the dominant themes in Kapoor's earlier work. The creation story may state that God's first words were: "Let there be light" (Genesis 1:3), but darkness preceded light, as the previous verse says: "The earth being unformed and void, with darkness over the surface of the deep" (Genesis 1:2). According to Jewish legend, darkness protested against God, fearing that if it were lit, it would become the slave of light. Which is why in the End of Days, darkness and its angels will support his claim in having played a role in creation, but God and his angels will defeat them, since God's angels were part and parcel of creation itself; as it says, "and heaven and earth were finished, and all their array" (Genesis 2:1)—array, that is God's angels.

His installations all possess a mysterious, almost mythical quality, and deal to a large extent with archetypes, with creation, life, and death. On an architectural scale or in a more intimate size on paper, Kapoor pulls the spectator into an energizing, enigmatic world. The transcendence Newman and Rothko realized in painting, Kapoor achieves decades later in sculpture.

1954 Born on March 12 in Bombay (Mumbai) to a Jewish mother from Baghdad

1971–73 Goes to Israel with one of his two brothers; stays in a kibbutz, then studies electrical engineering

1973–77 Moves to London; studies at the Hornsey College of Art

1977–78 Studies at the Chelsea School of Art and Design

1979 Travels to India; inspired to use powdered pigments

1990 Represents Great Britain at the 44th Venice Biennale

1991 Receives the Turner Prize

1992 Shows *Descent into Limbo* at Documenta 9 in Kassel

2003 Becomes Commander of the British Empire

2008 His sculpture *Memory* is shown at the Guggenheim in Berlin and New York

2009 Major solo exhibition at the Royal Academy of Arts, London

2010 *Turning the World Upside Down, Jerusalem* installed at the Israel Museum, Jerusalem; exhibits *Leviathan* at the Grand Palais in Paris

LITERATURE
Anish Kapoor: Memory, exh. cat. Deutsche Guggenheim (Berlin, 2008).
Anish Kapoor, exh. cat. Royal Academy of Arts (London, 2009).
Anish Kapoor: Turning the World Upside Down, exh. cat. Kensington Gardens (London, 2011).

left page
Anish Kapoor, *It Is Man / Installation with Angel*, 1989–90
Angels, 11 elements: slate, blue pigment, variable dimensions/sizes, approx. 60 x 260 x 115 cm, installation, Le Magasin, Centre National d'Art Contemporain, Grenoble
It Is Man, Sandstone, pigment, 241 x 127 x 114 cm, Museo National Centro de Arte Reina Sofia, Madrid

above
Photograph of Anish Kapoor

WILLIAM KENTRIDGE

JULIAN SCHNABEL

DAMIEN HIRST

1955 *The Family of Man* exhibition at
MoMA in New York

1955–68 Civil rights movement
in the U.S.

1979–89 Soviet-Afghan War

1973 Watergate scandal

| 1905 | 1910 | 1915 | 1920 | 1925 | 1930 | 1935 | 1940 | 1945 | 1950 | 1955 | 1960 | 1965 | 1970 | 1975 | 1980 | 1985 | 1990 |

William Kentridge, *Porter Series—Noah
Tapestry*, 2001, tapestry designed by
William Kentridge, woven by Marguerite
Stephens Weavings Studio, mohair,
silk, and embroidery, 400 x 300 cm.
Courtesy Marian Goodman Gallery,
New York/Paris

1994 End of apartheid in South Africa
Nelson Mandela becomes first South African president
Freeze, exhibition of Young **2007–10** Global financial crisis
British Artists in London **2009** Barack Obama becomes first African American U.S. president
2001 Terrorist attacks on World Trade Center (9/11)

1995　2000　2005　2010　2015　2020　2025　2030　2035　2040　2045　2050　2055　2060　2065　2070　2075　2080

WILLIAM KENTRIDGE

World-renowned South African artist William Kentridge's politically and socially incisive animated films have been projected onto screens throughout the world. He explores in a wide variety of media the complex and oftentimes ambivalent reality of apartheid and post-apartheid South Africa.

Telling History

William Kentridge, born in South Africa in 1955, was deeply disturbed by apartheid's racism and continues to deal with the legacy of racial prejudice. As a Jew whose grandparents had emigrated from Lithuania to South Africa, Kentridge stands on the side of the victims without exactly being one of them—both his parents were involved as lawyers in the anti-apartheid movement and represented many of its black victims.

In *Porter Series—Noah Tapestry* (2001) we see the two white characters who are omnipresent in Kentridge's work—animated films on apartheid and post-apartheid South Africa based on charcoal drawings, prints, photographs, and small figurines—and can be seen as his alter-egos: the sensitive artist Felix Teitlebaum, and the industrialist Soho Eckstein, founder of a coal mine, ruthless ruler with his telephone, and exploiter of black workers. While Jewish individuals (such as Kentridge's parents) and Jewish groups played a major role in resisting apartheid, as whites they also benefited from the economic racism of the South African system.

Falling from Grace

Telephone and megaphone are the instruments of communication for both ruler and oppressed parading in front of a map, depicting the dispersion of the children of Noah. Originally, at least as the Bible wishes us to believe, there was harmony in the world. But this harmony did not last long; almost immediately after humans were created, the complications began—Adam and Eve are expelled from the Garden of Eden after eating the fruit from the tree of knowledge of good and evil (Genesis 3) and their son Cain kills his brother Abel (Genesis 4). Perhaps humanity was not such a good idea after all, and God decides to wipe out all of mankind from the earth, sparing just one man, Noah, and his family.

After the flood, Noah plants a vineyard and the next problem arises—he gets drunk and lies naked. His son Ham sees him and calls his brothers Shem and Japheth, who cover their father's nakedness without looking (Genesis 9:18–29). According to the Bible, Shem, Ham, and Japheth are the ancestors of the nations of the earth: Shem would become the ancestor of Abraham and other Semitic tribes; Japheth would father the Greeks and other Europeans; and Ham, cursed by his father, begot the Egyptians and the Kushites—later identified as the blacks. The chart of nations in Genesis 10 expresses the unity of mankind without any identifiable racial pattern. South African apartheid however justified racial discrimination based on this story, running counter to the biblical tenet that all men are created in God's image (Genesis 1:27 and 9:6).

The idea of the Middle East as the cradle of ancient civilizations has a bittersweet aftertaste: here lie the roots of humiliation for millions, just as it possesses the ideals of human equality. In procession, the two protagonists shout their messages loudly and clearly, hoping to reach the observer. Kentridge represents a political position that is never self-righteous, but focuses rather on the moral urgency of his message. His story is there for us to interpret, and appeals to our own responsibility, guilt, and grief.

1955 Born on November 30 in Johannesburg
1973–76 Attends the University of the Witwatersrand, Johannesburg; studies politics and African studies
1976–78 Studies at the Johannesburg Art Foundation
1980s Becomes art director for television series and feature films
1981–82 Studies mime and theater at L'École Internationale de Théâtre Jacques Lecoq, Paris
1988 Founding member of the Free Filmmakers Co-operative
1993 Participates with animation films in the 45th Venice Biennale
1997 Participates in Documenta 10 in Kassel
1998 Major retrospective exhibition at the Palais des Beaux Arts, Brussels
2002 Participates in Documenta 11
2005 Participates in the 51st Venice Biennale
2008 10 *Tapestries* shown at the Philadelphia Museum of Art
2009–11 Comprehensive exhibition *Five Themes* at the San Francisco Museum of Modern Art, later traveling to Fort Worth, West Palm Beach, New York, Tokyo, Paris, Vienna, and Jerusalem

LITERATURE
Mark Rosenthal, ed., *William Kentridge: Five Themes*, exh. cat. San Francisco Museum of Modern Art / Norton Museum of Art, West Palm Beach (New Haven and London, 2009).

Photograph of William Kentridge

William Kentridge, *Drawing from Mine*,
1991, charcoal on paper, 100 x 70 cm,
Collection National Museum of African
Art, Smithsonian Institute, Washington,
D.C.

William Kentridge, *Captive of the City*,
1989, drawing for the film *Johannesburg,
2nd Greatest City after Paris*, charcoal and
pastel on paper, 96 x 151 cm, collection
of the artist, Johannesburg

1973 Yom Kippur War

1923 Reuven Rubin, *First Fruits* **1959** First happening by Allan Kaprow **1987–93** First Palestinian Intifada
 in New York

1938 Constantin Brancusi, *Endless Column* **1982** Lebanon War **1999** Kosovo War

1920 1925 1930 1935 1940 1945 1950 1955 1960 1965 1970 1975 1980 1985 1990 1995 2000 2005

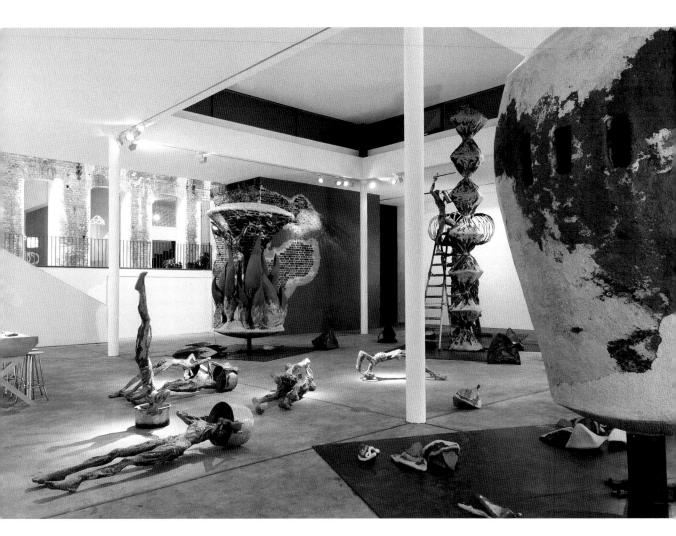

Sigalit Landau, *Doner Kebab*, *Crusaders*,
and *Eating as Much as You Can't* figures,
The Dining Hall, 2007, view of the
exhibition *The Dining Hall*, KW Institute
for Contemporary Art, Berlin

003 U.S. invasion of Iraq
2007–10 Global financial crisis
0–5 Second Palestinian Intifada

2010 2015 2020 2025 2030 2035 2040 2045 2050 2055 2060 2065 2070 2075 2080 2085 2090 2095

SIGALIT LANDAU

A sculptor and video and installation artist, Israeli-born Sigalit Landau explores personal themes through universal exploration, at times using both her own body and site-specific installations to reflect geopolitical struggle or ecological disaster.

Like many Israelis of her generation, Sigalit Landau (b. 1969, Jerusalem) can trace her formative years by the wars that raged about her: she was three years old during the Yom Kippur War (1972), and twelve when Israel invaded Lebanon (1981); during the first Palestinian Intifada (1987–93) she "had to do and undo the Israeli army." She studied dance at the Rubin Academy and art at the Bezalel Academy of Art and Design, both in Jerusalem.

Against the backdrop of the Israel-Palestine conflict, it is no surprise that war and conflict play an essential and frighteningly realistic role in her installations and videos. Apart from wars, Israel also faces numerous internal conflicts. Israel is a relatively young immigrant country, and while many groups have successfully integrated, there is tension between the usually well-educated, secular European Jews and the more religious and poorer Oriental Jews from Africa and Asia. One million of a total of six million Israeli citizens are either Christian or Muslim Palestinian. About a quarter of the population lives below the poverty line. Religion, which kept Jews together for two thousand years in the Diaspora, in Israel became a divisive force: Zionism is secular and, in principle, so is the Jewish state. But in Israel there is no clear division between state and synagogue, leaving a great deal of influence with a small minority of extreme Orthodox groups who do not even recognize the state. Landau's work evokes these conflicts—between different groups of Jews or between Israelis and Palestinians—as much as she pointedly refers to the larger apocalyptic threats that trouble the world in general.

Everything including the Kitchen Sink
In her project *The Dining Hall* (2007), Landau installed a large industrial dishwasher from an Israeli Kibbutz through which moved leftovers and assorted debris, producing sound, noise, and music. Several rooms were grouped around it: one filled with lamps hung at or below waist level, thickly encrusted with glistening salt crystals; another furnished as a 1950s living room with a kitchen, reminiscent of the interiors of recent immigrants. The four hotplates of the stove were replaced by speakers, from which the voices of women were heard talking about their recipes and their life experiences. In a large hall human figures climbed architectural structures and ladders or lied on the floor; others stood on their heads in big metal buckets and tubs. They looked like anatomical models, emaciated nudes fashioned from papier-mâché and painted the color of blood. One of the structures resembled a giant döner kebab, a reference to kebab houses; another echoed Brancusi's symbol of hope, the *Endless Column*; and others looked like gluttonous and seductive pillars of food for the hungry and greedy. Her decaying fruit is the antithesis of the luscious fruits of Reuven Rubin's pioneers in the 1920s.

Food, flesh, decay, long-since-lost Kibbutz romance and family intimacy, Zionist dreams turned into nightmares, the memory of war, persecution, extermination, apocalypse: in the work of Sigalit Landau, it is all there.

1969 Born in Jerusalem to parents of Romanian and British/Austrian descent
1990–94 Studies at Bezalel Academy of Art and Design, Jerusalem
1995 Installation *Temple Mount* at the Israel Museum, Jerusalem
1997 Participates in Documenta 10 in Kassel
2004 *The Endless Solution*, Helena Rubinstein Pavilion, Tel Aviv
2007 *The Dining Hall*, KW Institute of Contemporary Art, Berlin
2011 Represents Israel at the 54th Venice Biennale

LITERATURE:
Mordechai Omer and Sigalit Landau, *The Endless Solution*, exh. cat. Tel Aviv Museum of Art (Tel Aviv, 2004).
Gabriele Horn and Ruth Ronen, eds., *Sigalit Landau: The Dining Hall*, exh. cat. KW Institute of Contemporary Art (Berlin, 2007).
Kamel Mennour, ed., *Sigalit Landau: One Man's Floor is Another Man's Feelings* (Paris, 2011).

Photograph of Sigalit Landau

TIMELINE

18TH–14TH C. BCE Patriarchs and matriarchs migrate from Mesopotamia to Canaan

14TH–13TH C. BCE Joseph becomes viceroy in Egypt, Jews become more numerous

1275–1250 BCE Exodus from Egypt

1020 BCE Saul becomes the first king of Israel

1000 BCE King David makes Jerusalem into the capital

961 BCE Solomon builds the first Temple in Jerusalem

722 BCE Assyrians expel the ten tribes of Israel

586 BCE Babylonians destroy the Temple in Jerusalem; Babylonian exile

538 BCE King Cyrus permits the exiles to return

515 BCE Completion of the Second Temple in Jerusalem

333 BCE Alexander the Great occupies the land of Israel

300–200 BCE Judea under Hellenistic rule; Bible translated into Greek (Septuagint)

167 BCE Maccabean revolt; Jerusalem Temple defiled

164 BCE Jerusalem Temple rededicated

140 BCE Judea independent

63 BCE Pompey brings Judea under Roman rule

30 CE Crucifixion of Jesus of Nazareth under Roman governor Pontius Pilate

66 CE Jewish revolt against Rome

70 CE Destruction of the Second Temple by Titus; Judea becomes Roman

70–80 CE Codification of the Bible by rabbis in Yavneh

74 CE Fall of Masada; sectarians hide texts in Qumran

1ST–6TH C. CE Earliest synagogues in Palestine and the Diaspora

200 Judah the Prince codifies Jewish law: Mishnah

321 The first Christian Roman emperor Constantine allows Jews to settle in Cologne

500 Babylonian Talmud, commentary on the Mishnah completed

632 Death of Mohamed, the founder of Islam

638 Jerusalem conquered by Arab Muslims, who rule Palestine until 1099

691 Caliph Abd al-Malik builds the Dome of the Rock on the site of the Temple

712 Muslims overthrow Christian rulers in Spain; under Caliph Abd al-Rahman III (891–961) the three monotheistic traditions co-exist peacefully

1000 Speyer, Mainz, and Worms centers of Jewish learning

1066 Jews settle in England after the Norman Conquest

1070 Solomon ben Isaac (Rashi) writes commentaries of Bible and Talmud

1085 Beginning of the Christian re-conquest of Spain

1096 Crusaders murder Jews in the Rhineland

1144 First blood libel in York, England

1163 Jews in China build a synagogue in Kaifeng

1178 Maimonides writes comprehensive summary of Jewish law, *Mishneh Torah*

1178 Turkish sultan Saladin expels Crusaders from Jerusalem

1204 Crusaders plunder Constantinople (Istanbul) and burn Jewish quarter

1215 Fourth Lateran Council decides that Jews have to wear distinctive markings

1242 Public burning of Jewish books in Paris

1280 *Zohar*, the fundamental work of Kabbalah (Jewish mysticism), appears

1290 Expulsion of the Jews from England

1348–49 Jews massacred after being accused of poisoning wells and causing "the Black Death"

1364 Casimir the Great of Poland extends rights to Jews, attracting refugees from Germany

1391 Massacres and forced conversions in Spanish Christian Castile and Aragon

1394 Expulsion of the Jews from France

1421 Jews banned from Austria

1462 Establishment of the Frankfurt ghetto

1473 Blood libel of Trent, Italy; massacre of converted Jews in Cordoba, Spain

1470S The first Hebrew printed books are published in Italy, the Iberian Peninsula, and Istanbul

1481 Spanish Inquisition publicly burns Jews

1492 Jews expelled from Spain

1497 Jews expelled from Portugal

1516 Ghetto in Venice

1517 The Ottoman Empire conquers Palestine

1553 Poland and Lithuania offer greater freedoms to Jews

1600 Spanish-Portuguese Jews arrive in Amsterdam

1622 Salamone Rossi in Mantua composes music for the synagogue

1648–49 Cossack Bogdan Chmielnicki kills Jews in Poland and Lithuania

1654 Jews from Brazil flee to New Amsterdam (New York)

1656 Baruch Spinoza excommunicated by Amsterdam Portuguese Jews

1666 Pseudo-messiah Sabbatai Zevi converts to Islam

1670 Jews expelled from Vienna; refugees flee to Berlin

1700 Glückel of Hameln writes memoirs

1738 Financer Joseph Süss Oppenheim (Jud Süss) executed

1772 Rabbi Elijah, Gaon of Vilna, bans Hasidism, a movement founded by Israel Baal Shem Tov

1782 Joseph II of Austria issues Edict of Tolerance

1783 Moses Mendelssohn publishes *Jerusalem*, promoting the Jewish Enlightenment

1791 Equal rights for Jews in France

1793 Russia introduces the Pale of Settlement for the Jews

1796 Equal rights for Jews in the Netherlands

1797 Shneur Zalman of Liadi publishes the *Tanya* for the Lubavitcher Hasidism

1806 Napoleon calls a Great Sanhedrin to secure Jewish allegiance to the state

1823 Heinrich Heine converts to Christianity

1836 Samson Raphael Hirsch publishes his *Nineteen Letters of Ben Uziel*, establishing Modern Orthodox Judaism

1838 Rebecca Gratz founds Hebrew School in Philadelphia, a first step to women's emancipation

1840 A blood libel in Damascus; Moses Montefiore and other Jewish leaders intervene

1844–46 Reform Rabbinic Conferences in Germany introduce equality between men and women in the synagogue

1848 Revolution; countless Jews participate throughout Europe

1848 Karl Marx and Friedrich Engels publish the Communist Manifesto

1852 Louis Napoleon proclaims himself Emperor Napoleon III

1853 Abraham Mapu from Lithuania publishes the first Modern Hebrew novel

1854 Jewish Theological Seminary in Breslau, the rabbinic school of the Conservative movement

1860 Alliance Israélite Universelle founded to protect Jewish rights and education

1864 Mendele Mocher Sforim publishes the first modern Yiddish novel in Berdichev, Russia (now Berdychiv, Ukraine)

1866 Equal rights for Jews in the United Kingdom

1866 Moorish style New Synagogue in Berlin opened

1867 Equal rights for Jews in Austria

1868 Benjamin Disraeli, baptized at 13, becomes prime minister of the United Kingdom

1870 Equal rights for Jews in Italy

1871 Equal rights for Jews in Germany

1872 Rabbi Abraham Geiger founds the Liberal Seminary for the Science of Judaism in Berlin

1873 American Reform synagogues unite under one umbrella organization, the Union of Reform Judaism

1875 Hebrew Union College, the Reform Seminary starts training rabbis in Cincinnati, later with branches in New York, Los Angeles, and Jerusalem

1879 Wilhelm Marr introduces the term "anti-Semitism" to define Jews as a race rather than a religion

1880s Anti-Semitic movement in Germany; anti-Semitic pamphlets in France

1881–84 Russian pogroms cause mass emigration to the United States

1882 Leon Pinsker publishes Auto-Emancipation in Odessa

1886 Edouard Drumont publishes anti-Semitic book La France juive

1888 Wilhelm II German Emperor (until 1918)

1893 Central Union of German Citizens of the Jewish Faith founded in Berlin to combat anti-Semitism

1894 French captain Alfred Dreyfus wrongly accused of treason; found guilty and imprisoned on Devil's Island

1895 First Venice Biennale

1896 Viennese journalist Theodor Herzl writes The Jewish State

1897 The First Zionist Conference held in Basel

1901 Exhibition of Jewish art during Fifth Zionist Congress in Basel

1902 The Jewish Theological Seminary in New York (founded 1887) starts training Conservative rabbis

1903 Pogrom in Kishinev (now Chişinău, Moldova)

1904 The Jewish Museum, New York founded

1905 The first publication of the anti-Semitic pamphlet Protocols of the Elders of Zion

1906 Bezalel School of Arts and Crafts founded in Jerusalem

1906 Dreyfus verdict annulled

1909 Tel Aviv founded

1911 Yiddish author Sholem Aleichem publishes Tevye the Dairyman

1913 Anti-Defamation League founded in Chicago to combat anti-Semitism

1914 Joint Distribution Committee founded in New York, a worldwide Jewish relief organization

1914–18 World War I

1917 British foreign secretary Arthur Balfour favors a national home for the Jewish people in Palestine

1917 Russian Revolution; Jews receive equal rights (until Communists take power shortly after)

1919 Rosa Luxemburg and Karl Liebknecht, leaders of Berlin revolt, assassinated

1921 Albert Einstein wins Nobel Prize in physics

1922 German foreign minister Walther Rathenau assassinated

1925 Opening of the Hebrew University in Jerusalem

1925 Hitler publishes Mein Kampf

1928 Stalin creates autonomous Jewish region in Birobidzhan, Siberia

1929 Riots between Jews and Arabs in Palestine

1929 Stock market crash; world economic crisis

1933 Hitler and the Nazis come to power in Germany

1935 Nuremberg racial laws deprive Jews of their civil rights

1937 Degenerate "Art" exhibition in Munich

1938 Pogrom Night, November pogrom in Germany

1939–45 World War II

1940 The Nazis establish ghettos in Eastern Europe

1942 At the Wannsee Conference in Berlin, Nazis decide to systematically murder the Jews

1942–44 Nazis murder six million European Jews in extermination camps

1945–47 Survivors wait in German camps for "Displaced Persons" for a new homeland in the United States or Palestine

1947 Discovery of the Dead Sea Scrolls near Qumran, now in the Israel Museum, Jerusalem

1948 Declaration of Independence of the State of Israel, May 14

1948 The United Nations adopts Universal Declaration of Human Rights

THE HENLEY COLLEGE LIBRARY

1949	Israel becomes a member of the United Nations	1978	Isaac Bashevis Singer wins the Nobel Prize for Literature	2000–5	Second Palestinian Intifada
1952	Show trials against Jews in Soviet Union	1979	Israel-Egypt peace agreement	2001	9/11 terrorist attacks on the United States
1953	Death of Stalin	1982	Lebanon War	2001	Jewish Museum in Berlin, designed by architect Daniel Libeskind, officially opens
1953	Foundation of Yad Vashem, Jerusalem, to commemorate the Holocaust victims	1986	Elie Wiesel wins the Nobel Peace Prize	2005	Memorial to the Murdered Jews of Europe in Berlin, designed by Peter Eisenman
1955	First Documenta exhibition in Kassel	1987–93	The first Palestinian Intifada	2007–10	Global financial crisis
1956	Sinai (or Suez) Crisis	1989	Fall of the Berlin Wall		
1956	Saul Bellow wins the Nobel Prize for Literature	1990	Reunification of Germany		
1960–61	Adolf Eichmann tried and sentenced to death in Jerusalem	1993	The United States Holocaust Memorial Museum opens in Washington		
1961	Construction of the Berlin Wall	1994	Yitzhak Rabin, Shimon Peres, and Yasser Arafat win the Nobel Peace Prize		
1967	Six-Day War	1994	End of Apartheid in South Africa		
1969	Woodstock music festival	1995	Rabin assassinated by an Israeli radical during a rally in Tel Aviv to support the peace process		
1973	Yom Kippur War				

PHOTO CREDITS

The illustrations in this publication have been kindly provided by the museums, institutions, and archives mentioned in the captions, or taken from the Publisher's archives, with the exception of the following:

akg-images: Cover top, p. 57 below
Bridgeman Berlin: Cover (Man Ray and Modigliani), p. 67
Courtesy Hauser & Wirth: p. 6 (photo: Abby Robinson, New York, and Barbora Gerny, Zurich), p. 128 (photo: Abby Robinson, New York), p. 129
Courtesy Sigalit Landau and kamel mennour, Paris: pp. 10–11, 150, 151 (©photo Eyal Segal)
Stedelijk Museum, Amsterdam: pp. 24, 72
Städtisches Museum, Gelsenkirchen: p. 33
Joods Historisch Museum, Amsterdam: p. 34
Tel Aviv Museum of Art, Israel: pp. 36, 80, 130, 142
Jewish Museum Berlin, photo: Jens Ziehe, Berlin: pp. 38, 46
Musée d'art et d'histoire du Judaïsme, photo: Christophe Fouin: p. 42
Arnold Schönberg Center, Vienna/Florence Homolka: pp. 44–45
Galerie Schmit, Paris: p. 52
Private collection Zurich: p. 54
The Museum of Fine Arts, Houston: p. 55
Philadelphia Museum of Art: p. 57
The State Tretyakov Gallery, Moscow: pp. 58–59
Rheinisches Bildarchiv, Cologne: pp. 61, 140 above

Zadkine Foundation/G. L. Marchal: p. 63
Man Ray Trust Paris, ADAGP, Telimage: p. 64
Museum Boijmans van Beuningen, Rotterdam: p. 66
Estate of Jacques Lipchitz, courtesy Marlborough Gallery, New York: pp. 68, 69 (photo: F. K. Lloyd, New York)
Rubin Museum Collection, Tel Aviv: pp. 70–71
The Museum of Modern Art, New York, gift of Sam Salz: p. 76
Jankel-Adler-Archiv, Von der Heydt-Museum: p. 77
Collection of the Mishkan LeOmanut, Museum of Art, Ein Harod, Israel, photo: Avraham Hai: p. 78
Smith College Museum of Art, Northampton: p. 84
Ecumenical Chapel, Houston, photo: Hickey and Robertson: pp. 90–91
Berlinische Galerie, Landesmuseum für Moderne Kunst, Fotografie und Architektur: p. 92
Felix-Nussbaum-Haus, Osnabrück: p. 93
Kunstsammlung Nordrhein-Westfalen, Düsseldorf, photo: Achim Kukulies: p. 94
Jon Holstein: p. 95
Philadelphia Museum of Art, gift of the Aaron E. Norman Fund, Inc.: p. 96
Louisiana Museum of Modern Art, Humblebaek: p. 100
Charlotte Salomon Foundation, Joods Historisch Museum, Amsterdam: pp. 102, 104–105
Private collection, New York: p. 106
Larry Rivers Foundation / Eddy Novaro: p. 107
Lothar Sprenger, Dresden: p. 108

© Abe Frajndlich, 2010: p. 109
Westfälisches Landesmuseum für Kunst und Kulturgeschichte Münster, photo: Rudolf Wakonigg: p. 110
© Jaume Blassi: p. 112
© Tamar Karavan: p. 113
Private collection, courtesy Marlborough Fine Art London: p. 114
Marlborough Gallery, New York: pp. 115, 141
The Israel Museum, Jerusalem / Nachum Slapak: p. 120
©Arnold Newman: p. 121
Richter Verlag GmbH, Düsseldorf: p. 122
Wladimir Tschirsky/Galerie Brigitte Schenk: p. 123
Private collection, photo: courtesy of Pace Wildenstein, New York: p. 124
Courtesy Hauser & Wirth, Zurich/London: p. 127
Werner J. Hannapel, Essen: p. 132
Micha Ullman, Stuttgart: p. 134
Givon Art Gallery: p. 135
Courtesy of the Paula Cooper Gallery, New York: p. 136
Kunsthalle Emden, Donation Eske and Henri Nannen, gift of Otto van de Loo: p. 140 below
Gordon Gallery: p. 143
Centre National d'Art Contemporain, Grenoble: p. 144
Gladstone Gallery: p. 145
Courtesy William Kentridge & the Goodman Gallery: pp. 146–49

INDEX